BLACK SISTERHOODS

Paradigms and Praxis

Edited by Tamara Bertrand Jones,
Denise Davis-Maye, Sophia Rahming,
and Jill Andrew

DEMETER

Black Sisterhoods
Paradigms and Praxis
Edited by Tamara Bertrand Jones, Denise Davis-Maye, Sophia Rahming, and Jill Andrew

Demeter Press
PO Box 197
Toronto, Ontario
Canada
K0L 1P0
Tel: 289-383-0134
Email: info@demeterpress.org
Website: www.demeterpress.org

Demeter Press logo based on the sculpture "Demeter" by Maria-Luise Bodirsky www.keramik-atelier.bodirsky.de

Printed and Bound in Canada

Cover image: Sydney Foster
Cover design and typesetting: Michelle Pirovich
Proof reading: Jena Woodhouse

Library and Archives Canada Cataloguing in Publication
Title: Black sisterhoods: paradigms and praxis / edited by Tamara Bertrand Jones, Denise Davis Maye, Sophia Rahming, and Jill Andrew.
Names: Jones, Tamara Bertrand, editor. | Davis-Maye, Denise, editor. | Rahming, Sophia, editor. | Andrew, Jill, 1978- editor.
Description: Includes bibliographical references.
Identifiers: Canadiana 20220153973 | ISBN 9781772583786 (softcover)
Subjects: LCSH: Women, Black. | LCSH: Female friendship.
Classification: LCC HQ1163.B53 2022 | DDC 302.34082—dc23

Contents

CONTENTS

Black Women Defining, Enacting, and Shifting Sisterhood: An Introduction

Denise Davis-Maye, Tamara Bertrand Jones,
Sophia Rahming, and Jill Andrew

Sisterhood is an often elusive, if not misunderstood concept. Early in the history of African women in the Americas, specifically the United States, women of African ancestry began to circumscribe the roles of Black women[1] and their responsibility to one another— roles which were in direct opposition to roles ascribed by those who participated in the commercial trade of their bodies. Anna Julia Cooper and her peers recognized the significance of Black women in community and began to orchestrate the practical use of what they understood to be womanhood's benefits, with a focus on mutuality and peoplehood and acknowledgement of power and strength which fuels Black women's reliance on one another. Marnel Niles Goins charges that women's relationships are particularly significant for Black girls and women, as they provide sources of empowerment and gird the girls and women's ability to resist oppressions they face as a result of the double jeopardy associated with their gender and race. She goes as far as to propose that Black girls and women's friendship groups serve as a homeplace—a place of safety from which Black girls and women can prepare to respond to, rebel against, and resist the assaults of the larger society, and just be.

Defined by many as a biological or legal relationship, we situate sisterhood in varied representations as they appear in Black communities

7

and Black women's relationships. Many groups discuss friend types, like those Liz Welch identifies: the best friend, alter ego, work buddy, go-to-girl, cerebral match, childhood friend, and the mirror image. There are, of course, likely some similarities between the friendship relationships of Black women and women of other ethnicities. In fact, the peer needs of mutual support, companionship, bonding, and mirroring are likely beneficial to all women (Denton). However, Black girls and women must nurture these friendships, or sistering relation-ships, in contexts often rife with oppressive racism and sexism. Women in these sisterhoods serve as mutual consultants, confidantes, financiers, and matchmakers, and, importantly, hold one another accountable.

Sisterhood Complicated and Complex

As sisterhood goes, it is one aspect of womanhood which is, at times, maligned and simultaneously uplifted, hence the misunderstanding of the concept (Chaney). While Black women's perceptions of womanhood and its constructs continue to be difficult to solidify—they must negotiate gender-race bonds across class and ethnic identities—Katrina Bell McDonald argues that sisterhoods are usually characterized by "social similarity and shared experiences, frequent contact, and per-ceived mutual benefit of association" (2). Any discord within Black women's sistering relationships, according to McDonald, is generally viewed as a result of growing class and cultural diversity and centred in ambivalence to social, racial, gender, and ethnic loyalty.

We acknowledge a growing corpus of questions about who can be considered a part of the sisterhood. Some of the questions are long-standing, while others extend Black women's conceptions of the paradigm of sisterhood. Who can we call "sister?" Is sisterhood global? Are all Black women across the diaspora sisters? What if their positions stand in stark contrast to traditional values on reproductive rights (Wattleton), political perspectives (Schroeder), and views on the erosion of hard-won civil liberties in movements we acknowledged long before they acknowledged us (White)? Do we draw the boundaries of Sisterhood with a biological pen and declare its borders heterosexual and cisgender (Thomas)?

Despite all the factors that could impede the development, elevation,

and maintenance of sistering relationships, we know that Black women sisterhoods are necessary. To understand their relevance and sustain the intergenerational advancement of said collectives, we must conceptualize and thus operationalize sisterhood so that it can be applied in dynamic manners across time, context, and circumstances. Here where we are centred, as in the womanist canon, we can create a template for operating in the ethic of care and uplift of one another to the greater good of the whole.

In Akasha Gloria Hull, Patricia Scott, and Barbara Smith's introduction to *All the Women Are White, All the Blacks Are Men, But Some of Us Are Brave,* they discuss the import of Black women's explication of their lived experiences by naming who and what we are for ourselves. They argue that Black women must recognize the relational power they have with one another, with the institutional structures, including the academy, and with the conditions across the systems that Black women must abide. Despite this seminal work being written in the early 1980s and the many Black women scholars who have offered their interpretations of the intersecting roles of Black women in varied contexts since that time, these systems have changed little, only morphing slightly. These structures and institutional spaces continue to actively oppose the cultural-political value of Black women. The authors in this volume and their conceptualizations of sisterhood serve as an outgrowth of the radical responses and practical application of the sociopolitical thought from the 1980s.

As we reimagine the Black sisterhood paradigm and the support found within it, we must also grapple with egalitarianism versus gatekeeping, with the push and pull of inclusivity and exclusivity, with things remembered through difficult lessons learned and the possibility of new love, with new conceptions of time and space, as well as with new memories and discourses. Can we put new wine in old wineskins, or should we call the #DigitalSisterhood something else? Is Black sisterhood truly a sisterhood when we have never met, when our laughter is shared over broadband, and our pain and trauma salved by invisible arms miles, sometimes continents, away? Does a digital sisterhood retain the essence of what Black women have constructed around themselves? We expect that old questions will arise, and new ones will sit beside them or take their places. Black women's sisterhood is a living verb longing for us to be more nuanced, more strategic, and more radical.

9

The Future of Sisterhood

We have been hit by an unprecedented global pandemic. Due to the coronavirus, known colloquially as COVID-19, we have had to digitally adapt in many cases to maintain connection and to balance our commitments both inside and out of the home and within our now increasingly virtual workplaces. COVID-19 has influenced our friendships and disproportionately impacted women. Those particularly influenced are Black, Indigenous, other communities of colour, poor and working-class communities, and other vulnerable groups (Sultana and Ravanera). As Black women, many of our daughters, mothers, wives, partners, sisters, and our sisterfriends have had to work on the frontlines as essential workers in frontline healthcare, grocery stores, and factories.

During the pandemic, how we do sisterhood has been challenged like never before. As we have witnessed in many parts of the world, we have had to shapeshift in extraordinary ways to remain our "sister's keeper"; we have had to navigate space and time online differently and to keep socially distanced in the physical world while wearing masks, which erases our facial expressions. The future of our sisterhood depends upon our social, cultural, economic, and political praxis and a global recovery that centres intersectionality and gender equity. It depends on our ability to continue organizing, engaging, building, and acting by any means necessary so that we can reimagine a future in which Black women are not at the bottom but are proactively engaged and leading as *sisters* with voices, opinions, lived experience, and expertise that can and must be tapped to help shape and enact future policy and practice in our communities.

Nancy Fraser's concept of subaltern "counterpublics" is useful in describing the power and resilience of our sisterhood especially at a time when so many of us are fighting desperately to retain democracy. Subaltern counterpublics can be described as discursive arenas that develop in parallel to the official public spheres and "where members of subordinated social groups invent and circulate counter discourses to formulate oppositional interpretations of their identities, interests, and needs" (Fraser 123).

Our digital communities, which originated in and are supported by social media, become transformative methods of engaging, representing, and loving our sisters. These sites become acts of resistance and

resilience—digital sites of reclaiming our sense of self and our bodies amid the chaos and uncertainty of the COVID-19 pandemic and the even more pervasive global pandemic of white supremacy. Black support and advocacy groups on Facebook, Instagram posts capturing our sartorial fashion, hair, and accessories—our "soul style" (Ford)—digital connections through DMs, TikTok, and virtual book clubs, as well as "just checking on you" messages are all integral to our individual and collective mental health. They are emblematic of our burning desire to build and maintain meaningful Black sisterhoods across borders so we may continue to be seen and heard.

The future of Black sisterhoods must be understood through the lens of Black feminist thought, from which the importance of Black women's self and collective redefining stems (Collins). It is in this future that we sisters can lead the revolution and tackle the "matrix of domination" (Collins). Our sistering, especially during this historical moment, does not simply encompass relationships and interactions. Sistering, at this time, is a lifeline of support and validation. As we continue to move through this moment, which happens to also fall within the United Nations International Decade for People of African Descent (2015–2024), may we never forget the power of our diverse Black sisterhoods. Our sistering is—to invoke the tenets of the international decade—our human right.

Black Sisterhoods Organization

This volume attempts to simultaneously consider sisterhood as paradigm and praxis. In the first section, Sisterhood as Paradigm, we attempt to parse out the nature of sisterhood as it is understood in Black communities in the United States. We hope to convey an organized set of ideas about sisterhood to create sisterhood as a model of interaction or way of being with one another, specifically among Black women. Using sisterhood as a framework to provide support to peers in academic and professional settings is the goal of the next section, Sisterhood as Peer Support. Furthermore, as we consider the way sisterhood could be enacted as practice, we embark on a provision of applied exemplars of sistering in emerging digital media in the third section, Digital Sisterhood.

Sisterhood as Paradigm

Victoria Earle Matthews implored the attendees at the 1898 Hampton
Negro Conference to "let women and girls become enlightened, let
them begin to think, and stop placing themselves voluntarily in the
power of strangers" (qtd. in Kramer 243). While much has changed
since then, a great deal has remained the same. Black women's saving
lies in their own hands through enacting sistering and sisterhood. The
challenge is to dissect the concept of sisterhood such that its compon-
ents can be used as a balm or an intervention when necessary. How do
you clarify a concept that is so aptly used and addressed by the larger
populace? Certainly, reading through the readily accessible lexicon and
resource guides other scholars and authors in this volume have cited
is a start. In this section, we aim to view and apply the concept of
"sisterhood" as theory or paradigm—a model if you will—for fulfilling
the tasks and roles we often have in the world. We centre Black women,
but with open minds, these models can possibly be used with other
groups, particularly those who are marginalized or who experience
oppression.

In this section, Jade Crimson Rose Da Costa illustrates sisterhood as
a freedom agent and provides a model for social justice-centred sister-
hood. Haile Eshe Cole employs sisterhood as a conscious uplift to pro-
vide a map standing in the gap for one another. Raven Maragh-Lloyd
and Shardé M. Davis reposition sisterhood as a vehicle of resistance,
whereas Marcia Hernandez reviews what formally structured sister-
hood looks like in Black Greek letter organizations. Sara C. Flowers and
her colleagues—as well as Yarneccia D. Dyson, and Krystal Lee, and
Daphne R. Wells—consider sisterhood in practice and provide models
for replication for use in secondary through doctoral education settings.

Sisterhood as Peer Support

When oppression is overt, it is easy to label; at other times, however,
the uncertainty of whether an action has resulted because of an actor's
response to one's race, gender, or other minoritized identity is unclear.
In processing these moments of ambiguity, Black women rely on other
Black women to make meaning of their experience. This section
presents examples of how Black women use sisterhood in formal

programs and informal sisterships to create community with other Black women in higher education. The community these women depict serves as a soft landing spot from which Black women receive confirmation of oppressive experiences, affirmation of a complicated web of connected oppressive experiences that can be difficult to decipher, and inspiration to persist in the face of these challenges and to celebrate their accomplishments.

In this section, ArCasia James-Gallaway and her colleagues propose the idea of sistership to describe their relationships that have provided sustenance for their journey through academia. Next, Gloria L. Howell and her colleagues depict a counterspace, where their sisterhood attends to their personal wellbeing and scholarly development. Cherell M. Johnson and her sisters call their coalition #BlackGirlMagic and showcase how they created bonds and cultivated their academic brilliance. Kalisha V. Turner and her colleagues tell the story of creating a SisterCircle for first-year undergraduate women in a residence hall, whereas Angel Miles Nash and her colleagues discuss how they met one another at a Sisters of the Academy Research BootCamp and then detail how their sisterhood flourished even after the program ended. Finally, Ashley N. Gaskew and her sisters created a sistership to help them combat the racism inherent in their experience at a historically white institution.

Digital Sisterhoods

Sister circles continue to be an integral part of Black women's existence throughout the African Diaspora. Having an enduring sisterhood, holding membership in an empowering sister circle, and knowing that there is a "keeping it real" sistafriend to call for anything, is a special kind of privilege. The authors in this section contest any assumption that sisterhood is limited to blood relationships and physical proximity through descriptions of sisterhood experiences across the digital landscape. Inside online sisterhoods, sisters trust one another to have their backs and to "don't tell nobody."

Lisa Covington and colleagues' chapter explores how African American women operationalize a bounded digital medium where Black creative brilliance is protected from white appropriation. Erin L. Berry-McCrea and Briana Barnes's submission, meanwhile, explores

how digital territory can support African American women in completing their PhD programs. Joseanne Cudjoe's chapter discusses how beauty salons and natural hair groups have moved online and how over time, these online beauty spaces have come to mirror the in-person variety in both character and shared values. Finally, Adrianne Jackson and Lean P. Hunter examine National Pan-Hellenic Council sororities and discuss the importance of support within national and international digital social networking sites that embrace both the professional and personal. Taken together what we discover from the authors in this section is that digital sisterhoods have been able to mimic the nuanced nature of their in-person counterparts.

Acknowledgments

In the spirit of sisterhood, we would be remiss if we did not thank some important sisters who were integral in completing this project. We would like to acknowledge Dr. Dannielle Joy Davis for her ideas that conceived this work and laid its groundwork. We would also like to thank Sherrina Lofton, a doctoral student at Florida State University, for her work in helping us to get organized and making our work of editing the volume much smoother. Lastly, in the spirit of sisterhood, we each recognize the countless Black women who engage in sistering each day. Thank you!

Endnotes

1. Throughout the manuscript, we use "women" as an inclusive term encompassing all Black sisterhoods, including but not limited to heterosexual, 2SLGBTQ+, trans, gender nonconforming, asexual, genderless, and cyborg Black sisters.

Works Cited

Collins, P. H. *Black Feminist Thought: Knowledge, Consciousness, and the Politics of Empowerment.* 2nd ed. Routledge Classics, 2009.

Denton, T. "Bonding and Supportive Relationships among Black Professional Women: Rituals of Restoration." *Journal of Organizational Behavior,* vol. 11, no. 11, 1990, pp. 447-57.

Ford, T. C. *Liberated Threads: Black Women, Style and the Global Politics of Soul.* University of North Carolina Press, 2015.

Fraser, N. "Rethinking the Public Sphere: A Contribution to the Critique of Actually Existing Democracy." *Habermas and the public sphere,* edited by C.J Calhoun, MIT Press, 1992, pp. 109-142.

Frazier, E. F. *Black Bourgeoisie.* Free Press, 1957.

Goins, M. N. "Playing with Dialectics: Black Female Friendship Groups as a Homeplace." *Communication Studies,* vol. 62, no. 5, 2011, pp. 531-546.

Hull, A. G., P. Bell-Scott, and B. Smith. *All the Women Are White, All the Blacks Are Men, but Some of Us Are Brave: Black Women's Studies.* Feminist Press, 1982.

Kramer, S. "Uplifting Our 'Downtrodden Sisterhood': Victoria Earle Matthews and New York City's White Rose Mission, 1897-1907." *The Journal of African American History,* vol. 91, no. 3, 2006, pp. 243-266.

Lawson, B., editor. *The Underclass Question.* Temple University Press, 1992.

McDonald, K. B. *Embracing Sisterhood: Class, Identity, and Contemporary Black Women.* Rowman & Littlefield, 2006.

Morgan, R., editor. *Sisterhood Is Forever: The Women's Anthology for a New Millennium.* Simon and Schuster, 2007.

Sultana, A., and C. Ravanera. *A Feminist Economic Recovery Plan for Canada: Making the Economy Work for Everyone.* The Institute of Gender and the Economy (GATE) and YWCA Canada, 2020.

Thomas, V. E. *Embodying Sisterhood: Community Politics of Black Cisgender and Transgender Womanhood.* University of Washington, 2020.

Thomas, V. E. "Gazing at 'It': An Intersectional Analysis of Trans-normativity and Black Womanhood in Orange Is the New Black." *Communication, Culture, and Critique,* 2020, vol. 13, no. 4, pp. 519-55.

Welch, L. "The 7 Friends Every Woman Should Have." *Health (Time Inc. Health),* vol. 17, no. 4, 2003, p. 132.

SECTION I
Sisterhood as Paradigm

SECTION 1

Sisterhood as Paradigm

Chapter 1

Becoming Sisters, Becoming Free: Black Feminism, Sisterhood, and Social Justice

Jade Crimson Rose Da Costa

Sisterhood is a central tenet of feminist scholarship. Broadly defined, sisterhood refers to "a nurturant, supportive feeling of attachment and loyalty to other women" (Dill 132). Whether concerned with defining the concept (Dill; Morgan), critiquing its shortcomings (Carby; Hobson), or examining who has used it and to what aim (Fox-Genovese; Qi), feminists have long debated the role that sisterhood plays in the feminist movement. Although feminists approach the question of sisterhood in divergent and complex ways, most agree that its main function is to engender political solidarity among women (Lawston). Particularly, sisterhood is thought to high-light the responsibility women have to empower each other by caring for, protecting, and supporting one another (Dill; Fox-Genovese). Accordingly, feminist activists and scholars have historically used sisterhood as a mode of feminist praxis—as a means to inspire and strengthen women's coalition.

Much has been written on whether or not sisterhood is actually capable of building this kind of meaningful political connection (Bhatkal; Ong; Phillipson). Critics argue that the concept operates under the false assumption that women have "shared experiences and common interests," encouraging us to bond over some monolithic

notion of "female" oppression as if our lives were homogeneous (Qi 328). Although these critiques are important, their primary concern is with determining the validity of sisterhood as feminist praxis, which often leads them to overlook the myriad forms in which different feminist traditions have utilized the concept. Thus, this chapter seeks to work through some of the ways that certain rhetorics of sisterhood attempt to forge mutual solidarity among women.

Specifically, I examine how Black feminist mobilizations of sisterhood constitute a form of radical feminist praxis that is often overlooked by mainstream feminist scholarship. I begin my analysis by defining "sisterhood" as feminist praxis. I then build on this definition to highlight the social justice theoretic embedded within Black feminist constructions of sisterhood, or "Black Sisterhood." Afterwards, I draw on the epistemological violence of white feminism to explain that Black Sisterhood also functions to advocate for a more localized Black feminist consciousness. With both definitions in mind, I conclude by arguing that Black Sisterhood, above all else, represents Black feminism's larger commitment to love, solidarity, and liberation.

Background: Sisterhood as Feminist Praxis

Like most feminists, I have my own understanding of how, why, and when sisterhood operates as feminist praxis. Mainly, I consider sisterhood to be feminist praxis when it is aimed at mobilizing, what Audre Lorde calls, "the erotic." Although we often reduce eroticism to sexual desire, Lorde's understanding of the term resembles more a sense of being than a sense of wanting (*Sister Outsider*). In fact, in many ways, it can be considered a precursor to what we now call affect theory: a perspective that examines how affectual and phantasmal forces mark a given body's sense of (non)belonging to a world comprised of fantastic encounters (Seigworth and Gregg 2). A staple feature of affect theory is to explore how prevailing systems of domination generate specific phenomenological embodiments and atmospheric energies, thereby exposing the everyday sensations of power, privilege, and oppression (Ahmed, *The Cultural Politics*).

In line with affect scholarship, the erotic describes the affectual energies that minoritarian beings, particularly women, produce in and through our diametrical efforts to locate our lived realities within/

against the imperializing assemblages of late western modernity (Lorde, *Sister Outsider*). Within this milieu, women are taught to distrust what we think and how we feel in favour of a euroandrocentric imaginary that reproduces white cisheteropatriarchy (59). As a result, we are left with a reserve of untapped and unarticulated feelings that, if harvested, could trouble the rules and bounds of normative reality. This is what is meant by the erotic. As phrased by Lorde, "The erotic is a resource within each of us that lies in a deeply female and spiritual plane, firmly rooted in the power of our unexpressed or unrecognized feelings" (*Sister Outsider* 53). Whereas Lorde wrote directly of women in her work, we now have the language, particularly within academia, to extend her analysis to include femme and gender fluid people writ large and can similarly view her notion of the erotic as more broadly encapsulating the worlding of gender and sexual beings who are consistently subjugated and erased within and by western society.

A main benefit of the erotic is that it allows us to contend with the realities of our un/known and unimaginable lives. As such, it acts as a testament to our innate emotional, cognitive, and mental registers, providing us with confirmation that what we feel, think, and know is valid, and that our sense of the world is legitimate, real, and grounded (Nash). Since women are especially taught to misname and mistrust the authenticity of our existence, getting in touch with the erotic can help us resist subordination; when we connect with our erotic self, we affirm our intimate capacity to feel deeply and thus confront those parts of our current social order that instead of making us feel good, make us feel "despair, self-effacement, depression, self-denial" (Lorde, *Sister Outsider* 58). Once confronted, these murderous aspects can be jettisoned from the depths of our psyches and relocated to an external social realm, where they can be engaged with, not as fixed matter, but as moving social facts that are capable of alternation, revision, and transformation.

In essence, the erotic describes the phenomenology of the abjectly feminine subject (Ahmed, "Killing Joy")—that affectual realm within women/femme-identified people that enables us to repair and revision our humanity. It is for this reason that I identify the erotic as the central feature of sisterhood as feminist praxis: When we get in touch with the erotic part of our self, we realize that "the need for sharing deep feeling is a human need" (Lorde, *Sister Outsider* 58). This realization can form a

21

bridge between women/femmes of different sociopolitical orienta-
tions, as it provides a premise for mutual understanding and therefore
lessens "the threat" of our differences (Lorde, *Sister Outsider* 56). From
here, our ability to relate across difference is no longer confined to "the
elisions of identity politics" but rather is formed on the basis of our
shared humanity, thereby fostering a sense of collective agency (Nash
5). The erotic thus constitutes a radical affectual realm, a space from
which to create new becomings. As phrased by Jennifer C. Nash, the
erotic is "a kind of affective politic"—a way of understanding "how
bodies are organized around intensities, longings, desires, temporalities,
repulsions, curiosities, fatigues, optimism and how these affects
produce political movement" (3). For me, sisterhood as feminist praxis
is about mobilizing this politic; it is about getting to a place where we
can connect based on our similarities and our differences and thus
come together in political solidarity.

Much like Lorde's notion of the erotic, my approach to sisterhood is
rooted in the Black feminist intellectual tradition (James; Weheliye;
Wynter). Black feminists articulate gender and sex struggles within a
complex matrix of sociopolitical forces, often rejecting gender-centric
notions of inequality for a more thorough resistance to domination
(Bliss; Crenshaw; Davis; hooks, *Talking Back*). Specifically, Black
feminists reject a political consciousness that is ordered by identity
politics in favour of one that is ordered by collective agency (Nash).
This has been described as the social justice theoretic of Black
feminism: the tradition's overarching commitment to realize "the
possibility of a politics organized not around the elisions (and illusions)
of sameness, but around the vibrancy and complexity of difference"
(Nash 11). In a similar fashion, Black feminists' rhetoric of sisterhood is
to exhort women/femmes to identify and work through their differ-
ences to get them to "work on/against themselves" in order to work for/
with each other (Nash 18).

Unfortunately, mainstream feminist scholarship has tended to over-
look and overshadow the transformative impulse behind Black feminist
notions of sisterhood, or "Black Sisterhood" (Hobson; Nash). Hence, in
an attempt to reclaim Black Sisterhood's emancipatory potential, this
chapter revisits the foundational works of bell hooks, Audre Lorde, and
Patricia Hill Collins. Drawing on these renowned Black feminist
thinkers, I argue that Black Sisterhood operates on two levels. The first

level is that of the theoretical, which describes the above social justice theoretic of Black feminism. The second level is the level of praxis. At this level, Black Sisterhood functions to protect Black women by advocating for a localized Black feminist consciousness. I posit that both levels reinforce Black feminism's vision to mobilize a diverse political community—one "ordered by love and the radical embrace of difference" (Nash 18), thus concertedly representing Black feminism's belief in love, solidarity, and liberation.

Before I continue, however, I have one brief caveat about terminology. Although, as both an inclusive feminist and a gender nonbinary woman of colour, I recognize the potentially essentialist implications of using sisterhood to discuss feminist praxis, I personally regard sisterhood, not as a material or biological incantation of womanly belonging, but as an undefined *feeling* of feminist-based solidarity. My use of the term "sister/woman" to denote this feeling is both problematic and necessary. It is problematic because these categories inherently congeal gender into a distinct social formation that betrays its fluid nature. However, it is also necessary because much of the political recognition and resistance that feminism turns on depends on the category of "woman" (Chodorow 1097). Viewing sisterhood as a feeling is my attempt to begin to remedy this tension. I believe that though intimately bound to identity-specific language, sisterhood, like gender, is not a fixed biological or cultural condition but rather a state of being that, as Lorde (*Sister Outsider* 37) might put it, "just feels right" to me.

Black Sisterhood as a Theory of Justice

In *Ain't I a Woman: Black Women and Feminism*, hooks defines sisterhood as "the outcome of continued growth and change ... a goal to be reached, a process of becoming" (157). To describe sisterhood as a "process of becoming" is to recognize the inherent difficulty involved in bringing women of divergent socioeconomic stations together in political solidarity. hooks observes that because women are taught to relate to difference from a position of either oppression or privilege, our ability to connect with one another is challenged by our tendency to view each other as either superior or inferior (155). It is only when we confront this fact and stop exploiting, distrusting, and hurting one another, that hooks considers sisterhood to be a real possibility (156).

Accordingly, she understands sisterhood, not as an innate sense of gender-based loyalty but as a collective movement against internalized white cisheteropatriarchy. Here, sisterhood is about rendering women accountable; it is about getting us to confront our unconscious biases towards one another and, in doing so, start the process of identifying the ways in which we are complicit in maintaining and/or promoting one another's suffering.

A similar understanding of sisterhood appears in Lorde's edited book *Sister Outsider: Essays and Speeches.* As signalled by the title, much of this collection is dedicated to challenging feminist conceptualizations that position certain women as the Other of feminist theory and praxis—as the "sister outsider" whose lived reality is too foreign for the majority of feminist discourse to comprehend (117). In response to such rhetoric, Lorde urges women to address the differences that divide us by engaging in self-reflection. She writes:

> [Women's] future survival is predicated upon our ability to relate within equality. As women, we must root our internalized patterns of oppression within ourselves if we are to move beyond the most superficial aspects of social change. Now we must recognize differences among women who are our equals, neither inferior nor superior, and devise ways to use each other's difference to enrich our visions and our joint struggles. (122)

Much like hooks, Lorde locates introspection at the heart of sisterhood. Specifically, she views sisterhood as the process of unlearning the "patterns of oppression" that prevent women from coming together in collective agency. Similarly, Lorde speaks of sisterhood as something women must struggle towards, emphasizing the responsibility we all have to check our privilege and identify the systems of domination from which said privileges are located and draw strength.

In both descriptions, sisterhood is believed to be forged through rigorous self-critique. hooks and Lorde each recognize that self-critique allows us to identify how we are implicated in the oppression of other women, which, in turn, allows us to develop a sense of mutuality and thus come together in political solidarity. In other words, they each consider self-critique to be the first step towards collective feminist agency. As phrased by Lorde: "We sharpen self-definition by exposing the self in work and struggle together with those whom we define as

different from ourselves although sharing the same goals. For Black and white, old and young, lesbian and heterosexual women alike, this can mean new paths to our survival" (*Sister Outsider*, 123).

Though focused on creating solidarity among women, both hooks' and Lorde's approach to sisterhood is rooted in a larger impetus to mobilize against the interlocking systems of western domination, or what hooks would later call "white supremacist capitalist patriarchy" *Writing beyond Race*, 36). For instance, much of Lorde's (*Sister Outsider*; *A Burst of Light*) work posits that western society is comprised of various imperialist structures that teach all people to fear and misname difference. She often explores how self-critique can help us not only to unlearn this negative socialization but also to gather the insight we need to mobilize a more comprehensive resistance struggle: "Only within the interdependency of different strengths," Lorde writes, "can the power to seek new ways of being in the world generate" (*Sister Outsider* 111).

hooks' general body of work takes a similar approach to difference. She frequently writes about the importance of collective action and, more specifically, how minoritarian subjects must learn to embrace and harvest their differences in order to end domination in all its forms. hooks writes: "Meaningful resistance to dominator culture demands of all of us a willingness to accurately identify the various systems that work together to promote injustice, exploitation, and oppression" (*Writing Beyond Race* 37). Not only does hooks consider self-critique to be central to the development of collective agency, but she also considers collective agency to be central to the development of all types of human liberation, thereby rendering self-critique a necessary condition for meaningful political action.

The emphasis Lorde and hooks each place on self-critique reveals an important assumption within both of their works—that a resistance struggle is considered effective when it is able to generate a degree of mutual responsibility among its participants. For these two women, meaningful resistance is synonymous with collective resistance, and collective resistance demands mutual accountability: It is only when we become accountable to one another, that we are able to regard western domination as the complex nexus of oppression and privilege that it is and thus develop the necessary means to destroy it. In this sense, hooks and Lorde both consider mutual responsibility to be the defining

characteristic of transformative social change. It is thus unsurprising that they each define sisterhood as the process by which women confront the internalized systems of oppression that get us to devalue, exploit, and harm one another: By exhorting women to contend with the barriers that divide different groups of women, they inevitably get us to think through the barriers that divide humanity as a whole, thereby encouraging us to foster connections with, not just women of different racial, economic, and political orientations, but all peoples subjugated by prevailing systems of injustice.

Understood in this way, hooks and Lorde use sisterhood as a tool through which to achieve human liberation. This illustrates a point that Alexander Weheliye would later solidify in his pivotal book *Habeas Viscus*—that much of Black feminism turns on a critique of what Sylvia Wynter calls the "genre of the human as 'Man'" (22). Under this genre, prevailing systems of domination all work together to reinforce the larger western humanist ideology that only white, wealthy, western, cisheterosexual, and able-bodied men are fully human, thereby rendering everyone else not-or-not-quite-human (19). This ideology sorts people into distinct identity categories to erect hierarchies of difference that grant Man absolute power, forcing us to interpret ourselves as singularized beings so that Man's territorializing assemblages can remain intact.

The ontological implication here is that despite forcing elisions between people, gender, race, class, etc. are all mutually dependent logics, operating in tandem to secure "the centrality of Man as the sign of the human" (Weheliye 123). Accordingly, true emancipation can only happen, not with the abolition of identity categories but with the abolition of the ideology to which these categories are all attached: the genre of human as Man. Weheliye describes this as the "relational ontological totality" of late western modernity and argues that the defining characteristic of Black feminist thought is to articulate struggle within this terrain (29).

By locating self-critique at the nexus of sisterhood and solidarity, hooks and Lorde each exemplify what Weheliye would later argue: The strategic location of Black feminism is a political identity wherein a commitment to social justice, not just for Black women but for minoritarian subjects writ large, is key. The clearest articulation of this commitment appears in Collins's book *Black Feminist Thought*, wherein

she describes it as a devotion to human liberation, "both for Black women as a collective and for that of other similarly oppressed groups" (9). Collins advocates for a Black feminist consciousness that can mobilize and be mobilized by other social justice projects and claims that an important function of Black feminism is to allow "Black men, African women, White men, Latinas, White women, and members of other ... racial/ethnic groups" to accurately identify points of connection with Black women (37). At the same time, however, Collins claims that in order to enact this kind of solidarity, social justice advocates must first identify, reject, and challenge their own unearned privileges. She therefore advocates for a Black feminist critique of the many systems of western domination while simultaneously urging people to locate these systems within themselves.

Like hooks and Lorde, Collins understands self-critique as a necessary tool for human liberation, but unlike hooks and Lorde, she explicitly names this as the core political function of Black feminism and thus makes salient the tradition's commitment to social justice. This is an important addition because it speaks to how Black feminism, and by extension Black Sisterhood, is informed by the positionality of Black women. Black women have long existed at the intersections of oppression and thus emerge as a hybrid of identities unmarked by the exclusionary logics of western humanist ideologies (Carmen et al.). Hence, Black feminists reject the idea of a singularly gendered, racialized, or classed self in favour of a more multiplicitious subject (Bliss), adopting a politic that takes seriously how the various systems of western domination operate in tandem to dehumanize everyone who deviates from the genre of human as Man. Accordingly, Black feminists use sisterhood, not to establish women's coalition but to enact a feminist dialogic imagination that rejects the myth of western humanism and, in so doing, carves out a space in which liberation for all is possible (Nash).

Black Sisterhood as Praxis

Unfortunately, Black feminism's radical use of sisterhood is often challenged by white feminist articulations of the concept. As a paradigm, white feminism refers to a subsect of western feminism that attempts to maintain and extend the privileges of cis-straight, white

middle-class women by further marginalizing women of difference, especially Black, Indigenous, and women of colour (Park and Leonard; Da Costa). Perspectives emerging out of this terrain use feminism not as a tool of women's liberation but as a tactic of white-supremacist-capitalist-patriarchy (hooks, *Ain't I a Woman*; Hobson; Da Costa).

White feminists perpetuate the myth that the social status of all women is the same so that they can erase the fact that besides patriarchy, the interlocking systems of western domination stand to benefit most white women (hooks, *Ain't I a Woman* 123). Accordingly, white feminists' rhetoric of sisterhood is to exhort women to universally adopt a gender identity that is "defined by their skewed Western, Euro-American bourgeois experience" (Davies 55), thereby flattening the ideological and material differences that divide different groups of women. Chandra Talpade Mohanty describes this rhetoric of sisterhood as "universal sisterhood": a pathologized notion of feminist solidarity that seeks to obscure the unearned benefits that privileged white women gain from their race, class, nationality, etc. (116). In this context, sisterhood acts more as a means through which to obscure and gloss over, as opposed to identify and work through, the many sociocultural barriers that keep women from coming together in political solidarity.

Black Sisterhood as praxis seeks to yield political efforts that work against the imperialistic impetus of universal sisterhood by (re)substantiating the affectual knowledges of Black women. Particularly, it provides a forum to bridge the differences that exist among Black women in order to mobilize political spaces that advocate for the kind of radical feminist critique that white feminism denies. Black Sisterhood as a form of praxis is most often described by Black feminists as engendering solidarity between Black women of different sociopolitical backgrounds (Carmen et al.; Collins, *On Intellectual Activism*; Davies). A primary way it does this is by encouraging Black women to adopt an ethic of self-care, not as a "practice of self-valuation" but as an intentional effort to restore "the wounded black female self" (Nash 3).

For Black women to forge political solidarity with one another, let alone other women/people, they must first confront the "nightmare images inside" that have taught them to fear and misname their own difference (Lorde, *Sister Outsider* 165). Unfortunately, confronting these images is more complicated than simply addressing the violence of

internalized oppression. It involves a deeper interrogation of selfhood, prompting an existential reimagining of what it means for Black women to be, belong, and become amid white cisheteropatriarchy. To reclaim the "Black female self" within this milieu, Black women must unlearn years of negative socialization that have taught them to not only hate but also contort and mutate who they are so that they can mimic an unattainable myth of western selfhood—that we exist as singularized gendered, racialized, classed, and otherwise subjugated and subjectified selves (Nash).

Located at the nexus of racial, gendered, and classed oppression, Black women subvert this myth (Wynter) and are therefore taught to reject the multiplicity of their being in favour of a highly bifurcated consciousness (Lorde, *Sister Outsider*). In turn, solidarity between Black women is constantly stifled, not by the mere augmentation of self-hatred but by the larger (im)possibility, and subsequent rage, that they feel when, as a result of engaging other Black women, they are forc-ed to confront the violent reality of their own existence. This makes achieving solidarity among Black women particularly difficult. In the words of Lorde: "We give lip service to the idea of mutual support and connection between Black women because we have not yet crossed the barriers to these possibilities, nor fully explored the angers and fears that keep us from realizing the power of a real Black sisterhood" (*Sister Outsider* 153).

Black Sisterhood as praxis is about working through this anger and fear and forging political collectivity among Black women; it is about giving Black women the space that they need to get in touch with their erotic self and break down the internal barriers that prevent them from self-actualization. Once Black women do this, they can begin to love that part of their self "that is hardest to hold" and therefore make space to treat other Black women with "kindness, deference, [and] tenderness" (Lorde, *Sister Outsider* 175). This, in turn, allows them to confront the negative feelings that keep them from realizing the power of a real Black Sisterhood and thus begin the process of working on/ against themselves in order to work for/with each other.

Importantly, it is from this place of self-actualization that Black women can start to connect to other types of humanistic and affectual feeling, thereby allowing them to move towards a collective resistance struggle, one defined by "love and the radical embrace of difference"

(Nash 18). In other words, Black Sisterhood invokes self-love as a radical social act, as a means to encourage Black women to work on themselves so that they can prepare for the labour of advocating for/ with humanity as a whole (Nash 8). Black sisterhood is thus diametrically opposed to the same pathologizing logic that defines universal sisterhood; it promotes self-love among Black women as a strategy for moving beyond the hierarchies of western humanism and towards the liberatory promise of collective agency.

Understood in this way, Black Sisterhood's insistence on self-love is not separate from the social justice theoretic of Black feminism. On the contrary, empowering Black women is fundamental to Black feminism's larger impetus to achieve human liberation. As the Combahee River Collective famously put it: "If Black women were free, it would mean that everyone else would have to be free since our freedom would necessitate the destruction of all the systems of oppression" (qtd. in Weheliye 23). The implication here is that because Black women are located at the nexus of various struggles, Black feminism's "inward-looking focus" on Black women is rooted in an "outward-looking analysis of the intersecting power relations" of western society, thereby rendering the framework radical by nature (Collins *On Intellectual Activism* 13).

Accordingly, Black Sisterhood as praxis calls not for a separatist Black feminist movement per se but for Black women to gain the political autonomy they need to foster, as Collins puts it, "effective coalitions" with other socially oppressed groups (37). "When we're truly autonomous," Collins writes, "we can deal with other kinds of people, a mutuality of issues, and with difference, because we have formed a 'solid base of strength'" (37). It is in this way that Black Sisterhood as praxis helps to establish Black feminism "as a social justice project" (60): In order to find points of connection with other socially oppressed groups, Black women must first form a solid political base from which to come together and mobilize. Once Black women do this, they can begin to map out a resistance struggle aimed against domination as a whole.

This, I believe, is why Black Sisterhood acts as a type of praxis against universal or white sisterhood: Whereas the latter represents a general effort to bond over "female" oppression, thereby flattening the diversity of women's struggles, the former mobilizes Black women's

efforts to do so while also coming to terms with their lived experiences within the intersections of identity and resistance (Collins). Furthermore, this is done with the knowledge that eschewing the binds of selfhood that imperialize Black women in particular is a precursor for the destruction of all forms of imperialist subjectification, which are the same forms of subjectification that white sisterhood seeks to maintain and reproduce. In concert, whereas white sisterhood mobilizes against patriarchy on behalf of white women, Black Sisterhood mobilizes against the interlocking systems of western domination on behalf of all of humanity. Thus, while white sisterhood flattens and distorts difference, Black Sisterhood views difference, in the words of Lorde (1984/2007), "as a fund of necessary polarities between which our creativity can spark like a dialectic" (*Sister Outsider* 111). In short, Black Sisterhood demands the recognition and reconciliation of the same differences that white sisterhood only ever glosses over and ignores.

Conclusion

Both as a theoretic and as a mode of praxis, Black Sisterhood represents Black feminism's political impetus to move beyond the limitations of an idiosyncratic self and produce a political community forged around the multiplicity of human difference (Nash 11). For one, Black sisterhood strives to envision and enact the transformative and emancipatory possibilities signalled by these differences and to create a language of resistance that can eradicate domination in all its forms. Furthermore, it recognizes that this kind of collective agency depends on our ability to get in touch with our erotic self and thus know the Other as human, thereby allowing us to love and respect them as our sister, brother, and comrade. Understood in this way, Black sisterhood can be viewed as a tool through which Black feminists mobilize love as a theory of justice, using the power of love to collectively challenge western domination.

The practice of using love to inspire social change is well documented within the Black feminist intellectual tradition (Collins; hooks, *Writing beyond Race, Talking Back*; Lorde, *Sister Outsider*; Nash; Walker). This makes sense given Black feminism's emphasis on collective agency and transformative social change. When we love across difference, we challenge the idea that difference divides us, and we "reach down into

that deep place of knowledge inside ourselves and touch that terror and loathing of any difference that lives there" and begin to jettison it from our consciousness (Lorde, *Sister Outsider* 113). In doing this, we create the possibility of transcending hierarchical identity categories and start to embrace a multiplicitous self, subsequently allowing us to move towards a resistance struggle that is ordered by the diversity of human experience.

This carries significant weight for the Black feminist intellectual tradition: When we stop fearing difference as a whole, the many differences that negatively mark Black women start to lose their meaning, thereby allowing Black women to reclaim their erotic affectual energies and thus revision their humanity. While this is true for all people, the political identity of Black women has meant that Black feminism has been committed to breaking down these hierarchies from the onset (Davies; James). In "Becoming Visible: Black Lesbian Discussions," Shaila captures this reading of Black feminism's political identity well when she states: "I think we have the potential in us to be the most radical because all those forces have fashioned us: being women/Black/ Working class/lesbians/anti-imperialist/coming from Third World countries, so consciousness has been made up of surviving many oppressions [and] is necessarily going to expand to take in all these factors" (Carmen et al. 69).

Emerging from this consciousness, Black Sisterhood uses love to break down the barriers that divide not only women, but all people rendered non-or-not-quite-human under late western modernity. This is demonstrated in the works of hooks, Lorde, Collins and, by extension, Wynter. Particularly, it is demonstrated in their efforts to get us—women especially and the oppressed more generally—to overcome our internalized biases and connect with our erotic selves. Once connected, we can identify in the Other the many faces of our own oppression, recognizing how all of us not-quite-human subjects are denied true happiness within our current social order. This, in turn, forces us to confront how all of us, in some way or another, contribute to the oppression of the Other. When we become accountable to the Other in this way, we eschew the self that is separate from them and carve out a space in which we can work towards collective agency (hooks, *Writing beyond Race*; Nash). Black Sisterhood encourages not just women but all people to locate themselves within this place and to

start the process of becoming that will allow all of us to live more fulfilled and meaningful lives.

Works Cited

Ahmed, S. "Killing Joy: Feminism and the History of Happiness." *Signs: Journal of Women in Culture*, vol. 35, no. 3, 2010, pp. 571-94.

Ahmed, S. *The Cultural Politics of Emotion*. Edinburgh University Press, 2004.

Bhatkal, S. C. "Sisterhood and Strife." *The Women's Review of Books*, vol. 10, no. 10-11, 1993, pp. 12-13.

Bliss, J. "Black Feminism Out of Place." *Signs: Journal of Women in Culture and Society*, vol. 41, no. 4, 2016, pp. 727-49.

Carby, H. "White Woman Listen! Black Feminism and the Boundaries of Sisterhood." *The Empire Strikes Back: Race and Racism in Seventies Britain*, edited by Centre for Contemporary Cultural Studies, Hutchinson, 1982, pp. 212-35.

Carmen, Gail, Shaila, and Pratibha. "Becoming Visible: Black Lesbian Discussions." *Feminist Review*, vol. 17, 1984, pp. 53-72.

Chodorow, N. J. "Gender as a Personal and Cultural Construction." *Signs: Journal of Women in Culture and Society*, vol. 20, no. 3, 1995, pp. 516-44.

Collins, P. H. *Black Feminist Thought: Knowledge, Consciousness, and the Politics of Empowerment*. Routledge, 2000.

Collins, P. H. *On Intellectual Activism*. Temple University Press, 2013.

Crenshaw, K. "Mapping the Margins": Intersectionality, Identity Politics, and Violence against Women of Color." *Stanford Law Review*, vol. 43, no. 6, 1991, pp. 1241-79.

Da Costa, J. C. R. "The 'New' White Feminism: Trans-Exclusionary Radical Feminism and the Problem of Biological Determinism in Western Feminist Theory." *TransNarratives: Scholarly and Creative Works on Transgender Experience*, edited by K. Carter and J. Brunton, Women's Press, 2021, pp. 317-34.

Davies. C. B. *Left of Karl Marx: The Political Life of Black Communist Claudia Jones*. Duke University Press, 2007.

Davis, A. Y. *Women, Race and Class*. Vintage Books, 1981.

Dill, B. "Race, Class, and Gender: Prospects for an All-Inclusive Sisterhood." *Feminist Studies*, vol. 9, no. 1, 1983, pp. 131-50.

Fox-Genovese, E. "The Personal Is Not Political Enough." *Marxist Perspectives*, vol. 8, 1979, pp. 94-113.

Gregg, M., and G. J. Seigworth, editors. *The Affect Theory Reader*. Duke University Press, 2010.

Hobson, J. "Black Women, White Women and the Solidarity Question. *Ms. Blog Magazine*, 27 Nov. 2013, msmagazine.com/blog/2013/11/27/black-women-white-women-and-the-solidarity-question/. Accessed 2 Jan. 2022.

hooks, b. *Ain't I a Woman: Black Women and Feminism*. South End Press, 1981.

hooks, b. *Talking back: Thinking feminist, thinking black*. Routledge, 2014.

hooks, b. *Writing beyond race: Living theory and practice*. Routledge, 2013.

James, J. *Shadowboxing: Representations of black feminist politics*. St. Martin's Press, 1999.

Lawston, J. "'We're All Sisters': Bridging and Legitimacy in the Women's Antiprison Movement. *Gender and Society*, vol. 23, no. 5, 2009, pp. 639-64.

Lorde, A. *Sister Outsider: Essays and speeches*. The Crossing Press, 1984.

Lorde, A. *A Burst of Light: Essays*. Firebrand Books, 1988.

Mohanty. C. T. *Feminism without Borders: Decolonizing Theory, Practicing Solidarity*. Duke University Press, 2003.

Morgan, R. *Sisterhood Is Powerful: An Anthology of Writings from the Women's Liberation Movement*. Random House, 1970.

Nash, J. C. Practicing Love: "Black Feminism, Love-Politics, and Post-Intersectionality."*Meridians*, vol. 11, no. 2, 2011, pp. 1-24.

Ong, A. "Strategic Sisterhood or Sisters in Solidarity? Questions of Communitarianism and Citizenship in Asia." *Indiana Journal of Global Legal Studies*, vol. 4, no. 1, 1996, pp. 107-35.

Park, S., and D. Leonard. "Toxic or Intersectional? Challenges to (White) Feminist Hegemony Online." *Are All the Women Still White? Rethinking Race, Expanding Feminisms*, edited by J. Hobson, State University of New York Press, 2016, pp. 205-27.

Phillipson, M. "The Myth of Sisterhood?" *AQ: Australian Quarterly*, vol. 75, no. 3, 2003, pp. 32-40.

Qi, T. "Transforming Sisterhood to an All-Relational Solidarity." *Race, Gender & Class*, vol. 17, no. 3-4, 2010, pp. 327-35.

Wynter, S. (2006). Proud Flesh Inter/Views: Sylvia Wynter. *ProudFlesh: A New Afrikan Journal of Culture, Politics & Consciousness*, 2006, www.proudfleshjournal.com/issue4/wynter.html. Accessed 2 Jan. 2021.

Walker, A. *In Search of Our Mothers' Gardens*. Harcourt Brace, 1983.

Weheliye, A. G. *Habeas Viscus: Racializing Assemblages, Biopolitics, and Black Feminist Theories of the Human*. Duke University Press, 2014.

Blood and Water: Black Motherhood, Friendship, Survival, and the Power of Showing Up

Haile Eshe Cole

These visions of raising consciousness, mending wounds, telling stories, moving between one place and another, and making new worlds, are the work of friendship.

—Jafari S. Allen

The room was cold. I wished I had brought at least a light sweater to cover my arms. The sparse furnishings, a hospital bed and armchair, along with the persistent and high-pitched beeping of machines and intermittent hustle of nurses in the hallway made me wonder how anyone ever got any sleep here. It was your standard hospital setting, yet its sterility always seemed so disjointed from the phenomenon of birth and the assumedly joyous occasion of bringing new life into the world. Birth was the primary reason that we were gathered in that space to begin with.

A newborn baby lay swaddled and sleeping in the transparent glass hospital crib next to the newly delivered mom who lay covered in a plain white gown and draped in several white cotton sheets and woven blankets. There were three of us that showed up to the hospital that day.

We all stood flanking the woman on all sides—two on opposite sides of the bed and the other standing at her feet. We were like sturdy wooden posts grounding the rusty metal of a wired fence—operationally holding something in while simultaneously keeping something out. Our energy almost pulsated through the room. I am sure that anyone who came in could feel it. It felt as if a force or energy of sorts circulated the room—powerful and protective. The social worker, upon her entrance, glanced uncomfortably around. She was there to question the newly delivered mother only hours after delivery. Were we family? Would we all be present during the length of her visit? "I only have a few questions," she stated. Our intention to stay, if not apparent in our body language, was solidified by our verbal response.

I can't seem to remember where I was or what I happened to be doing that day when I received the call about a half an hour earlier. Quite often when I received a call of this sort, at any time of day, I could be doing any number of things. That day, my phone rang and the caller ID revealed, as it often did, KK's name, a close and long-term friend.

"Hey!"

"Hey girl. What's going on?"

"Nothing. Whatchu doing?" I could hear something in my good friend's voice. Or maybe it wasn't what I heard; maybe it was just that we knew each other so well. Something was up.

"We need your help. Can you come down to the hospital?"

I was quite familiar with this scenario, as it happened often in our work supporting poor and working-class Black and Latino pregnant and parenting women. Sometimes the call was to assist with physical and emotional support during labour. Sometimes the call was to aid with concrete logistics, such as food for the family or to ensure there was transportation or childcare. Other times, and more often that we wished, our presence served as a direct buffer between women and the surveillance and/or assault of the state via child welfare or attempts at criminalization sometimes before, during, and even hours after birth. Either way, I knew when I got the call there was an urgent need to act. I began to gather together a few things: my purse, diaper bag for the kiddo, and any other things that I might need for the next hour or so. *Hmm... I thought. Maybe it would be the next few hours.* On the other line, I could hear my friend's voice again coming through the line: "There is a social worker coming, and a few other people have come asking a

bunch of questions. We need them to see that she isn't alone and that she has people. We need some folks to show up."

The following essay builds upon ethnographic research conducted formally in 2011 and 2012. It includes insights obtained during years of ongoing community work around reproductive health and justice for Black women. The larger project examined the grassroots work of WE RISE,[1] an organization of mothers of colour in Texas, as well as national and state-level legislation and data about maternal and infant health disparities. This collective of mothers that I worked with was created with the intent to organize around necessities and to work towards creating the just world that the members envisioned. But the collective also acknowledged the oftentimes invisible and political work of mothering and caretaking. They worked with biological mothers but also articulated a broader understanding of what mothering looked like and about who can be and is already involved in the act of mothering and caretaking.

The broader research project situated the ethnographic insights within the larger repertoire of quantitative health literature on disparities and historicized the work alongside Black feminist theories of the body, history, and Black women's reproduction. Drawing from extended participant observations, interviews, focus groups, policy research, statistics, and archival work, I sought to unpack the large disparity that exists in maternal and infant health outcomes for Black American women and the ways in which policy, community organizing, and other geopolitical factors contribute to, mediate, or remedy this phenomenon. This chapter seeks to theorize one component drawn from this larger project, which focuses on the social support existing among Black women and its broader impacts.

In this chapter, I examine the potential for love and community to have real and lasting impacts on health, wellbeing, and survival by expounding upon the experiences of friendship/sisterhood between Black women and mothers. To accomplish this, the chapter begins by addressing the racial gaps existing in maternal and infant health outcomes as well as the role of social support as an example that intentionally centres Blackness, reproduction, and motherhood as a critical nexus to examine race, class, gender, and sexuality. Couched within the dialogues of maternal health disparities and chronic stress—or "emotional experiences accompanied by predictable biochemical,

physiological and behavioral changes" over an extended period of time and stemming from overexposure to racism over the life course (APA)— the chapter looks to love and friendship as a means to mitigate the impacts of the long-term stress and racialized oppression on the body. By including vignettes from the larger project and building upon Black feminist understandings of the role and impact of Black women's relationships with one another, this piece seeks to define and theorize the meaning and implication of "showing up." In the end, I argue that love, friendship/sisterhood, and community operate as important factors that protect against the impacts of institutional and systemic inequities. Ultimately, these relationships create conditions that contribute to the day to day survival of Black women and mothers while also serving as a model for the role of radical love in social trans-formation.

The Maternal Health Crisis in the United States

In the United States (US), maternal and infant health disparities have reached a level of crisis, with mortality rates outpacing other wealthy and developed nations (Bradley and Taylor; Grady; Tavernise). The racial gap reveals stark disparities in outcomes with Black women three to four times more likely to die from pregnancy related complications. According to the Centers for Disease Control and Prevention (CDC), Black women's maternal mortality rate was 40.1 per 100,000 live births compared to 12.1 for their white counterparts. Moreover, racism -induced stress has risen as a primary culprit for egregious maternal and infant outcomes, including mortality, low birth weight, and preterm birth (Carty et al.; Giscombe and Lobel; Hogue and Bremner; Jackson et al.; Parker Dominguez et al.; Rich-Edwards et al.; Rosenthal and Lobel). Central to this finding are the impacts of weathering and the burden of carrying what is called the "allostatic load." "Weather-ing," "increased stress age," and "the allostatic load" are terms denoting the continuous exposure to life stressors that subsequently and over time erode the overall health of the individual (Geronimus; Geronimus et al.; McEwan and Seeman; Seeman et al.). These terms have been used to describe the accumulation and impact of stress in the lives of women. Included in this analysis is the acknowledgment of the social determinants of health and the ways in which historic and

ongoing social inequities have broad and far-reaching impacts on the health and livelihood of Black mothers and their children. Growing international attention to this issue begs the question as to how healthcare systems can address centuries-old systemic and institutional oppression.

A 2018 report launched by the National Perinatal Task Force, titled *The National Perinatal Task Force: Building a Movement to Birth a More Just and Loving World*, explicitly calls out the "deep historical roots stemming from hundreds of years of explicitly racist policies reinforced by de-facto practices" that contribute to health and other forms of inequity (Cole, Joseph, and Rojas 15). In addition, the report calls for

a) In the short term, a means by which to mitigate and/or shield the vulnerable from the impacts of oppressive social conditions, and;

b) In the long term, a broad and dramatic shift in those conditions. (16)

In one of its most promising components, the report acknowledges the need for "increased social and community support as a means to mitigate the impacts of racism, stress, and other determinants that affect an individual's social conditions and, ultimately, health outcomes" (13).

Research on social support has found that it affects health outcomes. These studies examined family, partner, interpersonal, and community supports and found that the presence of these variables: 1) increased maternal satisfaction (Campbell et al.; Sauls); 2) increased infant interactive behaviour (Campbell et al.; Crnic et al.; Sauls); 3) mediated the adverse effects of stress (Crnic et al.); and 4) decreased the risk of postpartum depression (Carty et al.; Crnic et al.). Support during labour was shown to do the following: 1) reduce the utilization of pain medications (Mottl-Santiago et al.; Sauls); 2) decrease the risk of caesarean section or other operative interventions (Mottl-Santiago et al.; Sauls); 3) increase the intent and early initiation of breastfeeding (Campbell et al.; Sauls); and 4) decrease prevalence of postpartum depression (Carty et al.; Crnic et al.; Collins et al.; Turner, Grindstaff, and Phillips).

It is important to note that not all of the studies cited above examined the particular experiences of Black American women, and further examination of the impacts of social support is needed. Nevertheless, existing findings around the benefits of social support

and community show promise and may hold clues to help combat the impacts of racism-induced stress in the short term. If one accepts the culpability of racism and stress as causal in negative health outcomes, it is important to also note that the ongoing maternal health crisis overwhelmingly taking the lives of Black women and children is only a symptom of larger historically rooted processes of racial and gendered oppression.

Beginning with a case such as the current state of maternal health in the US is significant and useful in the conversation around motherhood, friendship/sisterhood, and survival, as it effectively connects the social to the physicality of the body. Although relationships and friendships/sisterhood among Black women and mothers potentially serve as a powerful model for transformative change, this chapter also argues it is important to note their life-sustaining and physical impacts in the present. Health is a concrete physiological example that carries extreme significance given its connections to mortality. For Black women, families, and communities, social support, and relationships as life-sustaining mechanisms are nothing new. Black feminist theorists have discussed extensively the impacts of relationships and community for Black women and their deep connections to survival.

The Thickness of Blood

"Blood Is Thicker Than Water..."

Although the origin and accuracy of its cultural translation over the years is debated, the reference above to blood and water contemporarily insists upon a kinship value system that centres the primacy of familial (blood) relationships over nonfamilial others (water). A central component of Black feminist theorizing on relationships is the importance of not only woman-centred connections to the Black community but also fictive kin and extrafamilial networks of support, calling into question the notion that blood is always thicker than water (Chatters, Taylor, and Jayakody; Stack; Aschenbrenner; Martin and Martin). These authors overwhelmingly maintain that fictive kin and extended networks have served as significant and important components of Black community support systems.

Generally, Black feminist understandings acknowledge the history of Black women's relationships with one another as a key part of

collective and individual survival. Gloria Wekker's ethnographic study of mati work in Suriname stands out as a salient and noteworthy example of the ways in which Black women navigate both same-sex relationships as well as relationships between men and women in order to create ideal conditions for survival. Moreover, Wekker illustrates the ways in which these networks of support were critical not only for the women's survival but also their children and how these relationships were also intricately intertwined with other social and cultural institutions. Similar to other works that examine networks of support in Black communities and among Black women, Wekker's work contributes to the argument that fictive kin and nonblood-related connections were critical to survival socially, economically, and with her examination of the Winti religious practice, even spiritually. Patricia Hill Collins also speaks of these connections directly: "The resiliency of women-centered family networks and their willingness to take responsibility for Black children illustrates how African-influenced understandings of family have been continually reworked to help African-Americans as a collectivity cope with and resist oppression" (Collins 183).

Most important here is the fact that Collins's analysis, unlike many others, does not elide the inherently political and resistive nature of these acts of survival—another critical Black feminist intervention. Collins's statement, it seems, is in many ways akin to Audre Lorde's assertion about self-care and preservation as an act of political warfare and is further explicated in her questioning of the boldness of Black women who dare to "love one another in a context that deems Black women as a collective so unlovable and devalued" (167)

Additionally, Collins's work, among others, highlights the centrality of Black women's motherwork and caretaking in these relationships and the links to survival and even activism. Collins has significantly expanded and contributed to our understandings of mothering with her conceptualizations of other/community mothers—those who care for children not their own as well as the larger community, biological connections notwithstanding. Still, mothering and carework involve looking after not only others but also the mothers themselves. In quoting Erica Lawson's work, Andrea O'Reilly states in her book *Toni Morrison and Motherhood: A Politics of the Heart* that mothering/motherwork for Black women served as "a form of emotional and

spiritual expression in societies that marginalize Black women" and "enable African Black women to use African derived conceptions of self and community" (6).

If Black women caring for one another is itself radical and resistive, it then follows that Black mothering is also inherently political and resistive. As Stanlie James maintains: "The act of other/community mothering, as exhibited historically by Black women, serves as an important Black Feminist link to the development of new models of social transformation" (45).

Broadly, we see the centrality of Black women's relationships with one another not only in Black feminist theorizing but also in Black women's literary work. Examples of this can be seen in Alice Walker's *The Color Purple* (1982), Dionne Brand's *In Another Place, Not Here* (2000), bell hooks's *Sisters of the Yam* (1999), and even Terry McMillan's *Waiting to Exhale* (2006), to name only a few. Within these examples, one can visualize the significance and meaning of shared experiences and/or struggle on the one hand, alongside the power of a supportive presence—the act of being there for one another—on the other. In furthering this idea, it is important to consider the process by which Black women enact this presence. It is a process I call the process of "showing up." In this, I offer "showing up" as a radical ethic of love and care that continues to be central to Black women's motherwork, to their relationships with one another and their communities, and to an ethic that contributes significantly to survival.

Showing Up

In thinking through my community involvement over the years with the collective of mothers working on reproductive justice issues and supporting Black and Latina women's reproductive health, I would argue that 99.9 per cent of the job was what I would call being able to "show up." Interestingly, not only is this a term that is directly connected to the cultural legacies of Black vernacular, but it also one that is being popularized and utilized repetitively in conversations about the needs of Black women. For example, a conference held in Austin, TX, in March of 2018, focusing on Black maternal mortality, was titled the "Show-Up for Black Mothers Summit" and stated adamantly that "it was time to show up for Black mothers" (black

mamasatx.com). An announcement advertising the March for Black Women held in September of 2017 also stated that what was needed was for "you to show up for Black women" (mamaBlack.org.). In both instances, what is being called for is undoubtedly much more than attending an event. Instead, I am arguing a deeper significance behind the act of "showing up"—an act that I define as being physically, mentally, spiritually, and emotionally present in order to: 1) actively offer significant parts of oneself in order to directly support and 2) combat systemic and institutional gendered and racialized oppression. As depicted in the above cases, this is enacted by and for Black women. In other cases, I believe it can also be in solidarity with and alongside Black women.

As evidenced from Black feminist scholarship, I argue that showing up as a component of Black women's sisterhoods and relationships has always been central to survival. Moreover, showing up as a concept and as a praxis continues to be relevant to reproductive health and justice movements and can take different forms. Being present and showing up, then, are multilayered, complex, and multifaceted and can operate and function as a 1) protective, 2) supportive, 3) connective, and 4) radical tool. Below are concrete examples, resulting from my ethnographic data as well as personal experience, that exemplify the ways in which I experienced these mechanisms at work.

Showing Up as Protective

It was often our assumption in WE RISE, if not our hope, that strength in numbers would work to our benefit. Existing in isolation seemed to exacerbate our vulnerability, and we found in our work that being present as advocates or even as a documenting and watchful eye curbed, at least temporarily, some forms of institutional attack. Experiences such as the opening depiction in the hospital reflect scenarios in which members of WE RISE physically showed up to protect against and challenge institutional racism and oppression—even amid our own precarious vulnerability in relation to the state and its power.

The social worker that day, though veiled beneath the guise of unbiased protocol and child protection, was inevitably there to question and ultimately judge the mothering capabilities of the women lying in the hospital beds. It is important to note that the racially disproportionate referral and intake rates of child welfare, as well as

their inextricable links to criminal justice, have been well documented (Roberts). Our own personal experiences and the experiences of those around us further served as evidence that the statistics (and risk) were verifiable and true. Thankfully, this incident resulted in a less than eventful and positive conclusion. Although some may argue that there is little to no direct evidence of causality to support this claim, similar past experiences alongside this one, had us convinced that a visible support system had some impact on this outcome. Showing up that day manifested itself not only in a collective will but also collective act to stop the direct assault on another Black woman and her family.

Showing Up as Supportive

One of WE RISE's primary goals was to improve maternal and infant health outcomes for women. Showing up meant directly supporting pregnant and parenting mothers to access the resources that their families needed to survive. This included not only prenatal, birth, and labour support but also childcare, employment, and housing, for example. WE RISE's ability to show up and affect health outcomes, for example, was directly linked to addressing the social determinants of health, or "the conditions in which people are born, grow, work, live, and age, and the wider set of forces and systems shaping the conditions of daily life" (WHO). Nevertheless, showing up still manifested in day-to-day caring and relationships. Providing support included making phone calls, doing regular check-ins, and making time to spend with one another and our children. Support was exhibited in the hugs, the conversations, the laughs, and the relationships and sisterhoods that sustained us and that oftentimes simply helped us get from one day to the next.

Showing Up as Connective

In discussing the role and effectiveness of connection, Collins asserts the following:

> Community othermothers' participation in activist mothering demonstrates a clear rejection of separateness and individual interest as the basis of either community organization or individual self-actualization. Instead, the connectedness with others and common interest expressed by community othermothers

model a very different value system, one whereby ethics of caring and personal accountability move communities forward. (192)

WE RISE imagined and attempted to create a just and equitable environment both organizationally and in the world at large. The organization operated as a collective body, and all decision making, conversations, and meetings were done as a group. Nonhierarchical structure and decision making were intentionally established in order to challenge traditional and oppressive power dynamics in the collective. It was not about the individual but about a collective process that not only subverted power but also served as a praxis and way of being that rooted the activism and organizing work and prioritized the wellbeing of a broader group.

Considering this, showing up reveals itself as acts that similarly reject individualism and exist on the basis of genuine connections with others; it is more importantly rooted in a value system that recognizes the power of community and prioritizes collectivity not only for survival but as a mode of activism, as Collins states. It is important to note that my conception of the act of showing up, though potentially read as selfless, is not sacrificial. Arlene Edwards paraphrases Jones in her work to depict the historical connections between slavery and Black women and mothers' caretaking practices: "Slavery engender-ed the adaptation of communality in the form of fostering children whose parents, particularly mothers, had been sold. This tradition of communality gave rise to the practice of othermothering. The survival of the concept is inherent to the survival of Black people as a whole" (80).

While others have also connected legacies reaching back to West Africa as foundational for Black women's ethics of care and family, the predicaments and oppression of slavery shifted the politics and burden of care. By increasing responsibility and labour (being forced to work in the fields and to birth the enslaved workforce) and the weight of sustaining an entire economic and social system, even when it did not benefit them or their loved ones, Black women essentially operated as societies' "mules" (Spillers). Although the effects of this legacy located Black women and mothers as the pillars of strength for Black communities, they also resulted in other problematic ideologies and images, such as the strong Black woman/mother who sacrifices herself for the benefit of others, resulting in her own physical, mental, and

emotional depletion. Showing up, as I envision it, does not require that one pours out and never gets replenished. Instead, it fosters connection that is not only interpersonal but also collective and reciprocal.

Showing Up as Radical

"I love you" were words that I heard repeatedly in conversation with KK and words that I often uttered in response. Our ability to show up was rooted in a genuine love for one another and a desire to support each other's wellbeing and the wellbeing of our families. Nevertheless, this affection spoke to and was also rooted in a compelling love and commitment to other broader ideals, such as community, liberation, and self-determination. Building upon the idea of connection as activism, showing up serves as an example of radical praxis. In the context of Black women's relationships, the enactment of "expressing love for one another as fundamental to resisting oppression" is essential to its counterhegemonic power (Collins 170). As Collins continues: "This component politicizes love and reclaims it from the individualized and trivialized place that it now occupies. Self-defined and publicly expressed Black women's love relationships, whether such relationships find sexual expression or not, constitute resistance" (170).

Michel Foucault's work "Friendship as a Way of Life" (1989) also sheds light on the radical and transformational aspects of friendship and love. Showing up as described thus far and modelled in Black women's relationships with one another is really about love. It is a presentation of radical and transformative love.

Conclusion

We are not lovers
because of the love
we make
but the love
we have
We are not friends
because of the laughs
we spend
but the tears
we save

I don't want to be near you
for the thoughts we share
but the words we never have
to speak
I will never miss you
because of what we do
but what we are
together

—"A Poem of Friendship" by Nikki Giovanni

Leaning up against my red and perpetually dusty Toyota in the parking lot outside of our office, tears streamed down my face. In fact, in that moment KK and I were both crying. Although we had shared many tears over the years, these tears were of anger and of frustration—not friends because of the laughs we spend but the tears we save.

Although the example in the hospital depicted our volunteer community work with WE RISE, KK and I had also been working vigorously over the last year as employees and coordinators with a local agency. After years of community work around reproductive health, as well as my graduate research studies on the topic, KK and I had been recruited to help the agency create programming that would support Black women and mothers in the local community while also helping to concretely improve their maternal and infant health outcomes. While combating institutional structure and the bureaucracy of a government entity proved frustrating in itself, we also quickly realized not only the problematic racialized and gendered dynamics that underscored the institution's operations but also the impacts that it had on our Black, gendered bodies in the space. Our existence on the job (although many may argue that this describes the conditions of the Black, gendered body more generally) was marked by what I would describe as nothing other than combat. We were constantly fighting. Fighting for fair pay. Fighting for benefits. Given our project's focus on Black women's health, we were fighting not only to be heard but also for our actual lives. This day had been particularly laborious.

"Am I crazy?" KK would ask. "Are we crazy?" We often wondered this, as those around us seemed oblivious to their perpetuation and reproduction of power and systemic oppression that served as the root

cause of many of the social ills that their programs sought to resolve. Worse, they failed to see the ways in which the two Black women sitting across from them at the table were aimlessly attempting to merely survive the day-to-day onslaughts.

Barbara Smith's work alludes to the ways in which the existence of Black women's relationships help to assuage feelings of craziness in a world where Black women are not made to feel that they belong (Smith). As an additional and personal reflection, I can confidently say that I survived those few years working for the agency only due to the presence of my dear friend by my side. More broadly, I realized that my survival—economic, social, emotional, and physical—and that of my children and family heavily relied upon not only friends like KK but the folks, and Black women, who served as my network and community. In this way, friendship/sisterhood was not only about support and survival, but a central piece of this process was also about belonging— the impact of mutual recognition and understanding in experience, and in this case, struggle. Moving through the world as a Black, gendered, body overwhelmingly manifests in the scrapes, bruises, and fatalities that result from living, moving, and navigating space and institutions where we were never meant to be, let alone survive.

Drawing upon examples of Black women's relationships and sisterhood begs the question about what we can learn from this modus operandi. I would argue that public health and medical professionals are failing to critically examine the concrete impacts of certain components of social and cultural existence. How can these examples direct us towards effective understandings and interventions around health and wellness? Moreover, what can we take from this version of radical love and care that protects and sustains life amid loss? What does this example tell us about the power of belonging, relationships, and collectivity? Most important, how do these longstanding examples of showing up lend themselves to models that ultimately guide us towards liberation and social transformation?

Endnotes
1. Names of individuals and groups have been changed.

Works Cited

American Psychological Association. *Understanding Chronic Stress*, www.apa.org/helpcenter/understanding-chronic-stress.aspx. Accessed 3 Jan. 2022.

Aschenbrenner, J. *Lifelines: Black families in Chicago*. Waveland Press Inc., 1983.

Bradley, E., and L. Taylor. *The American Health Care Paradox: Why Spending More Is Getting Us Less*. Public Affairs, 2013.

Campbell, D., et al. "Female Relatives or Friends Trained as Labor Doulas: Outcomes at 6 to 8 Weeks Postpartum." *Birth*, vol. 34, no. 3, 2007, pp. 220-27.

Carty, D. C., et al. (2011). "Racism, Health Status, and Birth Outcomes: Results of a Participatory Community-Based Intervention and Health Survey." *Journal of Urban Health*, vol. 88, no. 1, 2011, pp. 84-97.

Centers for Disease Control and Prevention. 4 Mar. 2017. *Reproductive Health. Pregnancy Mortality Surveillance System*, www.cdc.gov/reproductivehealth/data_stats/index.htm. Accessed 3 Jan. 2022.

Chatters, L. M., R. J. Taylor, and R. Jayakody. "Fictive Kinship Relations in Black Extended Families." *Journal of Comparative Family Studies*, vol. 25, no. 3, 1994, pp. 297-312.

Cole, H. J. Joseph, and P. Rojas. *National Perinatal Task Force: Building a Movement to Birth a More Just and Loving World*, 2018, perinatal taskforce.com/heads-up-maternal-justice-npt-2018-report-out-now/. Accessed 3 Jan. 2022.

Collins, P. H. *Black Feminist Thought: Knowledge, Consciousness, and the Politics of Empowerment*. Routledge, 2002.

Collins, N. L., et al. "Social Support in Pregnancy: Psychosocial Correlates of Birth Outcomes and Postpartum Depression." *Journal of Personality and Social Psychology*, vol. 65, no. 6, 1993, p. 1243.

Crnic, K. A., et al. "Effects of Stress and Social Support on Mothers and Premature and Full-Term Infants." *Child Development*, vol. 54, no. 1, 1983, pp. 209-17.

Dominguez, T. P., et al. "Differences in the Self-Reported Racism Experiences of US-Born and Foreign-Born Black Pregnant Women." *Social Science & Medicine*, vol. 69, no. 2, pp. 258-65.

Edwards, A. E. "Community Mothering: The Relationship between Mothering and the Community Work of Black Women." *Journal of the Motherhood Initiative for Research and Community Involvement*, vol. 2, no. 2, 2000, jarm.journals.yorku.ca/index.php/jarm/article/view/2141/1349. Accessed 23 Jan. 2022.

Foucault, M., and S. Lotringer. *Foucault Live:(Interviews, 1966–84).* Semiotext, 1989.

Giscombé, C. L., and M. Lobel. "Explaining Disproportionately High Rates of Adverse Birth Outcomes among African Americans: The Impact of Stress, Racism, and Related Factors in Pregnancy." *Psychological Bulletin*, vol. 131, no. 5, 2005, p. 662.

Geronimus, A. T. "The Weathering Hypothesis and the Health of African American Women and Infants: Evidence and Speculations." *Ethnicity & Disease*, vol. 2, no. 3, 1992, pp. 207-21.

Geronimus, A. T., et al. (2006). "'Weathering' and Age Patterns of Allostatic Load Scores among Blacks and Whites in the United States." *American Journal of Public Health*, vol. 96, no. 5, 2006, pp. 826-33.

Grady, D. "Maternal Deaths Decline Sharply Across the Globe." *New York Times*, 13 Apr. 2010, www.nytimes.com/2010/04/14/health/14births.html?pagewanted=all. Accessed 3 Jan. 2022.

Hoffman, S., and M. C. Hatch. "Stress, Social Support and Pregnancy Outcome: A Reassessment Based on Recent Research." *Pediatric and Perinatal Epidemiology*, vol. 10, no. 4, 1996, pp. 380-405.

Hogue, C. J. R., and J. D. Bremner. "Stress Model for Research into Preterm Delivery among Black Women." *American Journal of Obstetrics & Gynecology*, vol. 192, no. 5, 2005, S47-S55.

Jackson, F. M., et al. "Examining the Burdens of Gendered Racism: Implications for Pregnancy Outcomes among College-Educated African American Women." *Maternal and Child Health Journal*, vol. 5, no. 2, 2001, pp. 95-107.

James, S. M. "A Possible Black Feminist Link to Social Transformation?" *Theorizing Black Feminisms: The Visionary Pragmatism of Black Women*, edited by Abena P. A. Busia and Stanlie M. James, Routledge, 1993, p. 44.

Lawson, E. "Black Women's Mothering in a Historical and Contemporary Perspective: Understanding the Past, Forging the Future." *Journal of the Motherhood Initiative for Research and Community Involvement*, vol. 2, no. 2, 2000, jarm.journals.yorku.ca/index.php/jarm/article/view/2134/1342. Accessed 23 Jan. 2022.

Martin, E. P., and J. M. Martin. *The Black Extended Family.* University of Chicago Press, 1980.

Martin, J. M., and E.P. Martin. *The Helping Tradition in the Black Family and Community.* National Association of Social Workers, 1985.

McEwen, B. S., and T. Seeman. "Protective and Damaging Effects of Mediators of Stress: Elaborating and Testing the Concepts of Allostasis and Allostatic Load." *Annals of the New York Academy of Sciences*, vol. 896, no. 1, 1999, pp. 30-47.

McMillan, T. *Waiting to Exhale.* Penguin, 2006.

Mottl-Santiago, J. "A Hospital-Based Doula Program and Childbirth Outcomes in an Urban, Multicultural Setting." *Maternal and Child Health Journal*, vol. 12, no. 3, 2008, pp. 372-77.

O'Reilly, A. *Toni Morrison and Motherhood: A Politics of the Heart.* SUNY Press, 2004.

Rich Edwards, J., et al. "Maternal Experiences of Racism and Violence as Predictors of Preterm Birth: Rationale and Study Design." *Pediatric and Perinatal Epidemiology*, vol. 15, 2001, pp. 124-35.

Roberts, D. *Shattered Bonds: The Color of Child Welfare.* Civitas Books, 2009.

Rosenthal, L., and M. Lobel. "Explaining Racial Disparities in Adverse Birth Outcomes: Unique Sources of Stress for Black American Women." *Social Science & Medicine*, vol., 72, no. 6, 2011, pp. 977-83.

Sauls, D. J. "Effects of Labor Support on Mothers, Babies, and Birth Outcomes." *Journal of Obstetric, Gynecologic & Neonatal Nursing*, vol. 31, no. 6, 2002, pp. 733-41.

Seeman, T. E., et al. "Price of Adaptation—Allostatic Load and Its Health Consequences: MacArthur Studies of Successful Aging." *Archives of Internal Medicine*, vol. 157, no. 19, 1997, pp. 2259-68.

Smith, B. "Toward a Black Feminist Criticism." *The Radical Teacher*, 1978, webs.wofford.edu/hitchmoughsa/toward.html. Accessed 23 Jan. 2022.

Spillers, H. "Interstices: A Small Drama of Words." *Mumble Theory*, 1984, mumbletheoryhome.files.wordpress.com/2019/10/spillers-interstices.pdf. Accessed 23 Jan. 2022.

Stack, C. B. *All Our Kin: Strategies for Survival in a Black Community*. Basic Books, 1975.

Tavernise, S. "Maternal Mortality Rate in U.S. Rises, Defying Global Trend, Study Finds." *New York Times*, 21 Sept. 2016, www.bu.edu/news/2016/09/22/maternal-mortality-rate-in-u-s-rises-defying-global-trend-study-finds/. Accessed 3 Jan. 2022.

Turner, R. J., C. F. Grindstaff, and N. Phillips. "Social Support and Outcome in Teenage Pregnancy." *Journal of Health and Social Behavior*, vol. 31, no. 1, 1990, pp. 43-57.

Wekker, G. (2006). *The Politics of Passion: Women's Sexual Culture in the Afro-Surinamese Diaspora*. Columbia University Press, 2006.

World Health Organization. "Social Determinants of Health." www.who.int/social_determinants/sdh_definition/en/. Accessed 3 Jan. 2022.

Chapter 3

Unapologetic Responses to Unapologetic Exclusions: Advancing Communication within Sistah Spaces as a Vehicle of Resistance for Black Women in the Postracial Era

Raven Maragh-Lloyd and Shardé M. Davis

I t is increasingly evident that Black women are America's invisible population. Their bodies, subjectivities, and intellect are consistently rendered invisible due to social, legal, and economic mechanisms that maintain their erasure. Black women are situated between systems of domination that serve the interest of the elite and beset Black women's livelihood (Combahee River Collective). These systems create norms of behaviour, based upon the point of view of racially and sexually dominant groups, which emphasize to everyone, including Black women, that Black women's ways of thinking and behaving are non-normative. Casting Black women as the abnormal Other justifies their subordination by considering their way of being (and mere existence) as perverse from the standard (Collins). With systemic racial and gender oppression buried in the foundation of the United States (US), it is no surprise that various branches of discrimination against

Black women have sprouted across the US landscape, including the workforce, housing market, education, and legal system.

Furthermore, there is historical precedent for dismissing Black women during ongoing struggles for Black rights in the US. For instance, Black women were excluded from the planks of the civil rights and Black power movements (Collier-Thomas) and were overlooked when leaders were appointed despite their active participation at all levels. Women were told that their leadership weakened the way Black men would be viewed by white men, which evidenced, at the time, Black male leaders' suppression of issues of gender, sexuality, and class in pursuit of larger racial goals (Harris-Lacewell). A close examination of women's movements across US history reveals that white, middle-class women have committed similar atrocities by failing to include the needs of Black women, as early as the suffrage movement (Breines). These accounts paint a sobering picture that the erasure of Black women and their subjectivities is, in fact, a systemic issue.

In the contemporary, postracial era, the interlocking oppressions that Black women face are further expunged in structurally widespread ways. The term "postracial" refers to institutionalized racism that has become erased from view by the eschewing of race itself (Bonilla-Silva). Here, Black women's experiences are ushered under dominant umbrellas in ways that exclude the particularities of their identities. Specifically, in broader discussions on economic and health-related issues, statistics of Black women are often buried or assimilated into the dominant categories of at least race and gender (DuMonthier, Childers, and Milli).

In response, Black women establish a safe space, or "sistahood" to unapologetically celebrate Black womanhood and explicitly reject racial-gendered oppression as a collective of intersectionally subjected people (Crenshaw). The private sector has traditionally been an optimal space for Black women to employ their oppositional tactics. In the current digital era, this group has also discerned how to enact collective resistance within more public social justice discourses, as the online movements #SolidarityIsforWhiteWomen and #SayHerName demonstrate (Kuo). In a similar vein, #BlackLivesMatter activists—and indeed the founders themselves—have continued to struggle against the blatant erasure of the three Black women who created the movement: Opal Tometi, Alicia Garza, and Patrisse Cullors (Noble and

Tynes). In a colourblind era, the oppressions against Black women are deeply entrenched in ways that become even more difficult to excavate. Additionally, if the postracial assumes that the naming of race conjures up antiquated tenets of racism, then Black women's very existence and daring resistance to name all parts of themselves disrupts both historical and contemporary iterations of dominance. As we argue in this chapter, Black women continue to navigate and resist the erasure of our experiences by utilizing particular tools of communication within digital sistahoods.

Theoretical Arguments and Methodological Grounding

In the current chapter, we argue that communication is a viable tool that helps Black women resist external hostilities in response to the politics of the postracial. Through a case study of the largely visible online movement #MeToo, we will demonstrate two specific resistance strategies that Black women employ in order to speak themselves into existence: (1) resisting the erasure of Black women as creators and activists and (2) resisting the homogenization of womanhood. We further identify and interrogate the private-public continuum as spaces that Black women continue to navigate in their resistance strategies. Grounded in Black feminist theory (BFT) (Crenshaw; Collins), we specifically centre Black women's ability to access truth vis-a-vis our lived experiences, and particularly so online. BFT also allows us to theoretically frame interlocking—as opposed to hierarchical—oppressions; thus, in the current analysis, we can avoid the slippage of hierarchies regarding sexual assault.

Through a BFT theoretical framework, we then conduct a critical technocultural discourse analysis (CTDA) (Brock) of Black woman-centred blogs and other online media sites, such as podcasts and social media posts. CTDA stresses the importance of an information technology's hardware and software as well as the discourse of its users in order to open up "the cultural discourses that shape our use of the technology, and the societal expectations about those technocultural practices" (Brock 2). Through this approach, we argue that Black women utilize communicative tools to create digital sistahoods in ways that ultimately reshape what 'counts' as resistance in the contemporary post-racial era. Utilizing the CTDA technique allows for an in-depth

consideration of both the technological and cultural elements at play regarding Black women's resistance online.

Communication as a Viable Tool of Resistance

Everyday communication behaviours are viable resources that assist Black women's survival. Thus, communication is a productive entry point for scholars to understand how Black women address exclusionary politics. Prior work shows that language is functional for groups who are lacking power at the institutional level (Davis, "Taking Back the Power"). In fact, notable Black feminists have asserted that Black women find ways to confront oppressive forces by breaking their silence and talking directly "to those who have power to oppress and dominate" (hooks, *Talking Back*)—a point that has since been expanded to further exemplify this idea (Davis and Afifi). "Talking back" is Black women's unique way of resisting domination and transforming society and is a strategy used in more or less visible, extreme, and audible ways (Davis, "Taking Back the Power"; hooks, *Talking Back*).

For instance, words have the capacity to inflict more pain, damage, and humiliation than physical acts—a point illustrated in hooks's "Tongues of Fire" (hooks, *Sisters of the Yam*). She writes that some Black women are "sharp-tongued" and harshly critique those who "assert power over another person (and) assault someone else's psyche" (hooks, *Sisters of the Yam* 21). Unlike most other tools and resources in the US, language is free, easily accessible, and adaptable (Davis, "The Aftermath"). Although these resistive practices can viably assist an individual, they are most effective when Black women compound their talk back resources and mobilize together (Steele). However, fighting against systems and institutions of oppressive power is exhausting, especially when that effort is performed alone as the concept of "racial battle fatigue" outlines (Smith); the process can deplete women's emotional, physical, financial, and mental resources. Black women can combat feelings of isolation by connecting with people who empathize with their experiences—they can put down their weapons and "relax, tell stories, gain strength...and maintain harmony in their lives" (Niles Goins 531). In this chapter, we assert that communicative resistance is particularly effective when it transpires within the sistah circle.

The Sistah Circle

Black women place great value on their intraracial friendships because they are often the only people who can truly empathize with daily racial and gendered injustices (Davis, "The 'Strong Black Woman Collective'"; Scott). They have long considered each other to be "kinfolk" and have created the term "sistah friend" to capture the involuntary nature of their relationship (Anderson; DeFrancisco and Chatham-Carpenter). The term "sistah" has a historical legacy in the Black American community and signifies "a people's history [of] struggles ... a sense of familial tie where there is no blood; women trusting, celebrating, loving and being bound to other women" (Lugones and Roszelle 410). Many Black women cultivate kindredlike relationships with each other because the companionship assists their existence, survival, and even resistance to outsiders (Davis, "Taking Back the Power").

Since isolation and displacement are common characterizations of Black women's daily life, feeling connected to a group and finding a safe place from external danger is important. In these spaces, Black women can speak in a manner that rejuvenates and empowers one another to resist (Davis, "The 'Strong Black Woman Collective'"). This language is laden with idiosyncratic sociocultural and historical properties as well as linguistic codes and practices (Davis, "Taking Back the Power'"; Niles Goins); and it allows them to fully communicate about their personal experiences without the linguistic limitations of standard white English language (e.g., Scott).

A benefit of the sistah circle or sistahood is that it provides a loving community for women who are unnecessarily ostracized and isolated in dominant spheres within the US social landscape (e.g., McLane-Davison et al.). Fortunately, Black women can retreat to their sistah circle to celebrate their womanhood unapologetically; behave in culturally specific ways; nurture relationships with other women who share similar life experiences; receive validation of their race-related experiences; and fortify the metaphorical boundaries that protect their safe space from external dangers. One theory called the strong Black Woman collective (Davis, "The 'Strong Black Woman Collective'") reconciles all of these ideas by explicating how Black women use their language during group-level interactions to collectively promote solidarity and pride within the group and confront external oppressive

forces. Analyzing communicative resistance in the postracial era illuminates how Black women's unapologetic oppositional tactics are enabled through their sistah-relationships.

Private-Public Spectrum of Resistance

In order to cultivate these sistah circles, Black women have wielded tactics of resistance along the continuum of the private and public. Whereas feminist and critical race scholars have troubled the ideas of the Habermasian "public sphere" to advance discussions on private spaces and their political contributions, Black feminist scholarship has specifically analyzed how Black women uniquely respond to issues of the private and public (Collins). Britney Cooper, for instance, writes about Black women intellectuals and suggests that Black women's private lives can be useful in their intellectual work. That is, although some Black women hid their private lives, there also exists powerful instances in which Black women public intellectuals made their bodies and affect visible through embodied discourse, which has allowed Black women to merge their private and public selves in productive and multidimensional ways.

Darlene Hine's theory of dissemblance differently addresses Black women's resistance along the private-public in that Black women have had to protect their private selves in order to be made publicly legible. As Hine notes: "Only with secrecy ... could ordinary Black women accrue the psychic space and harness the resources needed to hold their own in the often one-sided and mismatched resistance struggle" (Hine 915). Together with Cooper's theory of embodied discourse, we argue that Black women have long navigated the layers of the private-public continuum both for self-protection and care of their sistahoods.

Online, Black women continue to grapple with the public and private in ways that advance a shared sistahood through specific digital practices, such as private enclaves (Steele). The utilization of their private networks to negotiate personal and political issues is an important aspect for Black women in galvanizing digital tools, which requires skilled technical and cultural capital (Brock, Kvasny and Hales). Additionally, Black women's public engagements with television texts while online allow for direct resistance to limiting cultural texts (Maragh). In the current analysis, we understand "digital sistahoods"

as illustrating the particular ways in which Black women navigate the private-public continuum in order to reimagine themselves as sites of *possibilities* within the postracial era. In other words, we view activity in both the private and public domains as illustrative of digital sistahood. Additionally, because sistahood invokes kindred relationships within coalitional circles, we understand "digital sistahood" as discursively created when Black women come together online to access and define our own truths (Collins).

Digital Sistahoods

On October 16, 2017, actress Alyssa Milano tweeted, "If you've been sexually harassed or assaulted write 'me too' as a reply to this tweet" in response to a wave of sexual assault allegations that surfaced against, mostly, prominent men in Hollywood. Within a matter of hours, thousands of posts donned the hashtag #MeToo as assault survivors shared their experiences online, demonstrating the sheer magnitude of sexual assault, particularly for women. As coverage of #MeToo extended into mainstream news agendas and social justice groups, many Black women-led online groups questioned if the online movement included them. By tapping into their digital sistahoods, Black women resisted their erasure along the private-public continuum in two primary ways: by centring Tarana Burke, the Black woman who founded MeToo, and by resisting the flattened notion of a monolithic womanhood. These online resistance strategies, we argue, demonstrate alternate modes of resistance that more accurately include the experiences of the multiply marginalized. To be clear, we analyze the role of Black women in critiquing the online responses to #MeToo rather than the movement of MeToo itself, which has foregrounded Black women and marginalized groups at its core.

When Milano (who later attributed #MeToo to Burke) ignited the #MeToo conversation online, Black-women-centred media sites and users were some of the first to correct the narrative and credit Burke for her decade-long work. Black women predominantly brought Burke to the mainstream news's attention, as online posts exemplify (See Figure 1). Additionally, the Black-women-centered blogs *Hello Beautiful*—a site "where Black women go to talk about themselves shamelessly"— published the article "By the Way, Viral Hashtag #MeToo Was Created

by a Black Woman" in early October, one day after Milano's initial tweet (Kelly). On October 20, *The Root* published a piece on their television series, titled, "The Real Woman Behind 'Me Too.'" Quoting Burke, the article notes, "Sexual violence knows no race or class or gender, but the response to sexual violence does, and Me Too is about the response to sexual violence" (León).

As the hashtag #MeToo gained momentum, Black women were well aware of the historical erasure of their intellectual and activist contributions. By using the public affordances of digital media (making their tweets public using open-access, high-profile blogs), Black women resisted the erasure of Burke as the founder of MeToo. That their resistance occurred in such public ways demonstrates how Black women continue to rewrite their own narratives for media outlets and others who shape the public imaginary. It is important to note that Burke also centred her own role through her social media and interviews (See Figure 2). As she stated in an interview, "I had to ring the alarm.... One, before my work is erased, and two, because if I can support people, I have to do that" (qtd. in Ohlheiser).

Black women also wielded communication as a tool of resistance by struggling against the monolithic notions of womanhood that seemed to besiege the online #MeToo conversation. As Burke describes, one of the movement's ideas, "empowerment through empathy," was created to recognize the utterance of a shared experience. "When two people exchange the words "me too," Burke says, "it is literally an exchange of empathy between people that says I hear you, I see you, and I believe you" ("You Are Not Alone").

Online, this shared experience risked the erasure of the experiences of girls and women of colour. Indeed, the comments section of several mainstream MeToo news articles revealed this rhetoric. For example, one commenter on the *Huffington Post* wrote, "Let's not take away from the conversation about sexual abuse by making any woman less worthy of protection than the next" (qtd. in Prois and Moreno). In this sense, any article that centres the experiences of Black women is inevitably framed as taking away from the conversation, thus implying that attention to Black women somehow diminishes the worthiness of white women, whereas the inverse is never the case. From a Black feminist thought framework, however, centring the experiences of Black women serves to critically engage with these interlocking identities in

discussions of sexual assault as opposed to taking something away from the conversation.

As digital media scholars contend, online discourses can emphasize the ways in which communities form, but they can also risk homogeneity by highlighting the majority of users, even within a particular ingroup (Maragh). Furthermore, although #MeToo responses certainly included men and people across the gender spectrum, it largely began to wrap itself around ideas of womanhood and/as whiteness—a postracial strategy that has mobilized across institutional and media sites (Mukherjee). As Eduardo Bonilla-Silva argues, actors who are racialized as white often espouse specific rhetoric, such as a reliance on universalism, which keeps racial structures and inequalities in place by seeking to erase race altogether. Doing so guarantees that these actors continue to receive, whether passively or directly, the institutional benefits of whiteness. In a similar way, dominant frames from the #MeToo response focused on sexual violence as a universal experience, despite MeToo's recognition of the "most marginalized amongst us" ("You Are Not Alone").

Black women, in turn, relied on their digital sistahoods to resist such universal iterations of sexual violence. In particular, the podcast *Listen to Black Women*, which emerged from collaboration between the blogs *Hello Beautiful* and *MadameNoir*, released as its fifth episode "Do We Want the #MeToo Movement for Us Too?" (Sanders, Kelly, and McGevna). The title of the episode signals Black women as agentic decision makers within the #MeToo conversation in that the online movement could not simply and unilaterally erase Black women. Rather, for the hosts of this podcast episode—Shamika Sanders, Keyaira Kelly, and guest host Allison McGevna—Black women can choose whether or not to stake their own claims as well. An analysis of the podcast's format in tandem with its content allows us to follow the private-public continuum with which Black women occupy as spaces of resistance. This podcast follows a similar format each episode. First, the hosts introduce the question of the week and provide contextual and historical information to the episode's topic. Second, they gather responses from online users in their "social media roundup" segment. Third, "the receipts" segment reveals poll numbers from audience members as solicited from the podcast's producers. Fourth, and lastly, the conversation follows with a broader discussion of the topic.

The hosts of "Do We Want the #MeToo Movement for Us Too?" began by historicizing Black women's role in reporting and otherwise resisting sexual violence as well as crediting Burke as MeToo's founder. As one of the hosts Shamika Sanders notes, however, "It's hard not to think our voices are being intentionally ignored." Here, "our voices" functions as a signal that immediately creates and prioritizes the digital sistahood for Black women. In their social media roundup segment, the hosts tap into the public affordances of social media by collecting posts that focused on the intersectionality of #MeToo. For instance, the women chose tweets to discuss the complex issue of protecting Black men in the fight against sexual violence.

Citing Nellie McKay, Patricia Hill Collins writes about the issues that Black women face in this realm of racial solidarity: "Taking sides against the self requires that certain elements of Black women's sexuality can be examined, namely, those that do not challenge a race discourse that historically has privileged the experiences of African-American men" (124). By pulling from online public posts, then, *Listen to Black Women* acts as a form of digital sistahood to name the importance of these issues and validate Black women. In doing so, they resist any claims that sexual violence is a monolithic issue.

In the receipts segment, the hosts then tap into the sensitivity of sexual violence by pulling from their anonymized poll to highlight audience members' experiences and opinions. Questions ranged from, "Have you ever been sexually abused?" to "Why do you think many Black women stay silent and do not report sexual violence?" In the ensuing discussion, the hosts discuss the criminal justice system: "We know that a lot of times [calling the police] could lead to death." Another question brought up the believability of Black women in sexual violence cases. Poll numbers revealed that 48 per cent of listeners stated that Black women are less believed "because society places less value on Black women." Here, one of the hosts of the podcast paused and said, "I just want to give a collective hug to all of us."

In this digitized moment, the private (anonymized) responders were brought into conversation with a nurturing digital sistahood through this discursive "collective hug." In the final segment of the podcast, the show's hosts cited an interview with actor Terry Cruz to emphasize the inclusion of men as survivors. As one of her final notes, host Keyaira Kelly exclaimed: "Believe Black women. Believe Black

women. Believe Black women!"

Conclusion

Sistah circles allow Black women to celebrate themselves, behave in culturally specific ways, nurture relationships with like-minded women, receive validation, and fortify the metaphorical boundaries of their safe spaces. As we have analyzed, sistah circles, or sistahoods, can function along the private-public continuum to resist articulations of the postracial era. In particular, online movements, such as #MeToo, reveal the tensions that Black women resist regarding the postracial. With likeminded sistahs, Black women helped to publicly centre Tarana Burke as the movement's creator. Moreover, through the format of the *Listen to Black Women* podcast, a particular kind of digital sistahood emerged that highlights the technical and cultural dexterity that Black women employ along the private-public spectrum. Whereas the utilization of a private poll allowed the hosts to bring audience members into the fold as an anonymous collective, more public social media posts were used to spark conversations specific to Black women. In each of these instances, *Listen to Black Women* tapped into rich resistance strategies that starkly contrast a homogenous sense of womanhood. Here, Black women demonstrate the fluidity of resistance. These strategies, which seamlessly ranged across the public and private, demonstrate Black women's persistence in writing ourselves into existence, and particularly so in this postracial era, through cultivated sistahoods.

Works Cited

Anderson, B. "African American Households in Transition: Structure, Culture, and Self-Definition." *Complex Ethnic Households in America*, edited by L. Schweded, R. Blumberg, and A. Chan, Rowman & Littlefield Publishers, 2000, pp. 196-216.

Bonilla-Silva, E. *Racism without Racists: Color-Blind Racism and the Persistence of Racial Inequality in America.* Rowman & Littlefield, 2014.

Breines, W. *The Trouble between Us: An Uneasy History of White and Black Women in the Feminist Movement.* Oxford University Press, 2006.

Brock, A., L. Kvasny, and K. Hales. "Cultural Appropriations of Technical Capital: Black Women, Weblogs, and the Digital Divide." *Information, Communication, and Society*, vol. 13, no. 7, 2010, pp. 1040-59.

Brock, A. "Critical Technocultural Discourse Analysis." *New Media & Society*, vol. 20, no. 3, 2016, pp. 1012-30.

Collier-Thomas, B. *Sisters in the Struggle: African American Women in the Civil Rights Black Power Movement*. NYU Press, 2001.

Combahee River Collective. *The Combahee River Collective Statement: Black Feminist Organizing in the Seventies and Eighties*. Women of Color Press, 1977.

Collins, P. H. *Black Feminist Thought: Knowledge, Consciousness, and the Politics of Empowerment*. Routledge, 2000.

Cooper, B. *Beyond Respectability: The Intellectual Thought of Race Women*. University of Illinois Press, 2017.

Crenshaw, K. "Demarginalizing the Intersection of Race and Sex: A Black Feminist Critique of Antidiscrimination Doctrine, Feminist Theory, and Antiracist Politics." *University of Chicago Legal Forum*, article 8, no. 1, 1989, pp. 139-67.

Davis, S. M., and T. Afifi. "Harming the Relationship While Helping the Friend: The Outcomes of Seeking Social Support about a Romantic Partner from Women Friend Groups." *Journal of Friendship Studies*, vol. 2, no. 1, 2014, pp. 18-44.

Davis, S. M. "The 'Strong Black woman Collective': A Developing Theoretical Framework of the Communication Process among Black Women." *Women's Studies in Communication*, vol. 38, no. 1, 2015, pp. 20-35.

Davis, S. M. "Taking Back the Power: An Analysis of Black Women's Communicative Resistance." *Review of Communication*, vol. 18, no. 4, 2018, pp. 301-18.

Davis, S. M. "The Aftermath of #BlackGirlsRock vs. #WhiteGirlsRock: Considering the Discursive Labor of a Black Women Counterpublic as *Disrespectable*." *Women's Studies in Communication*, vol. 41, no. 3, 2019, pp. 269-90.

DeFrancisco, V., and A. Chatham-Carpenter. "Self in Community: African American Women's Views of Self-Esteem." *Howard Journal*

of Communications, vol. 11, no. 2, 2000, pp. 73-92.

DuMonthier, A., C. Childers, and J. Milli. "The Status of Black Women in the United States (Rep.)." *Institute for Women's Policy Research*, 2017, iwpr.org/wp-content/uploads/2017/06/The-Status-of-Black-Women-6.26.17.pdf. Accessed 6 Jan. 2022.

Habermas, J. *The Structural Transformation of the Public Sphere: An Inquiry into a Category of Bourgeois Society*. MIT Press, 1989.

Harris-Lacewell, M. *Barbershops, Bibles, and BET: Everyday Talk and Black Political Thought*. Princeton University Press, 2010.

Hine, D. "Some Preliminary Thoughts on Rape, the Threat of Rape and the Culture of Dissemblance." *Signs*, 1989, pp. 912-920.

hooks, b. *Sisters of the Yam: Black Women and Self-Recovery*, 3rd edition. Routledge, 2015.

hooks, b. *Talking Back: Thinking feminist, thinking black*. South End Press, 1989.

Kelly, K. "By the Way, Viral Hashtag #MeToo Was Created by a Black Woman." *Hello Beautiful*, 30 Oct. 2017, hellobeautiful.com/2963545/harvey-weinstein-sexual-assault-me-too-hashtag/. Accessed 6 Jan. 2022.

Kuo, R. "Racial Justice Activist Hashtags: Counterpublics and Discourse Circulation." *New Media & Society*, vol. 20, no. 2, 2016, pp. 495-514.

León, F. "Watch: The Real Woman Behind 'Me Too.'" *The Root*, 20 Oct. 2017, www.theroot.com/watch-the-real-woman-behind-me-too-1819716901. Accessed 6 Jan. 2022.

Lugones, M., and P. Roszelle. "Sisterhood and Friendship as Feminist Models." *Knowledge Explosion: Generations of Feminist Scholarship*, edited by C. Kramerae and D. Spender, Teachers College Press, 1992, pp. 406-12.

Maragh, R. "'Our Struggles Are Unequal': Black Women's Affective Labor between Television and Twitter." *Journal of Communication Inquiry*, vol. 40, no. 4, 2016, pp. 351-69.

Maragh, R. (2018). "Authenticity on 'Black Twitter': Reading Racial Performance and Social Networking." *Television & New Media*, vol. 19, no. 7, 2018, pp. 591-609.

McLane-Davison, D., et al. "The Power of Sum: An Accountability Sistah Circle." *Journal of Social Work Education*, vol. 54, no. 1, 2018, pp. 18-32.

Mukherjee, R. *The Racial Order of Things: Cultural Imaginaries of the Post-Soul Era*. University of Minnesota Press, 2006.

Niles Goins, M. "Playing with Dialectics: Black Female Friendship Groups as a Homeplace." *Communication Studies*, vol. 62, no. 5, 2011, pp. 531-46.

Noble, S., and B. Tynes, editors. *The Intersectional Internet: Race, Sex, Class, and Culture Online*. Peter Lang Publishing, 2016.

Ohlheiser, A. "The Woman behind 'Me Too' Knew the Power of the Phrase When She Created It 10 Years Ago." *Washington Post*, 19 Oct. 2017, www.washingtonpost.com/news/the-intersect/wp/2017/10/19/the-woman-behind-me-too-knew-the-power-of-the-phrase-when-she-created-it-10-yearsago/?utm_term=.a340fbf01fe8. Accessed 6 Jan. 2022.

Prois, J., and C. Moreno. "The #MeToo Movement Looks Different for Women of Color. Here Are 10 Stories." *Huffington Post*, 2 Jan. 2018, www.huffingtonpost.com/entry/women-of-color-metoo_us_ 5a44 2d73e4b0b0e5a7a4992c. Accessed 6 Jan. 2022.

Sanders, S., K. Kelly, and A. McGevna. "LTBW Episode 5: Do We Want the #MeTooMovement for Us Too?" *Hello Beautiful*, 11 May 2018, hellobeautiful.com/2999023/isthe-me-too-movement-inclusive-of-black-women/. Accessed 6 Jan. 2022.

Scott, K. "Communication Strategies across Cultural Borders: Dispelling Stereotypes, Performing Competence, and Redefining Black Womanhood." *Women's Studies in Communication*, vol. 36, 2013, pp. 321-29.

Smith, W. "Higher Education: Racial Battle Fatigue." *Encyclopedia of Race, Ethnicity, and Society*, edited by R. T. Schaefer, Sage, 2008, pp. 615-18.

Steele, C. "Signifyin', Bitching, and Blogging: Black Women and Resistance Discourse Online." *The Intersectional Internet: Race, Class, Sex, and Culture Online*, edited by S. Noble and B. Tynes, Peter Lang, 2016, pp. 73-93.

Steele, C. "Black Bloggers and Their Varied Publics: The Everyday Politics of Black Discourse Online." *Television & New Media*, vol. 19, no. 2, 2017, pp. 112-27.

"You Are Not Alone" *Me Too*, 2018, metoomvmt.org/. Accessed 6 Jan. 2022.

Chapter 4

Service, Leadership, and Sisterhood: An Overview of Black Sororities in Social Science Research

Marcia Hernandez

For African American women, sisterhood is more than a label one
uses upon joining a sorority. Rather sisterhood is about embracing
people who are not related by blood into meaningful family-like
relations.... For [African American women], a woman is a sister not
just because she is the same sorority; she is a sister because she is an
important part of their lives and their families.

—C. M. Philips 345

Approximately one and a half a million members strong, Black
sororities and fraternities are a staple of African American
life (Ross Jr., *Divine Nine*). Sorority members have participat-
ed in social justice movements (Giddings; Whaley), lobbied for policy
changes (Parks and Neumann), created and sustained community
service projects for literacy, education, and civic engagement
(Hernandez and Arnold; Washington and Nunez), and promoted eco-
nomic development (Whaley). Black sorority chapters exist throughout
the United States, and the organizations have expanded internationally
with chapters in Africa, Asia, Europe and the Caribbean (Parks and

Hernandez). Black Greek letter organizations (BGLOs) are "among the oldest black campus organizations on most predominantly white campuses and are possibly the strongest nationwide social institutions in black America" (McKee 27). Despite their historical importance, and the influence of the organizations in communities, mainstream scholarship has largely marginalized or ignored Black sororities (Goss et al.). Although the scholarship of BGLOs has grown in recent years, due to the secrecy and exclusivity of membership and the taboo subjects often associated with the groups (e.g., elitism, colourism, and hazing), this body of research is relatively young with few topics explored in detail (Parks).

This study has two goals. The first is to provide an overview of research on Black sororities from 1988 to 2018. Second, by drawing on select themes in the research over a thirty-year period, this study highlights findings that explore how sisterhood is encouraged, enforced, and contested within sororities. The discussion begins with the origins of the Black sorority movement to provide context for how members have pursued their organization's ideals and goals through relationships with their sisters. Given the complexity of relationships within Black sororities and the impact of social, political, and historic events on an organization, a shared understanding of sisterhood is negotiated terrain. The conclusion offers suggestions for future research to develop a more complex understanding of sisterhood.

Origins of a Movement

Eight of the nine nationally incorporated BGLOs were founded in the early twentieth century by Black students attending historically Black colleges and universities (HBCUs) and select predominantly white institutions (PWIs). Four of the organizations were sororities. Paula Giddings (1988) describes the founding of BGLOs as a "full-fledged social movement" given their devotion to racial uplift, literacy and the arts, philanthropy, and efforts to change racist and sexist public policy. Black sororities were influenced by the women's club movement, religious institutions, collegiate secret societies, and campus literary clubs (Philips; Whaley).

Alpha Kappa Alpha Sorority, Inc. (AKA), founded in 1908, and Delta Sigma Theta Sorority, Inc. (DST), founded in 1913, were both

charted at Howard University. These groups are arguably the most popular and well-known organizations, as AKA was the first sorority founded by Black women, whereas DST boasts the largest number of members and chapters. A group of twenty-two women, some of them officers in AKA, chose to create a new sorority, DST. The most popular explanation for the separation was mounting disagreements among AKA's membership regarding the priorities and goals for the organization, including frustration over how much of a public activist identity the women should have (Giddings). Tension between AKA and DST members exists today, often in the form of friendly rivalry on college campuses. Although the competition is largely good-natured, Lawrence Graham notes, "The best things I recall my AKA relatives saying about the Deltas when I was growing up were backhanded compliments like, 'The Deltas are a great second choice for a girl who can't get into AKA.'" (95).

In 1920, Zeta Phi Beta Sorority, Inc. (ZPB) was also established at Howard University. The origins of ZBP are similar to AKA's, as founders in both groups had close relationships with fraternity members. A founder of Phi Beta Sigma encouraged his girlfriend, Arizona Cleaver, to create a sorority (Parks and Neumann). Sigma Gamma Rho Sorority, Inc. (SGR) was founded in 1922 at Butler University in Indiana to combat the intense racial segregation as well as to provide an intellectual home for women and leadership opportunities for members. Sisterhood for the early SGR members was most likely born out of a necessity for survival. The sorority was founded during "a time when the Ku Klux Klan included one-third of native born whites in Indiana" (Parks and Neumann 113).

Black sororities placed a heavy emphasis on community service, social uplift, and "the politics of respectability" (Whaley 33). (2011) write, Black sororities followed the values, norms and traditions of their predecessors in the Black women's club movement, which "implemented and fomented the Victorian ideals of family, home, hearth, and morality among themselves and in the community as a method to counteract the virulent stereotypes about African American women" (Tindall, Hernandez, and Hughey 37-38). Sorority founders embraced the notion of the "cult of true womanhood," allowing for members' activism and community service to be framed by socially accepted terms of family, domesticity, and servitude. Their work as college students

contributed to racial uplift and gender equality efforts on and off campus and later as professionals and leaders in their communities (Turk).

Black sorority members knew they would work to contribute financially to their families and to support their communities as leaders in education, healthcare, and business, and through civic engagement (Hernandez and Arnold). Members understood that they would not be afforded the same luxuries afforded to many white women with a degree who could opt out of paid labour after marriage (Philips). Black sororities provided members support during college and a network of mentors and friends to advocate and care for one's personal and professional endeavors throughout their lives.

Sorority founders encouraged women to understand sisterhood as an individualized, personal experience for each member. Giddings's research highlights, sisterhood and the relationship to one's sorority, was by design meant to change over time. She posits, "The sorority may be unique among Black purposive organizations as it was not conceived to transform society but to transform the individual" (Giddings 21). The symbiotic relationship between sorority members' ability to support their organizations and the strength and well-being of the groups is influenced by centuries of institutional discrimination experienced by Black women. Deborah Gray White writes,

> Black women's association history is, therefore, not a story of harmonious sisterhood, nor one about women selflessly sacrificing themselves for the good of the group. It is about women with missions that varied and often clashed, about women who aimed for progress and unity, but who sometimes fell short, about women who sometimes found the job of representing and fighting for themselves burdensome. It is also about women who found themselves caught in the middle of race and gender conflicts...Black women weathered the storms created by these and other issues but not without injury to their organizations, and without identity crisis. (16-17)

The admirable goals and lofty ideals infused in the mission state-ments of Black Sororities- sisterhood, scholarship and service to all people- are upheld by women seeking membership today. Yet in the twenty-first century, sisterhood has proven at times to be an elusive, contested concept.

Scholarship on Black Sororities

Black sororities are barely mentioned in academic research prior to the late 1980s. Early scholarship provides very little information about the groups' or members' experiences on their own terms. At most, BGLOs are utilized in research to provide a comparative experience to the White, mainstream norm (Parks). Most scholarship focused on college members' experiences while ignoring membership in alumnae chapters (Hernandez, "Sisterhood").

Giddings's groundbreaking research on DST is among the first, robust historical studies of a Black sorority. Her work offers detailed insight to the social, economic, and political impact of members' philanthropy and community service and delves into the leadership's successes and failures. The study heralded a new era for scholars interested in conducting research on BGLOs, specifically sororities, on their own terms. Her research provides ample evidence that sisterhood is not always easily achieved or automatic among members. She describes challenges to sisterhood and provides illustrative examples, some very personal, including violence experienced in the hazing and pledge process, classism, colourism, and other forms of exclusion practiced by group members. Yet Giddings describes Black sororities as social institutions capable of supporting women with diverse experiences and perspectives—if the membership is willing to accept and nurture a broad understanding of sisterhood.

Alexandra Berkowitz and Irene Padavic's research highlights how distinct historical experiences for college-educated Black and white women continue to influence contemporary sisterhood. The differences in the vision and value of sisterhood are telling: White sororities overwhelmingly prioritized and celebrated romantic, heterosexual relationships, whereas Black sororities prioritized academic achievement and career aspirations of members. Black sorority members were motivated by the image of strength and independence often attributed to Black womanhood. They sought out sisterhood for support in college; they also had a desire to do community service and to cultivate relationships for their own success later in life through mentorship and professional networks.

Although Berkowitz and Padavic's study provides greater detail about Black women's experiences in sororities and their relationship with their sisters, it is still comparative research. Black women and

their organizations are not studied on their own terms. We do not learn about how other intersecting identities may impact relationships within sororities. Scholars also do not focus on sorority life after college in comparative research, even though BGLO's have active alumnae chapters. These are some of the shortfalls in sorority scholarship focused primarily on collegiate sisterhood.

Reassessing and Reimagining Sisterhood in Black Sororities

In the 2000s, BGLO research expanded with the publication of multiple books on the organizations' culture, history, and current issues (Brown, Parks, and Phillips; Fine; Hughey and Parks; Kimbrough; Parks, "Introduction"; Ross Jr., *Divine Nine*). A more extensive view of Black sororities emerged, including how sisterhood is created or maintained with an increasingly racially diverse membership (Chen) as well as the impact of colourism, classism, and other forms of elitism within sororities (Tindall, Hernandez, and Hughey). This new era of research offered an increasingly nuanced understanding of relationships between members and the complex relationships within groups.

This section focuses on how Black sorority members encourage, negotiate, and test boundaries of sisterhood, including members' engagement in contemporary social justice movements (Owens) and how homophobia and heterosexism intersect with other social identities adding layers of complexity to membership (Literte and Hodge; Decaille). The topics are explored through the historical lens of the founding of the organizations. The conventional gender norms inherent in the politics of respectability provided a useful façade for the revolutionary vanguard work in the organizations' early years. However, recent scholarship demonstrates adhering to conservative ideology, including relatively restrictive gender norms and the politics of respectability, does not advance contemporary efforts to combat oppression in society today (Joseph and Rhodes; Rose).

In her book, *Righteous Discontent: The Women's Movement in the Black Baptist Church, 1880-1920*, Evelyn Brooks Higginbotham coins the term "politics of respectability." She posits Black Baptist women were hopeful that their morally focused work, refined manners, and proper behaviour would result in better treatment for Blacks in society.

Higginbotham notes Black women's precarious efforts to participate in the public sphere encouraged their adherence to specific, respectable behaviour with the aspiration of racial uplift. The politics of respectability was both a performance expected of, and reinforced by, the Black middle and upper classes and was considered proper behaviour regardless of one's class standing.

Like many strategies employed by Black communities in the quest for social justice, the politics of respectability is a multifaceted process. The conditions under which Black women in churches, clubs, sororities, and other associations practiced respectability politics reinforced hierarchies along the lines of class, education, sexuality, and skin tone (Whaley). Yet scholars note that respectability politics has both conservative and radical components as Black women sought to proactively counter negative and damaging stereotypes by practicing so-called good (i.e., Christian, middle-class, and heteronormative) behaviour and morals while performing public protests, such as marching, boycotting, and making verbal appeals to justice (Rose).

Recent commentary on Black sororities questions a continued reliance on respectability politics, particularly as groups are called to defend their relevancy against charges of elitism and exclusion against others in Black communities (Harris and Mitchell Jr.; Owens; Bates). Two noticeable examples are the heterosexism often enforced by group members and the response to members' participation in social justice protests, particularly those sponsored by Black Lives Matter (BLM).

Although the research on lesbian members of Black sororities is extremely limited, Patricia Literte and Candice Hodge note, "There are no contradictions when it comes to expectations about sexual orientation, as the majority of Greek organizations are overtly heteronormative and in many cases, concurrently overtly homophobic.... [Historically] standards of womanhood and public performances of femininity have included the implicit assumption that sorority members are heterosexual." Moreover, Jessica Harris and Vernon Mitchell Jr. argue that "Homosexuality or involvement in LGBT politics does not conform to the essentialist image of femininity black sorority traditionally projected or to the overall goal of racial uplift" (681-82).

The effort and will to challenge heterosexism in Black sororities is a complex process. Yet Lawrence Ross argues that a common challenge for BGLOs is for members to work with others from diverse back-

grounds to collaboratively accomplish a goal: "Members come from different regions, socio-economic backgrounds, and racial backgrounds. That said, some straight Black Greeks either don't feel comfortable around gays and lesbians, or feel that same sex relationships go with their faith. It's a difficult challenge for both sides to navigate" (Ross, "The Rainbow Greeks" para. 7).

Literte and Hodge interviewed twenty Black sorority members in alumnae and undergraduate chapters. Their respondents held complex views about homosexuality. Most members did not display outright homophobia or support discriminatory behaviour, yet they struggled to envision a lesbian sorority sister in their organization. Multiple factors influenced the respondents' views: "the influence of Christianity, power of the organizations' elders and exclusive standards of womanhood." Moreover, exclusionary tactics left "lesbian sorority sisters vulnerable to the matrix of domination, particularly the dual oppressions of racism and homophobia" (Literte and Hodge 693).

Though not explicitly stated as a source of their apprehension, respectability politics implicitly influenced the respondents' concerns, as members sought to avoid gossip between chapters and feared a decline in social status among their peers; they also alleged sorority elders would deny a woman entry into the sisterhood if they suspected she was a lesbian (Literte and Hodge). Maintaining the boundaries of respectability—including heterosexuality as well as unquestionable feminine behavior and decorum—are part of the appearance enforcement effectively enforced by the many of the elder sisters and sorority leadership (Hernandez, "Challenging").

The two lesbian respondents in the study discussed the various ways in which they were treated with caution and had to perform acceptable gender-conforming behaviour and dress to gain the respect and trust of their group (Literte and Hodge). The respondents had to prove that they supported their organization's mission and goals and "wanted to be part of a particular legacy in their community regardless of their sexual orientation" (Literte and Hodge 695). Despite being devoted to their sisters and their chapters, the researchers note there was little reciprocity of their organizations' advocacy to support civil rights and raising awareness of issues impacting the LGBT community. Only one of the undergraduate respondents mentioned her chapter's participation on a panel pertaining to lesbian and transgender experiences. Literte

and Hodge's research highlights that even among younger, presumably more liberal undergraduate members, there was not an acceptance to fully embrace sorority sisters whose identities challenged group norms.

Nia Decaille's op-ed highlights two women's different coming out experiences with sisters in their Black sororities. Candice, a member of SGR, describes her sisters as supportive and respectful yet also acknowledges "being femme made it easier to 'blend into the mold'" (Decaille para. 8). Her chapter had a large LGBTQ membership as well, making Candice's experience relatively unique. In contrast, Rachel describes her experience as a member of DST as "absolutely isolating." She continues: "I was in the closet, and the only thing my line sisters and I talked about while working together was Delta and *men*. I had nothing to contribute to the conversation and felt out of place" (Decaille paras. 4-9).

Although the respondents in Literte and Hodge's study were personally critical of the role heterosexism played in their organization, this was an issue they were unwilling to openly challenge, particularly with their elders. Yet Rachel and Candice imagined a way for lesbians to be included, albeit through two different paths. Whereas Rachel stated change should begin with leadership at the national level, Candice believed change should start at the local level with chapters, as this would require an organization's leadership to follow suit. Without a strong commitment to inclusion at the national level, the visibility and support for LGBT members within BGLOs are likely to remain marginal. The transformations and pace of inclusion are likely to remain unknown for some time, as LGBT members are often overlooked in research (Ross, "The Rainbow Greeks").

BGLOs are now celebrating one hundred years of existence; the age range of sorority sisters varies widely within alumnae chapters, as does the influence of individual members within chapters. Research on alumnae membership highlights the pressure felt by newer members due to the high expectations of, and unquestioned authority held by, senior sorority members. Gregory Parks, Rashawn Ray, and Shawna Patterson note the following: "The age gaps have been particularly relevant for younger members identifying with hip-hop culture and for older members with more 'traditional and mainstream views' on how BGLOs should promote themselves" (153-54). This phenomenon was clearly evident in recent sorority involvement in BLM protests.

In 2014, nationwide protests organized by BLM led to renewed interest in social justice issues, particularly within communities of colour. Sorority members wearing Greek paraphernalia at BLM events were initially chastised by their organization's leadership. Karen Bates notes that in December 2014 as BLM was growing, AKA and DST leaders "issued directives that sorors could wear their organization's colors—but not their letters or logos—at protests." The author continues:

> There were other warnings about conduct. "Do not make statements that are or can be construed as a position of Alpha Kappa Alpha Sorority, Inc.," wrote [the] AKA president ... "Should you choose to participate in the aforementioned event and others similar in nature," the Deltas were warned by their president... "you are solely responsible for yourself and your activities" (para. 3).

The leadership of ZPB did not issue a formal statement discouraging the wearing of letters during protests. SGR issued a statement about wearing paraphernalia at protests and announced a range of social action initiatives that aligned with BLM's own, including youth education programs about legal rights and promoting legislation requiring body cameras for police (Bates). Some interpreted the message from sorority leaders as shrinking from the battle: "[Sometimes] our fraternities and sororities, we get a little soft when it comes to social action. It's easier to meet with the president in our fancy suits or tell everyone 'dress in your finest and walk to the Capitol'" (Bates para. 14).

The message to avoid wearing one's letters sent conflicting messages, as Black sororities promote social activism and racial uplift as part of their core identity and mission. After facing public backlash on social media, the leadership of AKA and SGR altered their official stance regarding wearing Greek paraphernalia at peaceful protests. The president of SGR emphasized the initial ban was a liability issue: "If someone is wearing their colors, it looks as if they are speaking for the entire sorority. We are a sisterhood, but the reality is, there is also a business to protect." The divide between the younger sorority sisters' public activism and the hesitation of their senior leadership is guided in part by BGLO's nonprofit designation. The leadership's caution is a

well-founded concern, as the organizations are 501(c)(3) organizations, and to maintain this status, their political engagement has to be limited and largely nonpartisan.

BLM is an ideological and politically inspired movement by design to improve the lives of all members of Black communities. The group is perhaps best known for protests against police brutality towards African Americans and the prison-industrial complex. However, the goals of broadly supporting social justice and caring for all humans are shared by Black sororities and BLM. Yet the relatively radical phil-osophy of BLM does not neatly adhere to narratives of Black sororities' community engagement and racial uplift work. BLM holds a bold and defiant position to centre people who are often marginalized in Black liberation movements, including Black queer and trans folks. BLM members operate in contrast to the more conservative foundations of respectability politics often employed by other organizations supporting Black communities. The process of enforcing middle-class decorum and the politics of respectability has led to division within Black sororities. As the boundaries of sisterhood are questioned and tested, sorority leadership must address their groups' ability to be responsive and flexible to a shifting social and cultural landscape.

Conclusion

Researchers are just beginning to explore the complex dynamics of sisterhood in Black sororities, as they provide members with unique, life-long relationships, which are meant to grow in support and strength throughout their life. Scholarship indicates that sisterhood is a complicated process, not necessarily guaranteed, and is influenced by respectability politics that continues to influence sorority practice and culture. This chapter touched on a few themes in recent BLGO scholarship, but there are many topics that deserve further study. The generational differences in members' experiences, how membership in multiple civic, social, and professional groups influences women's definition of sorority sisterhood, and the experiences of members who practice a faith other than Christianity are but a few issues that merit additional attention by researchers.

Sorority leaders are at a crossroads regarding the future direction of the groups. Membership is a voluntary but costly endeavor for sisters,

who devote a lot of resources including their time and money to remain active, which may come at the expense of other important activities in their lives (Hernandez, "Sisterhood"). For now, the commitment to join and maintain sorority membership, even long after college and well into adulthood, remains high, as alumnae chapters enjoy robust support. To maintain their relevance in the twenty-first century, sorority members need to reassess and expand the definition of sisterhood—one that accommodates the full range of Black women's experiences and multifaceted identities.

Works Cited

Bates, K. G. "Black Fraternities and Sororities Split on Protest Policy." *NPR*, 13 Dec. 2014, www.npr.org/sections/codeswitch/2014/12/13/370427539/black-fraternities-and-sororities-split-on-protest-policy. Accessed 8 Jan. 2022.

Berkowitz, A. and I. Padavic. "Getting a Man or Getting Ahead: A Comparison of White and Black Sororities." *Journal of Contemporary Ethnography*, vol. 27, no. 4, 1999, pp. 530-57.

Brown, T., P. S. Gregory, and P. Clarenda. *African American Fraternities and Sororities: The Legacy and the Vision*. University of Kentucky Press, 2005.

Chen, E. W. "Transforming Racism: Asian Pacific American Women in African American Sororities." *Black Greek Letter Organizations 2.0: New Directions in the Study of African American Fraternities and Sororities*, edited by M. W. Hughey and G. S. Parks, University Press of Mississippi, 2011, pp. 139-61.

Decaille, N. "Black Sororities Are a Straight, Cisgender Women's Club, and That Needs to Change." *The Root*, 23 June 2017, www.theroot.com/black-sororities-are-a-straight-cisgender-women-s-club-1796185012. Accessed 8 Jan. 2022.

Fine, E. *Soul Stepping: African American Step Shows*. University of Illinois Press, 2003.

Giddings, P. *In Search of Sisterhood: Delta Sigma Theta and the Challenge of the Black Sorority Movement*. William and Morrow, 1988.

Graham, L. *Our Kind of People: Inside America's Black Upper Class*. Harper Perennial, 2000.

Goss, D. R, et al. "Teaching and Learning Guide for Black Greek-Letter Organizations." *Sociology Compass*, vol. 8, no. 5, 2014, pp. 571-87.

Harris, J., and V. Mitchell Jr. "A Narrative Critique of Black Greek-Letter Organizations and Social Action" *Black Greek Letter Organizations in the Twenty First Century: Our Fight Has Just Begun*, edited by G. Parks, University of Kentucky Press, 2008, pp. 143-68.

Hernandez, M. "Sisterhood beyond the Ivory Tower: An Exploration of Black Sorority Alumnae Membership." *Black Greek Letter Organizations in the Twenty First Century: Our Fight Has Just Begun*, edited by G. Parks, University of Kentucky Press, 2008, pp. 253-72.

Hernandez, M. "Challenging Controlling Images: Appearance Enforcement within Black Sororities." *Black Greek Letter Organizations 2.0: New Directions in the Study of African American fraternities and Sororities*, edited M. W. Hughey and G. S. Parks, University Press of Mississippi, 2011, pp. 212-29.

Hernandez, M., and H. Arnold. "The Harvest Is Plentiful but the Laborers are Few: An Interdisciplinary Examination of Education as Career Choice and African American Sororities." *Journal of African American Studies*, vol. 16, no. 4, 2011, pp. 657-73.

Higginbotham, E. *Righteous Discontent: The Women's Movement in the Black Baptist Church, 1880-1920*. Harvard University Press, 1993.

Hughey, M. W., and G. S. Parks. *"Black Greek Letter Organizations 2.0: New Directions in the Study of African American Fraternities and Sororities*. University Press of Mississippi, 2011.

Jones, R. *Black Haze: Violence, Sacrifice, and Manhood in Black Greek Letter Fraternities*. SUNY Press, 2004.

Joseph, R. L., and J. Rhodes. "Black Women and the Politics of Respectability: An Introduction." *AAIHS*, 24 Apr. 2017, www.aaihs.org/black-women-and-the-politics-of-respectability-an-introduction/. Accessed 8 Jan. 2022.

Kimbrough, W. *Black Greek 101: The Culture, Customs, and Challenges of Black Fraternities and Sororities*. Rosemont, 2003.

Literte, P. E., and C. Hodge. "Sex and Sisterhood: Attitudes about Homosexuality among Members of Historically Black Sororities." *The Journal of African American Studies*, vol. 16, no. 4, 2011, pp. 674-699.

Neumann, C. E. "Black Feminist Thought in Black Sororities." *Black Greek Letter Organizations in the Twenty First Century: Our Fight Has Just Begun*, edited by G. Parks, University of Kentucky Press, 2008, pp. 169-86.

Owens, D. M. "Sister Soldiers: A Look at Black Sororities in the Black Lives Matter Movement." *Essence*, 8 June 2015, www.essence.com/2015/06/09/sister-soldier-look-black-sororities-black-lives-matter-movement. Accessed 8 Jan. 2022.

Parks, G. S. "Introduction: Toward a Critical Scholarship." *Black Greek Letter Organizations in the Twenty First Century: Our Fight Has Just Begun*, edited by G. S. Parks, University of Kentucky Press, 2008, pp. 1-18.

Parks, G. S. *Black Greek Letter Organizations in the Twenty First Century: Our Fight Has Just Begun.* University of Kentucky Press, 2008.

Parks, G. S., R. Ray, and S. M. Patterson. "Complex Civil Rights Organizations: Alpha Kappa Alpha Sorority, an Exemplar." *Alabama Civil Rights & Civil Liberties Law Review*, vol. 6, 2014, pp. 125-66.

Parks, G. S., and C. Neumann. "Lifting As They Climb: Race, Sorority, and African American Uplift in the 20th Century." *Hastings Women's Law Journal*, vol. 27, no. 1, 2016, pp. 109-44.

Philips, C. M. "Sisterly Bonds: African American Sororities Rising to Overcome Obstacles." *African American Fraternities and Sororities: The Legacy and the Vision*, edited by T. Brown, G. Parks, and C. Phillips, University of Kentucky Press, 2005, pp. 341-62.

Ross, Jr. L. C. *The Divine Nine: The History of African American Fraternities and Sororities.* Kensington, 2000.

Ross, Jr. L. C. "The Rainbow Greeks: Part II." *The Root*, 12 July 2010, www.theroot.com/the-rainbow-black-greeks-part-ii-1790883545. Accessed 8 Jan. 2022.

Rose, T. "Black Feminism, Popular Culture, and Respectability Politics." *YouTube*, 2016, www.youtube.com/watch?v=ZtDJQ3TcaNc. Accessed 8 Jan. 2022.

Turk, D. B. *Bound by a Mighty Vow: Sisterhood and Women's Fraternities, 1870-1920.* New York University Press, 2004.

Tindall, N., M. Hernandez, and M. Hughey. "Doing a Good Job at a Bad Thing: The Prevalence and Perpetuation of Stereotypes about Black Greek-Letter Sororities." *Oracle: The Research Journal of the Association of Fraternity and Sorority Advisors*, vol. 6, no. 2, 2011, pp. 36-53.

Washington, M. H., and C. L. Nunez. "Education, Racial Uplift and the Rise of the Greek-Letter Tradition: The African American Quest for Status in the Early Twentieth Century." *African American Fraternities and Sororities: The Legacy and the Vision*, edited by T. Brown, G. S. Parks, and C. Phillips, University of Kentucky Press, 2005, pp. 137-80.

Whaley, D. *Disciplining Women: Alpha Kappa Alpha: Black Counterpublics, and the Cultural Politics of Black Sororities.* SUNY Press, 2010.

White, D. G. *Too Heavy a Load: Black Women in Defense of Themselves 1894-1994.* W. W. Norton & Company, 1999.

Chapter 5

Sisterhood Unexpected: "I Met My Best Friend In LEAP!" and Other Narratives by LEAP for Girls Alumnae New York City, 2006–2016

Sara C. Flowers, Danielle Krushnic, Deborah A. Levine, and Sara Birnel Henderson

The Leadership Empowerment and Awareness Program (LEAP) is an evidence-informed, curriculum-based sex education and leadership development program (Love Heals Center for Youth & Families). Love Heals, the Alison Gertz Foundation for AIDS Education launched LEAP in 2006, providing developmentally appropriate skills development programming to young women of colour living in the Bronx, Central Brooklyn, and East Harlem—neighbourhoods that concurrently experience some of the highest rates of HIV while being among the lowest resourced neighbourhoods of New York City. Led by women of colour sex educators, LEAP offers participants a safe space to learn about sexual health and HIV prevention while cultivating leadership, advocacy, and community engagement skills.

LEAP participants complete a confidential, linked pre-post questionnaire to measure change in knowledge, skills, and behaviour. Program evaluation outcomes show an increase in sexual health knowledge and safer sex negotiation skills for participants who complete the program. In addition, program evaluation demonstrated an increase in

communication with friends and family about sexual health topics and an increased feeling of sisterhood, a combination of trust and connection, by the end of the program (Love Heals, Inc.). Not only does LEAP provide comprehensive sexual health education to young Black women, but the program also creates an open and trusting space for young women to develop positive sexual health outcomes while developing new friendship and mentorship bonds that last long after the program ends. Program staff has used a mixed-methods data collection approach to evaluate youth initiatives programming.

In this chapter, the LEAP mixed-methods data collected between 2006 and 2016 will be discussed, with a focus on the lessons learned from developing, implementing, revising, reimplementing, and evaluating LEAP. The program evaluation revealed an unexpected programmatic outcome: a relationship between retention of sexual health knowledge and fostering of relationships and sisterhood among participants. These findings suggest that more robust, evidence-informed comprehensive sexuality education programs—those with a program design that goes beyond traditional evidence-based interventions by intentionally incorporating culturally congruent components that attempt to build rapport and reinforce safe space and connectedness—may offer socioemotional support and skills development to young Black women participants and alumnae (Flowers, "Perceptions").

Black Women Experience Disparate Rates of HIV and Other Sexual Health Outcomes

In 2006, LEAP was launched in East Harlem, Central Brooklyn, and the South Bronx in response to rapidly increasing rates of HIV and other sexual and reproductive health disparities among young women of colour in those neighborhoods. In the years leading up to the launch of LEAP, a disproportionate burden of HIV infections was present among women of colour, particularly women who identify as Black/of African descent and young women between the ages of thirteen and twenty-four (CDC; HIV Epidemiology Program; Augustine). National HIV surveillance data collected by the Centers for Disease Control (CDC) found significant racial and ethnic disparities of people living with HIV in 2006; 46.1 per cent were Black, compared to 34.6 per

cent and 17 per cent among white and Hispanic people, respectively (CDC). The national HIV prevalence rate for Black women was eighteen times higher compared to their white peers (CDC). At the same time, as men experienced a decline in HIV rates, there has been an increase in HIV cases among women between 2015 to 2016 (HIV Epidemiology Program). In New York City specifically, Hispanic and Black women made up 90.3 per cent of new HIV diagnoses in 2016 (HIV Epidemiology Program).

The increasing HIV rates among women, particularly Black and Hispanic women, suggests a gap in HIV prevention messaging, programming, and funding that specifically seeks to serve women and youth (National Minority AIDS Council). The LEAP curriculum strives to give young women comprehensive health education that includes education around biomedical interventions and agency-level advocacy for youth access to PEP and PrEP (Love Heals Center for Youth & Families). LEAP is an evidence-informed prevention program built upon the premise that providing information and fostering advocacy and leadership skills with young women of colour will equip them with the skills and knowledge to maintain bodily autonomy, have positive sexual encounters, and reduce rates of HIV/STIs and unintended pregnancy (DiClemente et al.; Harden; Basen-Engquist and Parcel).

Love Heals Center for Youth and Families and LEAP for Girls

Love Heals, Inc., now Love Heals Center for Youth and Families at Gay Men's Health Crisis, has over twenty-five years of experience providing adolescent sexual health education programming to youth living and attending school in those communities in New York City that are hit hardest by unintended teen pregnancy, STIs and HIV/AIDS. Love Heals's curriculum-based programs and alumni engagement initiatives use holistic approaches to wellness promotion to engage young people during out-of-school hours. The aim of these programs is to help young people develop skills to reduce risk-taking behaviours as well as prevent unintended teen pregnancy and STI and HIV transmission and foster leadership skills development with youth of colour, aged between fourteen and nineteen (Love Heals Center for Youth & Families).

In response to alarming rates of HIV among young women of colour, Love Heals, Inc. piloted and launched LEAP in 2006 (CDC; Augustine; Love Heals Center for Youth & Families). LEAP trains a new generation of youth community educators and activists in those New York City neighborhoods hardest hit by the HIV epidemic. Love Heals primarily implements these curriculum-based sex education and leadership development programs in East Harlem, Central Brooklyn, and the Bronx—areas of New York City and the nation that have been hardest hit by the sexual and reproductive health disparities (HIV Epidemiology Program, 2019).

Racism, as a system of oppression, has been shown to perpetuate and amplify health disparities among Black people in the United States (Prather et al.). This system constructs overt and covert barriers that hinder access to education, housing, employment, and healthcare, which negatively impact the health of Black women. Furthermore, internalized racism and compound stress is shown to have an impact on mental health as well as sexual and reproductive health practices (Prather et al.). Young women of colour navigating these systems of oppression are at elevated risk for contracting HIV due to the stressors compounded by personal, institutional, and systemic racism, which is further complicated by diminished self-worth, poverty, drugs, stigma, and other social pressures (Nahmias and Nahmias; Upadhya and Ellen; Prather et al.). Compounding this public health crisis are the negative images of youth of colour and unbalanced portrayals of relationships and power dynamics often portrayed in the media and popular culture, as they present unique challenges to addressing unintended adolescent pregnancy and HIV/STI prevention (Flowers, "Enacting"; Prather et al.). Religious and cultural beliefs forbidding condom use, low perceived disease risk, and societal views of Black and Hispanic/Latino youth also adversely affect the youth populations that Love Heals serves (Augustine; Flowers, "Enacting"). LEAP provides participants with an effective, culturally appropriate HIV prevention program that directly addresses these challenges.

Program Design and Dosage

Since its inception in 2006, the LEAP curriculum was designed and revised in three phases. Each phase of the program culminated with a

youth-led community action project, through which program participants were tasked with educating a minimum of two hundred of their peers about a topic covered during the program. At the end of Phase One, evaluation feedback from participants and facilitators alike sought more in-depth program offerings. Eight ninety-minute workshops were insufficient in both time and topic to adequately address the complex and nuanced issues young women of colour face when navigating adolescence, puberty, healthy relationships, and burgeoning sexuality. In the coming years, the program expanded so that Phase Two (2008–2013) expanded to twelve sessions, and Phase Three (2014–present) now offers eighteen sessions that are two hours each and take place twice weekly after school or in the evenings.

The version of the LEAP curriculum (Phase Three), current as of this chapter's publication date, includes sixteen sessions of interactive classroom-based learning plus a tour of an adolescent friendly health clinic, a youth-led community action project that educates 250 peers and community members on a sexual health topic, an adult-child communication workshop, and a graduation ceremony. The program is taught by two trained women of colour sexual health educators using a cofacilitation model. In addition to the trained sexual health education facilitators, program staff hired two alumnae facilitators-in-training (FITs). The FITs are program graduates from the previous cycle of LEAP for Girls who take the skills they learned as a participant and move into a leadership role where they are responsible for assisting with session preparation, attendance tracking, and coleading a minimum of one activity during every session. Our evaluation explores the ways in which the LEAP for Girls curriculum, cofacilitation model, and creation of a safe and trusting environment not only provide comprehensive sexual health information but also foster a strong sense of sisterhood among participants and facilitators.

Methodology

This analysis includes data collected between 2006 and 2016 (n=460). LEAP participants are unique; there are no repeat participants. The number of participant responses varies, with the number dependent upon the number of survey questions answered. For example, those who participated in an activity (e.g., being sexually active or not) may

have responded to follow-up questions, whereas those who abstain from the behaviour in question did not respond to them. LEAP evaluation employs mixed-method data collection tools. The LEAP evaluation tool is a forty-three-item pre- and postintervention survey, which is administered to participants at the beginning of the program and must be completed during the first three sessions and on the last day of the classroom-based sessions (session sixteen). In addition, there is a short participant satisfaction questionnaire administered during the graduation ceremony. This analysis included the open-ended responses from the participant questionnaire as well as the items on the pre and post survey that examine the concepts of sisterhood, communication between friends, family, and other women in partic-ipants' lives, as well as sexual health knowledge changes.

The participant satisfaction questionnaire includes eleven Likert scale questions and three open-ended questions. Findings from the open-ended questions were analyzed and included in this chapter. The pre- and postevaluation tool includes a total of forty-three items, consisting of demographic, multiple choice, Likert scale, and true/false questions that seek to assess sexual health knowledge, attitudes, and behaviour topics. Sexual health knowledge questions cover HIV and STI prevention and transmission, pregnancy prevention, and contra-ceptive options. Attitude questions cover the topics of sisterhood, communication with friends and family members, and self-esteem. The last section examines behaviour and behaviour intentions. These questions focus on condom use, shared responsibility between partners, sexual activity, and accessing reproductive healthcare. This research is focused on fostering sisterhood and analyzes how program involvement has changed the way participants connect with, relate to, and trust other women.

Questions from the pre/post instrument are grouped into several constructs, and summary variables were created and used in the analysis to reflect the constructs. This chapter analyzes the general psychosocial, sexual health knowledge, and sex communication constructs. Evaluation analysis was conducted during Phases Two and Three, by Anna Divney, DrPH, independent evaluator, and Alexa Kreisberg, MPH, senior director, analytics and evaluation, Gay Men's Health Crisis, respectively. The authors are especially grateful to Ms. Kreisberg for her enduring support of this work and for rerunning the

statistical analysis to ensure accuracy of the final draft of this manuscript during the COVID-19 pandemic.

To determine if responses related to sisterhood and increased communication between participants and other women in their lives are statistically significant, category means were compared from the presurvey and postsurvey data, and a paired samples t-test was run using SPSS. In a paired t-test, the post-test mean is compared to the pretest mean, and the mean difference is statistically significant at the 0.05 level. It is important to note that statistical significance does not equal causation, and while the mean difference for many categories is statistically significant in this evaluation, we are not able to state whether the curriculum, and the information it includes, is the only reason for this change.

Findings

SPSS version 25 was used to conduct the quantitative analysis and participant demographic information (Table 1) discussed in our findings. From 2006 to 2016, LEAP participant and alumni ages ranged from eleven to twenty-one years. Moreover, 86 per cent of all participants were between the ages of fourteen to eighteen years, and 43 per cent of participants identified as Black/African American. Regarding sexual orientation, 83 per cent of participants identified as heterosexual/straight, 2 per cent as homosexual/lesbian, 10 per cent as bisexual, 1 per cent did not identify, 1 per cent remained undecided, and 3 per cent preferred not to say. Furthermore, almost 2 per cent of participants reported their gender identity as something other than female (male or transgender).

Paired samples t-test results (Table 2) showed a statistically significant difference for the general behavioural (p-value of 0.010), general psychosocial (p-value of 0.006), sex communication (p-value of 0.000), and sexual health knowledge (p-value 0.000) constructs. Sexual communication had an average increase of 4.34 from pre to post, and sexual health knowledge increased on average by 1.47 from pre to post test.

Table 1. LEAP Frequency Tables

Gender Identity @ Post-Test

		Frequency	Per cent	Valid Per cent	Cumulative Per cent
Valid	Male	6	1.3	1.3	1.3
	Female	452	98.3	98.3	99.6
	Transgender	2	0.4	0.4	100
Total		460	100		

Age @ Post-Test

Age	Frequency	Per cent	Valid Per cent	Cumulative Per cent
12	12	2.61	2.61	2.61
13	14	3.04	3.04	5.65
14	83	18.04	18.04	23.7
15	135	29.35	29.35	53.04
16	93	20.22	20.22	73.26
17	59	12.83	12.83	86.09
18	26	5.65	5.65	91.74
19	8	1.74	1.74	93.48
20	1	0.22	0.22	93.69
21	1	0.22	0.22	93.91
System Total	432	93.91	100	
Unreported	28	6.09		
Total			460	100

Race/Ethnicity @ Post-Test

	Frequency	Per cent	Valid Per cent	Cumulative Per cent
Black/African-American	196	42.61	42.61	42.61
Hispanic/Latino	203	44.13	44.13	86.74
White (non-Hispanic)	2	0.43	0.43	87.17
Asian/Pacific Islander	8	1.74	1.74	88.91
Other (please specify)	23	5	5	93.91
System Total	**432**	**93.91**	**100**	
Unreported	28	6.09		
Total	**460**	**100**		

Sexual Orientation @ Post-Test

	Frequency	Per cent	Valid Per cent	Cumulative Per cent
Heterosexual/Straight	383	83.26	83.26	83.26
Homosexual/Gay/Lesbian	10	2.17	2.17	85.44
Bisexual	47	10.22	10.22	95.65
Did not identify	5	1.09	1.09	96.74
Undecided	3	0.65	0.65	97.39
Prefer not to say	12	2.61	2.61	100
Total	**460**	**100**	**100**	

Table 2. LEAP Paired Sample T-Test Pre-Post Constructs

	Mean	N	Std. Deviation	Std. Error Mean	Paired t test t value	df	Sig. (2-tailed)
GenBehav pre	6.0806	459	4.38736	0.20478			
GenBehav post	6.5599	459	4.36618	0.2038	2.591	458	0.010*
GenPsych pre	26.7817	458	2.98654	0.13955			
GenPsych post	27.2118	458	3.11433	0.14552	2.744	457	0.006*
SexCom pre	33.4309	427	14.69556	0.71117			
SexCom post	37.7705	427	15.05822	0.72872	6.872	426	0.000*
SexPsych pre	17.35	220	3.38952	0.22852			
SexPsych post	17.4545	220	3.63051	0.24477	0.475	219	0.635
SexHlthKnow pre	28.7804	460	3.65471	0.1704			
SexHlthKnow post	30.2543	460	3.88933	0.18134	8.581	459	0.000*

* $p < 0.05$

To have a well-rounded understanding of these gains, program staff also conducted qualitative data analysis. Dedoose v8.0.42 was used to analyze 267 responses. Forty-one codes were created categorizing responses to sisterhood, community, trust, facilitators, LEAP curriculum sessions, and the end-of-program participant satisfaction questionnaire. Codes to describe sisterhood included the following code names: LEAP FACILITATORS, OTHER TRUSTED ADULTS, PARENT/GUARDIANS, and PEERS. The codes were created to describe what participants had learned throughout the program based on the language used in the participant data.

Discussion

Overwhelmingly, LEAP participants are youth of colour; a larger percentage of LEAP participants identify as lesbian, bisexual, queer or questioning, as well as transgender or gender nonconforming than is typically seen in the general population. This demographic trend is consistent over time, suggesting that LEAP programming is serving as a safe space for queer and gender-nonconforming youth:

LEAP is a safe space! (LEAP Participant, Fall 2010, Bronx Site 1)
I liked how this was [our] safe space and we was able to protect
ourselves. (LEAP Participant, Spring 2016, Brooklyn Site)

Overall, analysis findings suggest that LEAP is providing par-
ticipants with the tools and information they need to effectively comm-
unicate with other women and family members they are close with
about issues related to sex and sexuality:

I think the educators are an essential portion of the sessions and
their ability to teach young girls in a manner that allows them to
not have to hide their thoughts and concerns. (LEAP Participant
2007, Harlem site 1)

Graduating from LEAP for Girls makes me feel like I can educate
other people too, so that they can be cautious and aware. (LEAP
Participant, Fall 2012, Bronx site 1)

In addition, this increase in communication among LEAP par-
ticipants could mean that as they become more knowledgeable about
sexual health, HIV/STI prevention, unintended pregnancy, and the
importance of health communication they have more self-confidence
and are more comfortable talking to trusted friends, family, and
romantic partners.

Sexual Health Knowledge

Sexual health knowledge included measures of sexual health know-
ledge, STI symptom knowledge, HIV transmission knowledge, and
STI protection method knowledge. These measures were evaluated to
understand if participants are completing the program with a deeper
understanding of HIV/STI symptoms, transmission and prevention
methods, as well as sexual health policies and medical facts. One
participant had this to say: "I learned about ... [STIs] and how to respect
myself and others" (LEAP Participant, Fall 2011, Bronx site 1).

LEAP uses sex education as a foundation of learning, both to
intervene against sexual health disparities and to strengthen participant
knowledge and skills to advocate for self and community. As one
participant said, "[I learned] skills that I found vital in my growth as a
woman. Without LEAP, I would still be ... timid and insecure.... Now I
have the confidence ... to make decisions ... beneficial to me [and] my

health. I would love if this program branches [out] to other states as well!" (LEAP Participant, Summer 2011, Bronx site 2).

Pillars of LEAP's program design intentionally go beyond traditional evidence-based intervention models. LEAP prioritizes the unique characteristics and needs of young women of colour and integrates their needs into interactive, practical, and skills-based learning modules that are rooted in evidence. In addition to providing quality information to bolster sexual health knowledge, LEAP responds to the realities of the participants' lives by introducing them to important concepts that will allow them to stay healthy and reduce stigma. As one participant elaborated: "I ... talk[ed] to somebody that was HIV-positive" (2014 alumna narrative).

LEAP shows participants how to positively navigate personal and sexual health through adolescence and young adulthood. Visiting a local youth-friendly sexual health centre is a program component of LEAP and lets participants become familiar with a specific location where they can receive healthcare. The sexual health clinic tour is sometimes the first time that participants have been to a health centre of this type, including in their own neighbourhood. One alumna of LEAP from 2014 said, "[I learned] there is a clinic around my area" (2014 Alumna Annual Evaluation narrative). Visiting a local youth-friendly sexual health centre introduces participants to resources and care. Learning about HIV through open and honest personal stories shared by HIV-positive health educators personalizes lessons about prevention while destigmatizing those living with the virus.

General Psychosocial

General psychosocial questions measure female social support and self-confidence among participants. Integral skills-based learning components of the program, such as the youth-led Community Action Project—in which participants are tasked with designing and implementing an educational activity for their peers on a topic they learned during the program—helps hone public speaking skills. The significant findings of this measure suggest that by the program's end, participants reported feeling more confident and receiving more support from other women in their lives:

I improved my presentation skills, [clarified] my values and... learned how to protect myself. (LEAP Participant, 2007, Harlem Site 1)

You grow throughout the sessions and ... build a bond with other [participants]. (LEAP Participant, 2008, Brooklyn Site 1)

[E]veryone got along so well ... so many bonds ... built [while] learning sexual safety and hazards. (LEAP Participant, Spring 2016, Bronx Site)

As illustrated in the quote above, the participants support the findings. In the process and program evaluation data, participants consistently report feeling supported by the program facilitators, facilitators-in-training, and fellow participants. Furthermore, these feelings of connectedness and sisterhood continue after graduation:

Since graduating from LEAP 3 years ago, I still come to many workshops with them. It's like a family. (LEAP Participant, Fall 2010, Bronx site 1)

[LEAP] helped me ... show my friends how to protect theirselves and...give them advice" (LEAP Alumna from 2014 narrative data)

These statements demonstrate how LEAP creates a sense of sisterhood that continues after the program is over. Not only do young women receive comprehensive sexual health education, but they leave the program with new friends and mentors with whom they stay in touch in coming years:

I ... recommend ... LEAbecause ... you learn about yourself and you...definitely make friends. (LEAP Participant, Fall 2011, Brooklyn site 1)

I ... learn[ed]... things I didn't know for... safe relationship[s] [and] got to meet...[new] friends. (LEAP Participant, Spring 2016, Bronx Site)

Sex Communication

Sex communication includes the measures of communication style knowledge, sex communication with family, sex communication with peers, sex communication with partner, and safe sex negotiation. These measures gauge how often participants are talking about pregnancy, HIV/AIDS, STIs, and safer sex negotiation with family, peers, and romantic partners.

Below, participants and facilitators-in-training share that LEAP taught them the importance of communication and how to synthesize classroom knowledge and then relay it to friends and family:

I ... learned ... to believe in myself and [my] decisions ... love myself ... to put my needs and wants first and to say NO when needed (LEAP Participant, Summer 2011, Bronx site 2).

My most treasured memory was teaching young girls the concepts...then, seeing [them] incorporate those concepts outside. (Facilitator -in -Training, Summer 2011, Bronx site 2).

Communities of colour and low-resourced communities experience sexual health disparities at a higher rate than their white and more affluent peers. It is important to note that vulnerable communities use social capital to protect against systems-level frameworks of oppression that reinforce health disparities. LEAP participants are cultivating social capital by learning how to talk about sex with trusted friends and family members:

My friends now talk about sex ... instead of ... avoiding [it]. (2014 alumni narrative)

I never ... used to talk to my mom about ... sex ... or ... protect[ing] myself ... but now we talk freely ... [LEAP] ... helped me talk to my friends [about] ... talking openly ... with their partners. (2014 alumni narrative).

LEAP is creating an environment in which a small group of women are learning, discussing, and practicing together how to communicate effectively to encourage healthy relationships. We believe the small and trusting spaces where LEAP is taught are not only providing necessary and comprehensive sexual health education but also helping provide

participants with the confidence to then talk about this newly learned information with friends, family, and romantic partner(s), which in turn strengthens these existing relationships:

> My most treasured memory was opening up to the girls. I am not much of a people person.... LEAP for Girls have changed that ... now I ... open up with more people. (LEAP Participant, Fall 2012, Bronx site 1)

> I learned that communication is important ... you find out a lot about yourself and you could make friends. (LEAP Participant, Fall 2011, Brooklyn site 1)

Recommendations

Lessons learned from implementing and evaluating LEAP over the course of a decade are summarized as follows:

1. *Cultural congruence matters.* Make a genuine effort to train and hire sex educators whose intersectional identities reflect those of the intended audience. When facilitators and learners share experiences, their mutual sociocultural understanding may help contextualize skills-based learning and make lessons and examples more relevant.

2. *Build and protect safe space.* Talking about sex at any age can make people feel vulnerable. By ensuring that sex education workshops happen in a safe space with trained sex educators, learners can feel safe to ask questions or explore themes without judgment. Facilitators should work to build a rapport of open communication and trust with participants, setting and maintaining the tone by referring to community-led group agreements regularly. Outside observers—including funders, other staff, and agency leadership—should not be permitted to observe workshops. Public-facing events, such as graduation or community action project implementation, are more appropriate for observation.

3. *Value youth contributions to learning and leadership.* Openly acknowledge and value the expertise that young people bring to the learning environment. Incorporate youth as thought partners,

particularly when decisions are being made that impact them and their programs. Train youth to strengthen their voices in support of local and community causes of their choosing. Research the youth-adult partnership model and find ways that your youth-serving organization could meaningfully centre youth voices and expertise. Incentivize youth attendance beyond token items—pay cash! Cash incentives acknowledge that young people choose to attend your program (compared to another activity) and provide spending money to young people growing up in a challenging economic environment that makes it difficult for teens to find other paid part-time work.

4. *Connect learning to reality.* Experience-based learning is valuable in sex education and leadership development. By incorporating components that help young people to ground abstract concepts, we strengthen skills development. Inviting an HIV+ speaker to talk about their real experience getting tested, being diagnosed, and living with the virus allows youth to ask questions in real time. Touring a local, youth-friendly sexual health centre introduces young people to the physical site and shows them what a visit could entail. Demonstrating connections in workshops and on field trips helps young people navigate healthy choices in real life.

Conclusion

By fostering sisterhood, trust, and connection between youth participants and intergenerationally between program participants and trained sexuality health education facilitators, comprehensive sexuality education programs have the potential to positively impact participants and their communities beyond knowledge of preventing HIV, STIs, and unintended pregnancy. Comprehensive, inclusive sex education programs have the potential to nurture psychosocial and emotional development of their intended audience. In doing so, the potential impact to strengthen and expand the skills development of program participants extends from the individual to community and societal level. Using comprehensive sex education as a platform for personal values exploration and skills development in a safe space, LEAP participants report increases in self-esteem, feelings of self-efficacy

related to personal decision making and health, as well as interpersonal and relationship skills.

Due to the inherent intimacy of topics covered in comprehensive sex education workshops, trust is a requisite program component in any quality sexuality education program. In creating safe and inclusive space for program participants, LEAP provides a platform upon which Black women and girls develop connections to support one another in numerous ways—in friendship, in school, and in community—to effectively build a community within a community that is cemented in sisterhood. Conversations exploring personal values and shared stories that help girls recognize that they have support of peers and mentors as they navigate the confusing path to adulthood allows youth to explore adolescence securely. The supportive and nurturing safe space LEAP cultivates provides participants with a sense of feeling welcome and secure as they explore their gender identity or sexual orientation, and it offers an opportunity to grapple with the ways that their personal value system may differ from that of their parents. For others, it meant disclosing the dynamics of a romantic relationship and exploring the ways they aligned with personal goals and ideals—and then feeling clarity about and being empowered to find ways to change those dynamics if need be. In hiring and training professional sexuality health educators who may share personal qualities with their participants (i.e., race, sexual orientation, gender identity, ethnicity, language of origin, or area of residence), facilitators and participants are well positioned to find common ground and build a rapport based on those similarities.

Over the course of a decade of program implementation, evaluation, and revision, LEAP staff and facilitators have repeatedly sought ways to document the connectedness that they observed taking place between individual program participants and between participants and facilitators. These mixed-method analyses seek to demonstrate the benefits of a comprehensive sexual health curriculum that is intentionally created from its inception to be culturally congruent and competent, providing relevant learning tools to program participants. The LEAP evaluation has illustrated that sisterhood is an integral component of the way participants learn about sexual health, and the friendships, knowledge retention, skills development, and self-confidence that stem from program participation continue to nurture participants' personal growth even after graduating from the program.

Works Cited

Augustine, J. *Young Women of Color and the HIV Epidemic.* Advocates for Youth, 2003, www.advocatesforyouth.org/wp-content/uploads/storage//advfy/documents/fsyngwom.pdf. Accessed 9 Jan. 2022.

Basen-Engquist, K., and G. S. Parcel. "Attitudes, Norms, and Self-Efficacy: A Model of Adolescents' HIV-Related Sexual Risk Behavior." *Health Education Quarterly*, vol. 19, no. 2, 1992, pp. 263-77.

Centers for Disease Control and Prevention. "HIV Prevalence Estimates—United States, 2006." *MMWR. Morbidity and Mortality Weekly Report*, vol. 57, no. 39, 2008, p. 1073.

DiClemente, R. J, et al. "Efficacy of an HIV Prevention Intervention for African American Adolescent Girls A Randomized Controlled Trial." *JAMA: Journal of the American Medical Association*, vol. 292, no. 2, 2004, pp. 171-79.

Flowers, S. C. "Perceptions of Fidelity and Adaptation in Evidence-Informed Interventions by Women of Color Sexuality Health Educators." *CUNY Academic Works*, 2016, academicworks.cuny.edu/gc_etds/1586. Accessed 9 Jan. 2022.

Flowers, S. C. "Enacting Our Multidimensional Power: Black Women Sex Educators Demonstrate the Value of an Intersectional Sexuality Education Framework". *Meridians*, vol. 16, no. 2, 2018, pp. 308-25.

Giscombe C. L., and M. Lobel. "Explaining Disproportionately High Rates of Adverse Birth Outcomes among African Americans: The Impact of Stress, Racism and Related Factors in Pregnancy." *Psychol Bull*, vol. 131, 2005, pp. 662-83.

Harden, K. P. "A Sex-Positive Framework for Research on Adolescent Sexuality." *Perspectives on Psychological Science*, vol. 9, no. 5, 2014, pp. 455-69.

HIV Epidemiology Program. *HIV Surveillance Annual Report, 2018.* New York City Department of Health and Mental Hygiene, 2019.

Love Heals, Inc. *LEAP for Girls 2014 Evaluation Methods and Measures.* Internal Evaluation Report. Unpublished, 2014.

Love Heals Center for Youth & Families. "LEAP for Girls." *Acria*, 2018, www.acria.org/leap-for-girls/. Accessed 9 Jan. 2022.

Nahmias, S. B., and D. Nahmias. "Society, Sex, and STIs: Human Behavior and the Evolution of Sexually Transmitted Diseases and Their Agents." *Annals of the New York Academy of Sciences*, vol. 1230, 2011, pp. 59-73.

National Minority AIDS Council. *Expanding Access to Biomedical HIV Prevention: Tailoring Approaches for Effectively Serving Communities of Color.* National Minority AIDS Council, 2018.

Prather, C., Fuller, T. R., Jeffries, W. L., 4th, Marshall, K. J., Howell, A. V., Belyue-Umole, A., & King, W. (2018). Racism, African American Women, and Their Sexual and Reproductive Health: A Review of Historical and Contemporary Evidence and Implications for Health Equity.*Health equity,2*(1), 249–259. https://doi.org/10.1089/heq.2017.0045

Upadhya, K. K., and J. M. Ellen. "Social Disadvantage as a Risk for First Pregnancy among Adolescent Females in the United States." *The Journal of Adolescent Health: Official Publication of the Society for Adolescent Medicine*, vol. 49, no. 5, 2011, pp. 538-41.

Chapter 6

For the Culture: The Utilization of an African-Centred Paradigm as a Pipeline to Ensuring Success for Black Women Scholars in Academia

Yarneccia D. Dyson

Black Women in Academia

There are individual as well as collective gains from the existence of Black sisterhood relationships across the African diaspora, and these relationships are inherently important when navigating the sometimes treacherous and tedious waters of academia. According to the National Center for Educational Statistics, Black women account for 2 per cent of fulltime faculty members in the United States. As a whole, women faculty of colour are underrepresented and largely understudied in the academy, and the experiences of these scholars on the spectrum from doctoral student to faculty member are important (Grant et al.; Turner et al.). Furthermore, navigating the academy is not an easy task and the existence of a village/community has proven to be vital for the success of Black women scholars (Johnson-Bailey et al.; McLane-Davison et al.) The purpose of this chapter is to discuss the utilization of an African-

centred paradigm, "lift as you climb," in describing the benefits of an established accountability circle in the form of a village/community for Black women scholars in the academy. This chapter highlights epistemological lenses for understanding the lived experiences of Black women, such as Black feminist thought, and the importance of balancing intersectionality while also identifying key methods, such as mentoring and the importance of collectivism and sisterhood as vital components for ensuring success in the academy. Finally, this chapter will conclude with recommendations to consider for supporting Black women scholars from doctoral programs to the tenure track.

In addition to achieving professional goals by accelerating in the academy, Black women are also agents of social change occupying unique positions within the ivory tower (Gregory; Moses; Wallace et al.). While maintaining their roles as a scholar, Black women also have to engage in work focused on deconstructing historical barriers (Grant et al.; Schwartz et al.). These unique positions often present as a crossroads that force Black women to navigate the intersection of race and gender while also addressing the injustices that can occur within their academic departments and campus communities as a whole, which requires an extreme level of resilience and focus (Rasheem et al.).

Furthermore, Denise Davis-Maye, Annice Dale Yarber, and Tonya E. Perry describe underlying values and behavioural codes that Black Women often conceptualize for womanhood as they move through society, which include how they view themselves, possess a sense of security and feeling protected, honour their voices and lived experiences, and maintain supportive connections. These values and behavioural codes can also be seen in the academic setting when Black women scholars navigate within the marginality of their place in the space. Patricia Hill Collins describes the act of navigating within the marginal roles and positions in the academy as the "outsider within" status, which produces Black feminist thought as a praxis to viewing oneself in regards to family and the larger society.

Black Feminist Thought as an Epistemological Lens

Additionally, Black feminist thought embodies three characteristics: Black women's self-definition and self-valuation; the interlocking nature of oppression; and the importance of African American

women's culture, which refers to how the intersections of their identities (race, class, and gender) shape their consciousness and subsequent responses to oppression through activism. Furthermore, this praxis specifically exposes Black women scholars directly to the triple jeopardy of race, class, and gender and provides them with a standpoint of how to explain this nexus to other Black women scholars in the academic setting, which ultimately serves as a protective factor for success. The use of Black feminist thought as an epistemological lens allows Black women scholars to place themselves central to their environments and honours their voices and lived experiences. Within the academy, Black feminist thought provides Black women scholars with tools and strategies to deal with injustices they may encounter on campus. Collins emphasizes that Black women scholars share the commonalities of lived experiences from the intersectionality of race, class, and gender as well as the marginalization that can occur in the academic setting, which can range from covert to overt microaggressions and oppression.

Thus, it is important for Black women scholars to empower and support one another, especially within the academy because of their shared understanding. In addition to research studies and work that involves Black women, Black feminist thought has been widely used as a theoretical framework to understand the unique experiences of Black women scholars in the academy because of its centralizing structure and conceptualization (Dyson et al.; Grant et al.). This epistemological lens is important to understand when centring Black women for the purposes of ensuring their success in the academy because it acknowledges aspects of their identity, such as race and gender, and how these social factors impact how they navigate academic structural systems.

African-Centred Paradigm: Lift as You Climb

In 1896, the National Association of Colored Women (NACW) was founded by Mary McCleod Bethune, Ida B. Wells, Mary Church Terrell, and Frances Harper with the goal of advocating for women's rights as well as uplifting and improving the status of African Americans as a whole (Hegel and Schmiegelow). In the spirit of collectivism and community, the founders of this organization adopted "life

as you climb" as their motto, which emphasizes the obligation of women to ensure one another's success. This act of sisterhood and support perfectly aligns with African-centred paradigms, such as African-centred perspectives and Afrocentric theory (Bent-Goodley et al.), which emphasize community and ask Black women to uphold their responsibilities to one another to ensure their personal and professional success as well as their overall wellbeing and security. Regarding academia, this act of sisterhood reiterates the inherent need for sistering relationships among Black women scholars, which are reciprocal and ultimately work to ensure everyone's individual as well as collective victories.

Furthermore, Black women scholars share unique experiences that require a level of trust with one another to overcome instances of racial injustice and unfairness they may face in the academy, particularly where they are the minority, such as predominantly white institutions (PWIs). Following the NACW, it is imperative that Black women scholars embody the motto "lift as you climb" to ensure the success of their fellow sisters in the academy; the motto should be understood as a silent oath that must be passed down from senior level scholars to first-year doctoral students.

Collectivism and Sisterhood

In addition, the existence of a well-defined network and community has been found to have positive outcomes for Black women in any setting but especially for Black women scholars in academia. Black women have also relied on accountability circles or sister circles in order to balance the various isms they face in the academy. As an example, Denise McLane et al. have shared the benefits of an accountability sistah circle (ASC) model that connected virtually and allowed the members to share their experiences and receive support on how to navigate the academy successfully while also providing a space to be open, vulnerable, and receive feedback for errors while developing solutions to be implemented in their research and scholarship. Accountability circles among Black women scholars in the academy provide a sense of collectivism and sisterhood that validates lived experiences in addition to providing a checks and balances approach to ensuring that professional goals are met and exceeded. This example of

collectivism and sisterhood is powerful and embodies the communal aspect of sistering relationships and collectivity, which have been proven to also increase Black women scholars' ability to manage and address the nuances of racial- and gender-specific ills that confront them in the academy. Support often comes outside of their home departments and universities, including online forums and accountability circles as well as established organizations that describe supporting Black women in their mission statement. One thing found to be existing in the sistering relationships found in the academy is the notion of "life as you climb," which emphasizes this grounding of the community/village and communicates a commitment to ensuring one another's successes.

Recommendations

From a historical perspective, Black women in the academy have had to overcome stereotypes that portray them as inept and incompetent in comparison to their Black male counterparts (Black men) as well as to their white men and women colleagues who enjoy more privilege than both (Bertrand Jones, Wilder, and Osborne-Lampkin). In order to ensure the success of Black women scholars in the academy, there are some strategies that must be employed. Dannielle Joy Davis found that the academic success of minorities in academia was positively linked to faculty mentoring. Oftentimes, Black women scholars have to seek professional support and guidance outside of their home institutions in order to be successful because of the injustices they face (Grant, et al.). To this point, the use of the symbolic "lift as you climb" mantra is integral in ensuring the success of Black women scholars in academia. Black women know and understand the exhaustion that comes from dealing with patriarchy and hegemony in the academy. Moreover, Black women also share unique lived experiences that simply cannot be easily understood by outsiders, especially when they are the minority in their departments. From an epistemological aspect, acknowledging the impact of intersecting identities, such as race and gender for Black women scholars, is inherent if the goal is to support their forward progress in the academic environment. The success of these scholars is tied to the organic evolvement of supportive mentoring relationships, the existence of shared identity/mutual interest, the

presence of space that makes room for personal transformation, and an increase in access and opportunity for leadership positions.

From a structural aspect, it is important that academic institutions provide faculty development and intentional mentoring and support for Black women scholars on campus (Bertrand Jones, Wilder, and Osborne-Lampkin). This would ultimately signify a commitment to Black women scholars' success in academia by validating their presence as faculty members and displaying interest in their research agendas, scholarship, and community engagement activities.

Moreover, Black women scholars often experience challenges obtaining mentoring and support in the academy because these networks tend to be exclusive and hard to reach, which results in fewer Black women scholars having a formalized mentoring relationship with someone who can assist with guiding them to their professional goals and providing feedback for growth (Crawford and Smith; Thomas and Hollenshead; Yoshinaga-Hano). This also emphasizes the higher likelihood that mentoring relationships may occur with people of a different race/ethnicity and/or gender due to the lack of presence of Black women scholars in academia (Shollen, et al.). To this point, Christine Stanley found that "cross-race faculty mentoring is also helpful for enhancing faculty relationships and administrative skills." There is a gap in the literature surrounding the nontraditional approach of cross-race and gender mentoring, although it has been found to be an effective strategy that has aided Black women scholars in not only finishing their doctoral programs but also advancing at PWIs (Davidson et al.; Grant; Grant et al.).

A study by Monika Shealey et al. found that absence of mentoring as well as a lack of teaching and research support contributed to the challenges Black women scholars faced in being successful in the academy. In addition to traditional one-direction approaches to mentoring that involve a mentor-mentee relationship, establishing and maintaining a network of mentors have been found to be integral to the success of Black women scholars because these networks support a collaborative, nonhierarchical, and nurturing relationship for all participants (Sorcinelli and Yun). Furthermore, the opportunity to be exposed to different types of mentors through these networks can maximize opportunities as well as feedback. Finally, for Black women scholars, mentoring plays a vital role in securing their success within

the academy; mentoring also helps Black women scholars learn the ways of the professoriate to enhance their self-efficacy and resilience as well as to ensure there is a steady pipeline of future scholars entering and surviving the ivory tower (Bandura; Dixon-Reeves; Sorcinelli and Yun; Sule; Tillman). We must life as we climb!

Works Cited

Bandura, A. "Self-Efficacy Mechanism in Human Agency." *American Psychologist*, vol. 37, 1982, pp. 122-47.

Bent-Goodley, T., C. N. Fairfax, and I. Carlton-LaNey. "The Significance of African-Centered Social Work for Social Work Practice." *Journal of Human Behavior in the Social Environment*, vol. 27, no. 1-2, 2017, pp. 1-6.

Bertrand Jones, T., J. A. Wilder, and L. Osborne-Lampkin. "Employing a Black Feminist Approach to Doctoral Advising: Preparing Black Women for the Professoriate." *Journal of Negro Education*, vol. 82, no. 3, 2013, pp. 326-38.

Collins, P. H. "Learning from the Outsider Within: The Sociological Significance of Black Feminist Thought." *Social Problems*, vol. 33, no. 6, 1986, pp. S14-S32.

Collins, P. H. *Black Feminist Thought: Knowledge, Consciousness, and the Politics of Empowerment*. Unwin Hyman, 1990.

Crawford-Smith, K., and D. Smith. "The We and the Us: Mentoring African-American Women." *Human Resources Development Review*, vol. 5, 2005, pp. 148-75.

Davidson, M. N., and L. Foster-Johnson. "Mentoring in the Preparation of Graduate Researchers of Color." *Review of Educational Research*, vol. 71, 2001, pp. 549-74.

Davis, D. J. "The Academic Influence of Mentoring Upon Undergraduate Aspirants to the Professoriate." *The Urban Review*, vol. 42, no. 2, 2010, pp. 143-58.

Davis-Maye, D., A. D. Yarber, and T. E. Perry. *What the Village Gave Me: Conceptualizations of Womanhood*. University Press of America, 2014.

Dixon-Reeves, R. "Mentoring as a Precursor to Incorporation: An Assessment of the Mentoring Experience of Recently Minted

PhDs." *Journal of Black Studies*, vol. 34, no. 1, 2003, pp. 12-27.

Dyson, Y. D., et al. "Gender, Race, Class, and Health: Interrogating the Intersection of Substance Abuse and HIV Through a Cultural Lens." *Affilia*, vol. 32, no. 4, 2017, pp. 531-42.

Few, A. "Integrating Black Consciousness and Critical Race Feminism into Family Studies Research." *Journal of Family Issues*, vol. 28, no. 4, 2007, pp. 452-73.

Giddings, P. *When and Where I Enter: The Impact of Black Women on Race and Sex in America*. New Bantam, 1984.

Gilkes, T. *If It Wasn't For The Women*. Orbis Books, 2001.

Grant, C., and J. Simmons. "Narratives on Experiences of African American Women in the Academy: Conceptualizing Effective Mentoring Relationships of Doctoral Student and Faculty." *International Journal of Qualitative Studies in Education*, vol. 21, 2008, pp. 501-17.

Grant, C. "Advancing our Legacy: A Black Feminist Perspective on the Significance of Mentoring for African American Women in Educational Leadership." *International Journal of Qualitative Studies in Education*, vol. 25, 2012, pp. 99-115.

Grant, C. M., and S. Ghee. "Mentoring 101: Advancing African-American Women Faculty and Doctoral Student Success in Predominantly White Institutions." *International Journal of Qualitative Studies in Education*, vol. 28, no. 7, 2015, pp. 759-85.

Gregory, S. T. *Black Women in the Academy: The Secrets to Success and Achievement*. University Press of America, 1995.

Hegel, T., and F. Schmiegelow. "NACW at Thirty: A Work in Progress."*Rangifer Report*, vol. 35 no. 23, 2015, pp. 6-7.

Johnson-Bailey, J., et al. "Mentoring While Black & Female: The Gendered Literacy Phenomenon of Black Women Mentors." *Adult Education Research Conference*, 2015, newprairiepress.org/aerc/2015/papers/29. Accessed 9 Jan. 2022.

McLane-Davison, D., et al. "The Power of Sum: An Accountability Sistah Circle." *Journal of Social Work Education*, vol. 54, no. 1, 2017, pp. 18-32.

McLane-Davison, D. "Cornbread, Collard Greens, and a Side of Liberation: Black Feminist Leadership and AIDS Advocacy." *Meridians*,

vol. 16, no. 2, 2018, pp. 286-94.

Moses, Y. T. "Black Women in Academe: Issues and Strategies" *Black Women in the Academy: Promises and Perils*, edited by L. Benjamin, University of Florida Press, 1997, pp. 23-37.

National Center for Education Statistics. *Digest of Education Statistics*. Institute of Education Services, 2015.

Rasheem, S., et al. "Mentor-Shape: Exploring Mentoring Relationships of Black Women in Doctoral Programs." *Mentoring and Tutoring: Partnerships in Learning*, vol. 26, no. 1, 2018, pp. 50-69.

Schwartz, R. A., et al. "'Ain't I a Woman, Too?': Tracing the experiences of African American Women in Graduate School." *Journal of Negro Education*, vol. 72, 2003, pp. 252-68.

Shealey, M., et al. "'Sista Doctas' Taking a Seat at the Table: Advocacy and Agency among Women of Color in Teacher Education." *NASPA Journal About Women in Higher Education*, vol. 7, 2014, pp. 19-46.

Shollen, L. S., et al. "Establishing Effective Mentoring Relationships for Faculty, especially across Gender and Ethnicity." *American Academic*, vol. 4, 2008, pp. 131-58.

Sorcinelli, M. D., and J. Yun. "From Mentor to Mentoring Networks: Mentoring in the New Academy." *Change*, vol. 39, no. 6, 2007, pp. 58-61.

Stanley, C. A. "Coloring the Academic Landscape: Faculty of Color Breaking the Silence in Predominantly White Colleges and Universities." *American Educational Research Journal*, vol. 43, no. 4, 2006, pp. 701-36.

Sule, T. V. "Black Female Faculty: Role Definition, Critical Enactments, and Contributions to Predominantly White Research Institutions." *NASPA Journal About Women in Higher Education*, vol. 2, no. 1, 2009, pp. 91-119.

Thomas, G., and C. Hollenshead. "Resisting from the Margins: The Coping Strategies of Black Women and Other Women of Color Faculty Members at a Research University." *Journal of Negro Education*, vol. 70, no. 3, 2001, pp. 166-175.

Tillman, L. C. "Mentoring African-American Female Faculty in Predominantly White Institutions." *Research in Higher Education*, vol. 42, no. 3, 2001, pp. 295-25.

Turner, C. S. V., J. C. González, and J. L. Wood. "Faculty of Color in Academe: What 20 Years of Literature Tells Us." *Journal of Diversity in Higher Education*, vol. 1, 2008, pp. 39-168.

Wallace, S. C., S. E. Moore, and C. M. Curtis. "Black Women as Scholars and Social Agents: Standing in the Gap." *Negro Educational Review*, vol. 65, no. 1-4, 2014, pp. 44-63.

Yoshinaga-Hano, C. "Institutional Barriers and Myths to Recruitment and Retention of Faculty of Color." *Faculty of Color: Teaching in Predominantly White Colleges and Universities*, edited by C. A. Stanley, Anker Publishing Company, 2004, pp. 344-60.

Chapter 7

Black Girls Don't: Correcting the Record of What Black Girls Can and Cannot Do

Krystal O. Lee and Daphne R. Wells

> Black girls don't swim. They can't get their hair wet.
> Black girls don't exercise. Black girls don't have time for arts
> and crafts. Black girls don't travel. Black girls are crazy.
> Black girls don't get along with each other. Black girls don't cry.
>
> —Stereotypes of Black women and girls

Negative stereotypes of Black women are not a new phenomenon. In fact, stereotypes of Black womanhood have had consistent and worsening impacts on Black women since slavery. The stereotype of the strong Black woman (SBW)—one who is self-sufficient, resilient, and committed to caring for others while neglecting herself—has been internalized by many as a means of overcoming oppression for generations. This ability to show strength has enabled the kind of goal-focused behaviour that has been considered necessary for Black women (Linnaberry, Stuhlmacher, and Towler; Watson-Singleton). In reality, the SBW stereotype is a manifestation of racism and sexism (Shorter-Gooden) and has a devastating impact on the Black community in general and Black women specifically.

This chapter will briefly describe the SBW stereotype as well as

identify its origins and impact on Black women. Furthermore, as online communities based on social support have been associated with higher levels of wellbeing (Grieve et al.), we will examine how Black women obtain encouragement, emotional support, inspiration, and motivation through their membership in identity-based digital communities.

"I'm Rooting for Everybody Black"—Issa Rae

The experiences of Black girls and women in the United States are shaped by the intersections of race, gender, and socioeconomic status (Settles). This is why Issa Rae's words at the 2017 Emmy Awards—"I'm rooting for everybody Black.... I'm betting on Black tonight"—hit home for so many Black people. It became something of a calling card for Black people. Issa Rae's sentiment points to the essence of Black sisterhood: the idea that Black women can be part of a community where they are seen, celebrated, supported, and free to be themselves. This type of social support is critical in the healing and empowerment of Black women, who have historically been overlooked and unsupported not only in Hollywood but across the country (Bryant-Davis). Issa's words spoke to Black nominees as well as those Black people who have been ignored or felt invisible. She said, "I see you. I hear you. I support you."

This sentiment goes against many of the contemporary perceptions of Black women, which are often fed by television portrayals of undesirable stereotypes, such as the SBW, Jezebel, and Sapphire. They are also perpetuated by stereotypes of friendships between Black women featuring one upmanship, jealousy, pettiness, and deceit while completely ignoring the fact that Black women are capable of building and maintaining wholesome, vibrant, and supportive relationships with one another (Sanders).

The Strong Black Woman Schema

Black girl magic is a rallying call of recognition. Embedded in this every day is a magnificence that is so easy to miss because we're so mired in the struggle and what society says we are.

—Ava Duvernay

Mammy, Jezebel, and Sapphire are all common stereotypes of Black women. Mammy, the inept domestic servant, stands in stark contrast to Jezebel, the sex object, and Sapphire, the angry Black woman (Mgadmi). The Jezebel and Sapphire caricatures have been characterized in derogatory and dehumanizing ways (Morton), being described as primitive, lustful, seductive, domineering, unwomanly, and dirty (Mgadmi). Mammy, however, escaped this characterization. She was stereotypically depicted as dark skinned, strong bodied, thick lipped, obese, and ugly but regarded as a skilled cook, devoted housekeeper, and the perfect mother, capable of taking care of white children, looking after her own children, and sustaining her family. She was Mother Earth and superwoman all rolled into one— stronger than her man and less feminine than other women. Her devotion and loyalty to her masters bestowed upon her an elevated status, which kept her out of the fields (Mgadmi).

Despite her exaltation, the Mammy stereotype is arguably the most dangerous. This persona—also referred to as the SBW schema (Beauboeuf-Lafontant; Black and Peacock; Harrington, et al.; Woods-Giscombe) and embodied by historical figures, such as Sojourner Truth and Harriet Tubman—is superhuman. She is strong and resilient in the face of adversity, serves multiple roles, and takes care of others before herself (Watson and Hunter). During slavery, when their husbands and children were sold away from them (Mgadmi), Black women were left to come to terms with their feelings and to display the very strength that was used to justify their enslavement (Watson-Singleton).This strength was, and still is, exhibited by demonstrating perseverance in the midst of obstacles, smiling in the face of difficulties, and deftly maintaining a sense of self-sufficiency even with limited resources (Beauboeuf-Lafontant)—characteristics seen as central to contemporary perceptions of Black womanhood (Watson and Hunter).

The politics of respectability—a concept traced back to writers and activists including W. E. B. DuBois and Booker T. Washington— emerged as a means to counter the negative stereotypes of Blacks as lazy, stupid, and immoral. Black leaders and intellectuals hoped these new rules would challenge the racial injustice and inequality while presenting positive images of themselves, thus imbuing Black people with dignity and self-respect (Mgadmi). The unintended consequence of attempting to reform individual behaviour was an acceptance, and

internalization of, these limited representations. This resulted in the development of contemporary conceptualizations of strength that often obscure the hardships and stresses endured by Black women while still being widely embraced as a badge of honour in Black culture (Collins; Watson and Hunter).

Emerging empirical research indicates that the SBW schema has also had detrimental effects on Black women's health and wellbeing. It is associated with increased distress and rumination (Giscombe and Lobel) compulsive eating, shopping and drinking, and reports of sadness, depression, anxiety, and feelings of hopelessness (Harrington et al.; Schiller et al.). Research has shown that suppressing their emotions and using these coping mechanisms may be partially responsible for the disproportionate rates of cardiovascular disease and obesity in Black women (Thom et al.; Woods-Giscombe).

The SBW schema reinforces the belief that Black women are happy to play multiple roles and make personal sacrifices for their family and community, when in reality, they typically do so out of necessity and often at the expense of their own mental and physical health (West). Although it is not always possible, desirable, or healthy for Black women to abandon these roles, or delegate some of the responsibilities, it can be equally unhealthy for them to consistently love, nurture, protect, and save others while neglecting themselves (West). Black women must give themselves permission to move from superhuman to merely human, which will allow them to express the doubts, fears, depression and frustration that accompany the hardships they face (Morgan). As such, it is critical that Black women, as individuals, learn to set boundaries, nurture themselves, refuse unreasonable requests, and seek and accept social support (West).

Digital Communities and Homeplace

Digital communities allow Black women to form sisterhoods in which they can lean on others and sustain their emotional wellbeing in stressful circumstances (Zuckerman and Gagne). In this way, they provide a space for members to root for everybody Black. This is one way in which Eileen Linnaberry, Alice Stuhlmacher, and Annette Towler say that Black women can deal with the stress and anxiety that have become synonymous with living the SBW stereotype. Social

media platforms, such as Facebook, have been instrumental in providing these supportive spaces. In fact, informal online peer groups or sister circles have been used in the areas of healthcare and social work to provide support for people suffering from similar health issues and people with shared professional experiences (Neal-Barrett et al.).

These online spaces allow for the creation of fictive kinship networks for their members: "People who are designated as fictive (pseudo- and para-) kin are unrelated by either blood or marriage, but regard one another in kinship terms" (Chatters, Taylor, and Jayakody 297). These online communities create a digital homeplace that allows Black women to find shelter, voice concerns, and be vulnerable in a safe space (Hassan). A homeplace, according to bell hooks is a "space where we return for renewal and self-discovery, where we can heal our wounds and become whole" (hooks 49). These online groups can allow Black women the space to engage with other Black women who share their interests and can receive emotional support, a sense of connectedness, and advice in a safe and trustworthy environment (Gandy-Guedes et al.).

Digital homeplaces are especially beneficial because such computer-mediated communication transcends time and space—meaning that physical proximity is not a prerequisite for membership in the group. An additional benefit is that they provide easy access to a more diverse range of views and opinions than members might find in their local friend groups (Wright and Bell). Olodade Hassan refers to these digital homeplaces as "Mbongi-a spaces," in which knowledge is created, validated, and critiqued. "Mbongi" is a term used by the Bantu-Kongo communities of West Africa to refer to a "room without walls" or a learning circle. These spaces also meet Quinten Jones's criteria for defining a community that includes a publicly accessible space in which members can interact over time. In other words, a digital community exists if its members experience a shared sense of belonging and recognize the space as a common milieu (Caliandro and Gandini).

Black Girls Do...

> We must reject not only the stereotypes that others have of us
> but also those that we have of ourselves.
>
> —Shirley Chisholm

Although there are some stereotypes that can be interpreted as positive—such as Black people being athletic, rhythmic, musical, or socially savvy (cool)—other stereotypes limit the experiences of Black folks in general and Black women in particular. For example, Black people are sometimes considered inferior to whites in that they are unintelligent, lazy, and criminals (Czopp and Monteith). Other stereotypes, such as Black people do not swim, actually arise from consistent racial discrimination and efforts to prevent Blacks from using the same pools as white people (Ito). The result is the perception that Black people, and Black women, specifically, do not swim, which is a baseless stereotype that goes against historical facts (Wigo).

Organizations—such as Black Girls Run!, Black Girls Craft, and the Nomadness Travel Tribe—are working to dispel myths around what it means to be a Black woman. The real world and virtual spaces created by these organizations allow Black women to seek and accept social support and nurture their own skills and talents in an encouraging and reassuring environment.

...Run

Distance running in the United States, according to the National Runner Survey, is a predominantly white sport (Jennings). According to the CDC, Black women are less likely to participate in physical activity than other demographic groups. However, this does not take into account the wide array of racist and sexist barriers that Black women have to overcome. There are many intrapersonal, interpersonal, and environmental factors that prevent Black women from exercising, such as limited time and motivation, lack of knowledge, concerns about their physical appearance, the cost of facilities, family roles, and lack of social support (Harris and Roushanzamir). "Black Girls Run!, a national advocacy and networking organization for Black women

runners, that aims to address this lack of knowledge, motivation, and support. Through their blog, and the accompanying digital communities, the organization works to address the negative health outcomes experienced by Black women by encouraging them to prioritize fitness and healthy living (Harris and Roushanzamir).

...Craft

In 2014, Mary DeBoise-Morgan created the Black Girls Craft LLC and its accompanying Facebook group to be a place for "women to come together to share our creations, inspire one another, encourage creativity and CREATE." There are posted guidelines for participation and membership, which are enforced. Members are encouraged to introduce themselves and discuss their past, current, and future projects, share craft templates, access advice on how to use new crafting tools, and share files they use to make their individual products. The group's administrators post monthly craft challenges, and members can share everything from the creation they are most proud of to information on coupons and sales at local and regional crafting stores. Members also support one another's businesses when buying gifts for holidays and other special occasions; in this way, they also support one another other financially.

...Travel

The Nomadness Travel Tribe (NTT), affectionately called "The Tribe," is another such digital homeplace. Evita Robinson, founder and CEO of NTT says "community is the theme of Nomadness. It's all about bringing people together" (Personal communication). NTT comprises more than 30,000 people all over the world, with 85 per cent of its membership being Black women. The group is open to men and women of every ethnic background, but Robinson surmises that because she, a Black woman, is the founder, Black Women are drawn to the group because it means their "needs and desires" are catered to (Personal communication).

Thema Bryant-Davis explains the role of sisters and sisterhoods as a way to "help to identify safe places, good people, and glimpses of home. They welcome you in even when they are still finding their way around

a new place." In some respects, the NTT serves the same purpose as the Negro Motorist Green Book published in 1936 by Victor Hugo Green. *The Negro Motorist Green Book* was an annual publication that provided Black travellers with information on safe places for lodging, fuel, food, and areas that were generally friendly to Black people during the Jim Crow era (Franz). *The Green Book* was published from 1936 to 1966 and covered travel tips for Black people from all across North America. The publication ceased in 1966 as the civil rights movement eliminated many of the discriminatory practices that made travel difficult for Black travellers (Freedon du Lac).

Black Girls Run, Black Girls Craft, and the Nomadness Travel Tribe all serve as digital homeplaces for Black women. They provide space for women to form a sisterhood as well as tools for members to defy stereotypes and receive emotional and financial support, motivation, and inspiration. Audre Lorde asks what are "our responsibilities to other Black Women and their children across the globe we share, struggling for futures?" One thing we can do is join with others to actively engage with and support Black women. Being a part of such a sisterhood means being in community with women who look like and have similar interests, goals, and aspirations as you. It is a means of survival because it tells people they are not alone.

> Our melanin will always make us marvelous....
> Just imagine what that sea of sisterhood would look like. Magic!
>
> —Alexandra Elle

Works Cited

Beauboeuf-Lafontant, T. "You Have to Show Strength: An Exploration of Gender, Race, and Depression." *Gender & Society*, vol. 21, 2007, pp. 28-51.

Bryant-Davis, T. "Sister Friends: A Reflection and Analysis of the Therapeutic Role of Sisterhood in African American Women's Lives." *Women and Therapy*, vol. 36, no 1-2, 2013, pp. 110-20.

Caliandro, A., and A. Gandini. *Qualitative Research in Digital Environments: A Research Toolkit.* Routledge, 2017.

Chatters, L., R. Taylor, and R. Jayakody. "Fictive Kinship Relations in

Black Extended Families." *Journal of Comparative Family Studies*, vol. 25, no. 3, 1994, pp. 297-312.

Collins, P. H. *Black Feminist Thought: Knowledge, Consciousness, and the Politics of Empowerment*. 2nd ed. Routledge, 2000.

Czopp, A., and M. Monteith. "Thinking Well of African Americans: Measuring Complimentary Stereotypes and Negative Prejudice." *Basic and Applied Social Psychology*, vol. 28, no. 3, 2006, pp. 233-50.

Danielle, M. "Connecting Women of Color Travelers through Social Media." *On She Goes*, 15 May 2017, www.onshegoes.com/stories/social-media-travel-groups/. Accessed 9 Jan. 2022.

Davis, S. M. "The 'Strong Black Woman Collective': A Developing Theoretical Framework for Understanding Collective Communication Practices of Black Women." *Women's Studies in Communication*, vol. 38, 2015, pp. 20-35.

Ellington, T. "Social Networking Sites: A Support System for African American Women Wearing Natural Hair." *International Journal of Fashion Design, Technology and Education*, vol. 8, no. 1, 2014, pp. 21-29.

Franz, K. "African-Americans Take to the Open Road." *Major Problems in American Popular Culture*, edited by K. Franz and S. Smulyan, Cengage Learning, 2011.

Freedon du Lac, J. "Guidebook That Aided Black Travelers during Segregation Reveals Vastly Different D.C." *The Washington Post*, 12 Sept. 2010. www.washingtonpost.com/wp-dyn/content/article/2010/09/11/AR2010091105358.html?noredirect=on. Accessed 9 Jan. 2021.

Gandy-Guedes, M., et al. "Using Facebook as a Tool for Informal Peer Support: A Case." *Social Work Education*, vol. 35, no. 3, 2016, pp. 323-32.

Giscombe, C. L., and M. Lobel. "Explaining Disproportionately High Rates of Adverse Birth Outcomes among African Americans: The Impact of Stress, Racism and Related Factors in Pregnancy." *Psychological Bulletin*, vol. 131, 2005, pp. 662-83.

Grieve, R., et al. "Face-to-Face or Facebook: Can Social Connectedness Be Derived online?" *Computers in Human Behavior*, vol. 29, 2013, pp. 604-09.

Harrington, E. F., J. H. Crowther, and J. C. Shipherd, "Trauma, Binge Eating, and the 'Strong Black Woman.'" *Journal of Consulting and Clinical Psychology*, vol. 4, 2010, pp. 469-79.

Harris, F., and Roushanzamir, E. "#Blackgirlsrun: Promoting Health and Wellness Outcomes Using Social Media." *Fire!!*, vol. 3, no. 1, 2014, pp. 160-89.

Hassan, O. *#Melanin: How Have Dark-Skinned Black Women Engaged In Social Media Hashtags To Affirm, Validate and Celebrate Their Beauty?* Georgia State University, 2018.

Ito, G. "Barriers to Swimming and Water Safety Education for African Americans." *International Journal of Aquatic Research and Education*, 8, 2014, pp. 240-57.

Jennings, J. "Why Is Running So White?" *Runner's World*, vol. 46, no. 12, 2011, pp. 92-125.

Linnabery, E., A. Stuhlmacher, and A. Towler. "From Whence Cometh Their Strength": Social Support, Coping and Well-Being of Black Women Professionals." *Cultural Diversity and Ethnic Minority Psychology*, vol. 20, no. 4, 2014, pp. 541-49.

Lorde, A. "Sisterhood and Survival." *The Black Scholar*, vol. 17, no. 2,1986, pp. 5-7.

Mgadmi, M. "Black Women's Identity: Stereotypes, Respectability and Passionlessness (1890–1930)." *Revue LISA/LISA e-journal*, vol. 7, no. 1, 2009, pp. 40-55.

Morgan, J. *When Chickenheads Come Home to Roost... My Life as a Hip Hop Feminist.* Simon and Schuster, 1999.

Morton, P. *Disfigured Images: The Historical Assault on Afro-American Women.* Praeger, 1991.

Neal-Barnett, A., et al. "In the Company of My Sisters: Sister Circles as an Anxiety Intervention for Professional African American Women." *Journal of Affective Disorders*, vol. 129, 2011, pp. 213-18.

Robinson, E. Personal interviewer. 18 Oct. 2018.

Sanders, M. "The Value of Black Women Friendships." *Chicago Defender*, 28 Mar. 2018, chicagodefender.com/2018/03/28/the-value-of-black-women-friendships/. Accessed 9 Jan. 2022.

Schiller, J. S., et al. *Summary Health Statistics for U.S. Adults: National Health Interview Survey (2010).* National Center for Health Statistics.

Government Printing Office, 2012.

Settles, I. H. "Use of an Intersectional Framework to Understand Black Women's Racial and Gender Identities." *Sex Roles*, vol. 54, no. 9-10, 2006, pp. 589-601.

Thom, T., et al. "Heart Disease and Stroke Statistics—2006 Update: A Report from the American Heart Association Statistics Committee and Stroke Statistics Sub-Committee." *Circulation*, vol. 113, 2006, pp. e85-e151.

Watson, N., and C. Hunter. "'I Had to Be Strong': Tensions in the Strong Black Woman Schema." *Journal of Black Psychology*, vol. 42, no. 5, pp. 424-52.

Watson-Singleton, N. "Strong Black Woman Schema and Psychological Distress: The Mediating Role of Perceived Emotional Support." *Journal of Black Psychology*, vol. 43, no. 8, pp. 778-88.

West, C. "Mammy, Jezebel, Sapphire and Their Homegirls: Developing an 'Oppositional Gaze' towards the Images of Black Women." *Lectures on the Psychology of Women*, edited by J. Chrisler, C. Golden, and P. Rozee, McGraw Hill, 2008, pp. 286-99.

Wigo, B. "Understanding and Disproving Racial Stereotypes." *Swimming World*, vol. 59, no. 2, 2018, pp. 19-21.

Woods-Fiscombe, C. L. "Superwoman Schema: African American Women's Views on Stress, Strength, and Health." *Qualitative Health Research*, 20, 2010, pp. 668-83.

Wright, K., and S. Bell. "Health-Related Support Groups on the Internet: Linking Empirical Findings to Social Support and Computer-Mediated Communication Theory." *Journal of Health Psychology*, vol. 8, no. 1, pp. 39-54.

SECTION II

Sisterhood as Peer Support

Chapter 8

Sistership: Towards a Praxis of Communal Support among Black Women Graduate Students

ArCasia James-Gallaway, Autumn Griffin,
and Melanie Marshall

*O*n *a chilly winter day in the Midwest in early 2017, a small group of Black women graduate students sat down for an unsuspecting dinner filled with tortilla chips, salsa, laughter, story trading, solace, support, and immense respite. This somewhat impromptu occasion took many of us by surprise in its* Waiting to Exhale (McMillian, 1992; McMillian et al., 1995) *qualities. To depart, we stood to say our good-byes, readorn ourselves in the coats and scarves characteristic of Mid-western winters, and prepared for a quick photo session that captured our bliss in convening with fellow sisters surviving graduate school. Little did we know, we were on the precipice of an age-old practice of sistership, one that continues to carry us through.*

We were there, and it was everything. Autumn and Melanie met on this day, both having known ArCasia beforehand. This meeting introduced an equilibrium we all acknowledged was missing from our graduate school experiences. The beginnings of this journey encompass our praxis of sistership. Our purpose in this chapter is to define, delineate, and apply this concept. Centrally, we argue that sistership is a lifeblood of Black feminist praxis that well serves and supports Black women doctoral students.

We begin with a working definition of sistership, which is followed by a discussion of the three tenets we argue comprise this practice and personal instances of our own sistership. Next, we offer two examples of sistership, one literary and one media, that extend our own engagement, and we conclude with a discussion of sisterships' implications, underscoring its function and significance.

Defining and Situating Sistership as Black Women Graduate Students

As Black women academics, we identify as both Black, signaling our diasporic African heritage, and African American. We base our claims to the academy on African Americans' complex historical relationship to knowledge production in the United States (US) and the afterlife of slavery (Hartman). Our right to the academy is based on our lineage as the descendants of those who built it and whose exploited lives enabled its development (Jones)—a legacy of abusive malfeasance that reaches back to the period of legal enslavement (Owens). The practice of sistership sustains and compels us to struggle towards equity and justice in education.

We wholly accept Barbara Smith's contention that "the concept of simultaneity of oppression is still the crux of a Black feminist understanding of political reality" (xxxiv) and build on this particular analysis as Black women academics whose coalesced identities shape our navigation of the academy and broader social worlds as well as our treatment therein. Like our Black feminist foremothers, we see no "reason to rank oppressions" (Smith xxxiv) because we recognize how our ability status, class, racial, gender, and sexual identities produce what Black feminist scholar Patricia Hill Collins describes as subjugated knowledge. It is from this place that we seek to continue African American women's efforts to "develop a distinctive Black women's standpoint ... by using alternative ways of producing and validating knowledge" (252).

Therefore, we define "sistership" as a practice in which we as Black women graduate students (BWGS) call on the wisdom of our Black women foremothers to engage authentically, deeply, and vulnerably with one another in delight, misery, and all points in between. It is a shared enterprise of disclosing our assumptions and predilections about

what is real, right, and true, only to be met with profound understanding and empathy. These responses contribute directly to our work together as sister scholars in which we assemble and develop our communal knowledges to produce scholarship by, for, and about us. We get each other, and because of that, we can engage on another realm. Given this shared understanding, our work and journeys do not seem as futile; thus, sistership sustains us despite the academy's work to silence our voices (hooks, *Talking Back*), stifle our scholarship (Brown et al.), and discourage our ways of knowing (Dillard). The fact that we are thriving in a space where we were never meant to survive is testament to the fact that we are still here, in large part, because of one another (Lorde). Reflecting on how we are bound together due to the nature of our shared struggle, we turn now to a delineation of sistership's tenets.

This piece represents an alternative to conventional scholarship in its transdisciplinary elucidation of our collective wellness-seeking strategies to survive doctoral study. These efforts enable us to produce much of the knowledge we share here, knowledge borne out of our positions relative most expressly to capitalistic white supremacist patriarchy. Like the sage Combahee River Collective, we find "our origins in the historical reality of Afro-American women's continuous life-and-death struggle for survival and liberation" (para. 3) because we know we join a long, underacknowledged line of Black women who have sacrificed for us to be able to undertake a life of the mind (hooks, *Sisters of the Yam*).

Tenets of Sistership

This act of communion, so unequivocally tied to our work as sister scholars, can be understood in three tenets. We argue that sistership draws on and is deeply indebted to the Black feminist tradition (Combahee River Collective; Collins; Crenshaw; Davis; Hill et al.; Lorde; Smith) and sister-circle practices (Croom et al.; Harley; Neal-Barnett et al.). We describe it as historical, collectivist, and transcendent. Figure 1 represents our model and the analysis we offer in this chapter.

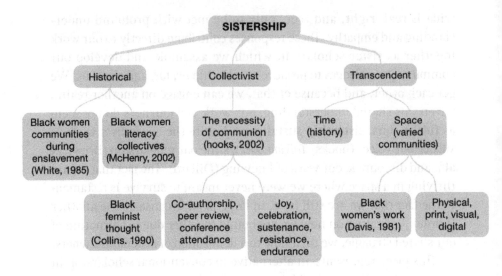

Figure 1. Conceptual model of sistership complete with historical, collectivist, and transcendent tenets.

Historical

To begin, we must acknowledge that this practice of sistership is not one we created ourselves. Rather, we draw this notion from the historical work of our foremothers, Black women who came before us and passed these practices down through generations. Historically, Black women have worked together, both in and out of the academy, to build communities focused on care, gendered and racialized uplift, and scholarship. Even in enslaved communities, Black women communed in groups on plantations to sustain themselves and strengthen their resolve for survival. Deborah White has examined the nature of these sisterships, noting that Black women's allegedly inherent strength largely derived from their functioning in groups; she argues that their cooperation, interdependence, self-reliance, and self-sufficiency resulted from the female networks in which they worked and lived, as they were able to do for one another, even in enslaved conditions. In a context where families were routinely sundered, these enslaved female networks fortified the Black women within them, creating, in some cases, networks more significant than enslaved women's blood ties. Such sistership antecedents exemplify the long legacy of communalism from which we draw to support one another and sustain, consequently, ourselves.

Concurrently, free Black women in the northeastern region of the US formed literary societies. These groups, dating back to the 1800s, are responsible for some of our earliest records of collective writing practices (Garfield; McHenry; Muhammad). Women like Maria Stewart, Anna Julia Cooper, and Ida B. Wells-Barnett came together to read, write, think, and engage in discourse around ideas that worked towards improving social conditions for Black folks in the US. At a time when it was illegal for most Black Americans to read and write, these women came together to encourage one another's academic pursuits for the purposes of Black liberation. Their work was foundational for Black feminists who would come after them. This work, which we continue in our own scholarship and praxis, is only possible because of those who came before us to lay the foundation.

Collectivist

Not mutually exclusive from the historical nature of sistership is its collectivist notions. Black women's historical practices of reading, thinking, dialoguing, and writing in community inform our own practice in our work as scholars. As hooks (2002) explains in *Communion: The Female Search for Love*, it is only in communion—through moments of sharing pain, struggle, work, and fears—that we are able to come to a place of joy and celebration. It is only through our decentring of the Westernized *I* and our centring of the *we* that can we truly come to successfully take up the work of creating scholarship by, for, and about Black women.

Our own practice of sistership looks like the following: the late night and early morning phone calls to think through our work or dialogue about our day; the group texts where we engage in critical analysis of scholarship and our lived experiences; the prayers we say with and for one another for encouragement; the critical analysis we do of one another's work, challenging each other when and where we need to be challenged; and the celebratory tweets and Facebook statuses we create to encourage one another on the journey. Each of these practices is rooted in the idea of collectivity, which helps us succeed in our respective programs while also pushing us to challenge the hegemonic norms that seek to debilitate us and invalidate our worldviews.

Transcendent

Lastly, our notion of sistership, while particularly relevant to our discussion of our work in the academy, is not confined to academic scholarship. In fact, to delimit this work to the ivory tower is to minimize its power in the lives of Black women. Thus, we argue that sistership is transcendent. Building on our earlier two tenets, transcendence relies on sistership's ability to be able to exist across time (history) and space (varied communities) to apply to Black women across multiple fields of work and life. Black women, who are often treated as "mules uh de world" (Hurston, p. 85) have engaged in work that is located within intersecting oppressions of race, class, and gender both in and out of the home (Collins; Davis; Smith). The gruelling and often dehumanizing nature of this work called—and continues to call—for Black women to live in community with one another no matter the occupation. As such, our notion of sistership as a historical practice of community in which we rely on the love, support, and encouragement of our sisters cannot be bound solely to the work we do as graduate students in the academy. Rather it can—and in fact we urge that it should—be applied across multiple fields to understand the ways Black women's lived experiences urge the formation of community with their sisters. Since this fellowship abounds beyond the boundaries of academia, in what follows, we offer extra-academic cases of sistership in media and literature that we regard as both inspirational and aspirational.

Exemplars: *The Color Purple* and *Living Single*

In efforts to concretize this notion of sistership, we turn to two of what we consider to be exemplars of this concept. Sistership resonates most profoundly as it is experienced by Black women, and thus we look towards Black women's contributions to media and literature to further illuminate our conversation. We begin with Alice Walker's *The Color Purple* and move into a brief discussion of the popular 90s sitcom, *Living Single*. Although situated in different points in history and thus in different social and political contexts, these two contributions are widely recognized as cultural touchstones by the Black American public. In these examples, we see true embodiments of sistership, and

we discuss how each encompasses the three tenets of historicism, collectivity, and transcendence.

Literature: *The Color Purple*

Widely acclaimed for both its literary and film merit, Alice Walker's *The Color Purple*, published in 1982, offers insight into Black woman sensibilities and relationships as they connect to the intertwined tenets of sistership. Following the life, loves, tragedies, and liberation of Celie, audiences are privy to the compounded knowledge and enactments of sistership in and throughout her life. A true "mule uh de world," Celie is subject to the power and demands of men—whether it be her stepfather, who raped her; her husband, Mister, who beat her; or Mister's children, who demanded her willing attention. However, it is in her women-centred relationships that Celie finds solace. This comfort she finds in the collective is what Walker defines as "womanism." This love between women, whether platonic or sexual, pays particular attention to the culturally specific intersections of race and class yet continues to acknowledge the existence and necessity of Black men (Walker). It is through this love—a sisterly love for Nettie; a romantic love towards Mister's lover, Shug, and a protective and maternal love towards her daughter, Olivia—that Celie is able to both draw on the historical strength of Black women before her and also transcend into the life of love, family, and excitement that she longs for. Celie's actions are magnified by Walker's choice to write her as the protagonist—all-knowing and particularly aware of herself *in relationship* to gendered others. Celie's enactment of sistership is transcendent in that it was never bound to institutions, particularly her marriage to Mister; it is collective, in that her relationships with women existed in multiplicities of shapes and forms, and historical, by way of her connection and transmission of personal experience and knowledge to not only characters but to the readership of *The Color Purple*.

Media: *Living Single*

Our second example, the popular 90s sitcom *Living Single*, speaks to the ways in which sistership is enacted across the wide range of Black women's existences and experiences. Following the lives of four young

Black women who comprise the show's focus, along with two Black men of a similar age who transition in and out of the spotlight in New York City, *Living Single* represents the complexities of these women's friendships with one another. These multifaceted portrayals deepen the audience's understanding of how this friend group functions as a unit.

The women of *Living Single* include young professionals Khadijah James, Synclaire James, Regine Hunter, and Maxine Shaw. Sistership is widely accessible to these women by way of their long-standing and intertwined relationships, be it blood, college, or otherwise. This vivacious group of Black women contend with different love interests, assert themselves in their respective workplaces, quarrel with one another, and try to make a life for themselves within a context hostile to their very beings and the merits they have to offer.

In all of their oscillating joy and strife, this group's rich dynamic unfolds on screen, supplying insight into how their sistership bonds establish a cohesive framework for the messy and painful task of self-actualization. This process is enabled by collectivist sistership in their group interactions and by transcendent sistership in their ascension beyond the academy. Moreover, although brought together by different connections and engaged in widely dissimilar interests and career paths, these women, their experiences, and their struggles as Black women transcend what we consider to be disciplinary knowledges; this culmination translates into a common language, thus establishing a strong sense of collectivity. *Living Single* offers an intergenerational appeal—now almost three decades past its launch in 1993—and embodies fully how we envision this notion of sistership.

Between the Two

Taken together, these two exemplars offer legible notions of sistership that span time, generations, and mediums. Rounding out our chapter, these examples dynamically portray the complexity of Black women's lives and the sustaining support we offer one another. In our final comments that follow, we highlight the wide-reaching implications of sistership and key considerations we deem significant in developing a generative understanding of our evolving praxis.

Discussion, Considerations, and Conclusions

In *Sisters of the Yam*, hooks speaks profoundly of the importance of community in the lives of Black women: "Working together to build communities that foster a sense of kinship that goes beyond blood ties or bonds of friendship, black women expand our horizons. When communities of resistance are everywhere the norm in our lives, we will not be without a circle of love or a healing place" (122). Suggesting that these communities of resistance do not exist solely in either our personal or our academic lives, hooks advances that instead Black women must function from a "both/and" stance—intentionally working to centre community, and thus sistership, in all areas of our lives. Our notion of sistership echoes this assertion. Our community, our kinship, and our sisterhood have allowed us to endure throughout our academic journey, have undoubtedly enhanced our scholarship, and have thoroughly helped us to live more full lives. By relying on one another for academic, emotional, and familial or social support, we affirm ourselves in ways that society refuses to do (Minnett et al.). As clear indications of society's disdain for Black women and girls proliferate (Blake et al.; Epstein et al.; Morris), we forge forwards in hopes of improving the academy and our realms of the world so that the Black girls and women who come after us have less of said labour to perform.

The implications of this work are broad, as is its significance. Sistership benefits groups outside of Black women because as Black feminists have argued, the fate of the Black race in particular and society in general hinges on the plight of Black women as a group that is located near the very bottom of the social hierarchy at the margins of society (Collins; Cooper; Crenshaw; Davis; Jones; Smith). Therefore, we bring all others with us when conditions improve for us—that is, improvements to our benefit are socially amplified. In this, we do not leave behind, for instance, our Black brothers whose enhancement works in tandem with our own. Sistership, then, is a practice that improves the lot of society while centring Black women's truths, assumptions, and needs.

Furthermore, we acknowledge the tenuous terrain on which we tread in discussing Black women as a seemingly conscribed group. There is no such monolith, and our experiences are as diverse and multifaceted as our hair textures and skin tones. Working in opposition

to homogenizing accounts of Black women, we offer this chapter in service of the sistership we engaged across varied groups of people who identify as Black women. It is not to essentialize us or our experiences but to highlight the dynamic and innovative ways we enact mechanisms of support in the face of systemic injustices. Routinely creating something out of nothing, we have shown ourselves to see many over on *This Bridge Called My Back* (Moraga and Anzaldua). And now, we seek redress in one another, recognizing the many other areas from which we draw inspiration and strength.

Engaging fictive kin (Chatters et al., 1994) in such creative ways has long sustained us as Black women, and this act in part helps explain why we draw so much power from this practice. Understanding graduate school, for example, from the vantage point of sistership transforms its meaning and importance. The possibilities around what is feasible shift, particularly with regard to the competitive aspect of graduate studies. One commonality within the small group of Black women, who began this piece in the opening vignette, is that we remain put-off by the individualistic and cutthroat atmosphere of our graduate programs (Minnett et al.). Many of our own instincts work against these types of attitudes and dispositions because it often feels more appropriate to establish norms of communalism. However, we have quickly learned that our epistemologies are marginalized, and we constantly work to reconcile these hegemonic expectations with our own.

As a practice unconstrained by time or space, the historical, collective, and transcendent nature of sistership also serves a heuristic role in exhibiting the merits of a communal mindset and a conscious acknowledgment of our foremothers' shoulders on which we stand. More explorations of similar models would benefit not only research communities interested in self-care practices but also laypersons striving to enhance their perspectives on (in)equity. Having account-ability partners and peers who speak your language helps filter through many of the anxieties associated with navigating the world daily, especially in unfamiliar company.

Oppression does not seem as daunting or debilitating when viewing the world through a sistership lens. Unfortunately, this view is not reality, so our work together serves an expressly survival purpose. As Black women, we face some of the worst forms of inequity, yet we press

forwards and lean on one another when our own wherewithal wanes. In step with our foremothers, we proceed by carrying their torches and struggling to create a world in which liberation is reality and justice reigns.

Works Cited

Blake, J. J., B. R. Butler, and D. Smith. "Challenging Middle-Class Notions of Femininity: The Cause of Black Females' Disproportionate Suspension Rates." *Closing the School Discipline Gap: Equitable Remedies for Excessive Exclusion*, edited D. J. Losen, Teachers College Press, 2015, pp. 75-88.

Bowser, Y. L. *Living Single.* Warner Bros. Entertainment, 1993.

Brown, R., R. Carducci, and C. Kuby, editors. *Disrupting Qualitative Inquiry: Possibilities and Tensions in Educational Research.* Peter Lang, 2014.

Chatters, L. M., R. J. Taylor, and R. Jayakody. "Fictive Kinship Relations in Black Extended Families." *Journal of Comparative Family Studies*, vol. 25, no. 3, 1994, pp. 297-312.

Christian, B. "The Race for Theory." *Cultural Critique*, vol. 6, 1987, pp. 51-63.

Collins, P. H. *Black Feminist Thought: Knowledge, Consciousness, and the Politics of Empowerment.* Unwin Hyman, 1990.

Combahee River Collective. *The Combahee River Collective Statement: Black Feminist Organizing in the Seventies and Eighties.* Kitchen Table, Women of Color Press, 1977.

Cooper, A. *A Voice from the South.* Oxford University Press, 1988.

Crenshaw, K. "Demarginalizing the Intersection of Race and Sex: A Black Feminist Critique of Antidiscrimination Doctrine, Feminist Theory, and Antiracist Politics." *University of Chicago Legal Forum*, vol. 140, 1989, 139-67.

Croom, N., et al. "Exploring Undergraduate Black Womyn's Motivations for Engaging in 'Sister Circle' Organizations." *NASPA Journal About Women in Higher Education*, vol. 10, no. 2, 2017, pp. 216-28.

Davis, A. *Women, Race, and Class.* Random House, 1981.

Dillard, C. B. "The Substance of Things Hoped for, the Evidence of Things Not Seen: Examining an Endarkened Feminist Epistemology in Educational Research and Leadership." *International Journal of Qualitative Studies in Education*, vol. 13, no. 6, 2000, pp. 661-81.

Epstein, R., J. J. Blake, and T. Gonzalez. *Girlhood Interrupted: The Erasure of Black Girls' Childhood*. Center on Poverty and Inequality, Georgetown Law, 2017.

Garfield, M. N. "Literary Societies: The Work of Self-Improvement and Racial Uplift." *Black Women's Intellectual Traditions: Speaking their minds*, edited by C. B. Conway, University of Vermont Press, 2007, pp. 113-28.

Harley, S., editor. *Sister Circle: Black Women and Work*. Rutgers University Press, 2002.

Hartman, S. V. *Lose Your Mother: A Journey along the Atlantic Slave Route*. Farrar, Straus, and Giroux, 2007.

hooks, b. *Communion: The Female Search for Love*. Harper Collins, 2002.

hooks, b. *Sisters of the Yam: Black Women and Self-Recovery*. South End Press, 1993.

hooks, b. *Talking Back: Thinking Feminist, Thinking Black*. South End Press, 1989.

Hull, G. T., P. B. Scott, and B. Smith, editors. *All the Women are White, All the Blacks Are Men, but Some of Us Are Brave: Black Women's Studies*. The Feminist Press at The City University of New York, 1982.

Hurston, Z. N. *Their Eyes Were Watching God*. Fawcett, 1937.

Jones, C. "An End to the Neglect of the Problems of the Negro Woman!" *Political Affairs*, vol. 28, no. 6, 1949, pp. 51-67.

Jones, J. *Bad Blood: The Tuskegee Syphilis Experiment*. 2nd ed. Free Press, 1993.

Lorde, A. *Sister Outsider: Essays and Speeches*. Crossing Press, 1984.

McHenry, E. *Forgotten Readers: Recovering the Lost History of African American Literary Societies*. Duke University Press, 2002.

McMillian, T. *Waiting to Exhale*. The Viking Press, 1992.

McMillian, T., et al. *Waiting to Exhale*. Twentieth Century Fox Film, 1995.

Moraga, C., and G. Anzaldua, editors. *This Bridge Called My Back: Writings by Radical Women of Colour.* Persephone, 1981.

Morris, M. *Pushout: The Criminalization of Black Girls in Schools.* The New Press, 2016.

Muhammad, G. "Searching for Full Vision: Writing Representations of African American Adolescent Girls." *Research in the Teaching of English*, vol. 49, no. 3, 2015, pp. 224-47.

Neal-Barnett, A. M. "In the Company of My Sisters: Sister Circles as an Anxiety Intervention for Professional African American Women." *Journal of Affective Disorders*, vol. 129, no. 1-3, 2011, pp. 213-218.

Minnett, J. L., A. D. James-Gallaway, and D. L. Owens. *Help a Sista Out: Black Women Doctoral Students' Use of Peer Mentorship as an Act of Resistance. Mid-Western Educational Researcher*, vol. 31, no. 2, 2019, pp. 210-38.

Owens, D. C. *Medical Bondage: Race, Gender, and the Origins of American Gynecology.* University of Georgia Press, 2017.

Smith, B., editor. *Home Girls: A Black Feminist Anthology.* 2nd ed. Rutgers University Press, 2000.

Walker, A. *The Color Purple.* Washington Square Press, 1982.

White, D. G. *Art'n't I a Woman? Female Slaves in the Plantation South.* W.W. Norton, 1985.

Chapter 9

Let's "SLAY" Together: Building Sisterhood, Scholarly Identity, and Solidarity among Black Women Doctoral Students

Gloria L. Howell, Christina Wright Fields,
Francesca A. Williamson, and Katrina M. Overby

Let's SLAY together. *Succeed. Lead. Achieve. Yaaaaaas!* For four Black women[1] in higher education, this mantra, including the universal Black girl affirmation (yaaaaaas!), represents our sisterhood at work. We acknowledge that, although our individual paths and goals may differ, the sisterhood we have created and sustained has made all the difference on our journeys as doctoral students and professionals.

Getting "*PHinisheD*" is difficult for anyone pursuing a terminal degree as politics, mental and physical fatigue, and financial constraints trap some of the most driven doctoral students into what seems like a never-ending cycle of highs and lows from start to completion. Although these issues affect graduate students of various backgrounds, they are often intensified for students of color, particularly Black women. Pursuing advanced degrees is a constant disruption and resistance of institutional systems that were not created for us. Despite the fact that we are attaining advanced degrees and entering the professoriate now more than ever before, we are still likely "to be seen

145

as intruders in the academic world who do not really belong" (hooks, *Teaching Critical Thinking* 101). According to the National Science Foundation (2016), of the 25,278 women who received doctoral degrees in 2016, 6 percent (1,663) of them were Black compared to 21 percent (5,522) Asian and 53 percent white. The disparity speaks to the various challenges that Black women encounter during their degree programs.

Although some research does exist concerning the experiences of Black women doctoral students, the literature lacks examples of concrete practices for supporting them. Thus, we consider the role of fictive kinship as a means of academic and personal support for Black women pursuing doctoral degrees.[2] Fictive kinship refers to familial-like relationships (e.g., sisters) among unrelated individuals with shared identities (Fordham). These networks facilitate "identity-affirming environments" necessary for the wellbeing of Black women (Harris-Perry 102). Daniella Ann Cook and Tiffany Williams consider fictive kinship networks as ways for Black women to persist, resist, and reclaim our place in academia. Cook herself identifies three functions of fictive kinship: solidarity, advocacy, and resilience. These functions undergird the significance of our network and how it empowered us to persist.

In this chapter, we first situate our discussion in the social positions of Black women in academia. We then discuss the conceptual frameworks that ground our understanding and interpretation of Black women sisterhood. Specifically, we focus on Kimberlé Crenshaw's concept of intersectionality and build upon the aforementioned discussion of fictive kinship in a historical context surrounding Black women's organizational affiliation. Finally, we present our individual narratives that demonstrate sisterhood as a counterspace wherein we foster solidarity, strengthen our scholarly identities, and create opportunities for our experiences and values to be affirmed.

Black Women in Academia

In her book *Black Women in the Ivory Tower, 1850-1954*, Stephanie Evans states: "There once was a time when some scholars believed that the world was flat, the sun revolved around the earth, and that Black women did not belong in the academy. The first two myths have been dispelled; let this book lay to rest the third" (13). Black women

including Mary Jane Patterson—the first Black woman to receive a bachelor's degree in 1862 from Oberlin College—blazed trails for those of us who would follow generations later.

Balancing a number of responsibilities while experiencing what Anna Julia Cooper called the "woman question and race problem" (Evans 145) made educational attainment and career advancement in the field incredibly difficult for Black women. For example, Lucy Diggs Slowe, the first dean of women at Howard University, a historically Black university in Washington, DC, constantly faced gender discrimination from her colleagues, including university president, Mordecai Johnson. Slowe was excluded from important decision-making processes, and Johnson dismantled programs she created for women on campus (Thomas and Jackson). She also received substantially less pay than her male colleagues and was dismissed when she reported complaints from women regarding sexual harassment from a male faculty member (Bell-Scott). Slowe's experience at Howard University is only one example of the many obstacles Black women faced early on in the academy.

Organizational Affiliation

Historically, Black women have created and participated in organizations for solidarity and to rally against our unique oppressions at the intersection of race, gender, and class (Davis). Similarly, Slowe found refuge in a group of Black women educators at other universities. Membership within a specific group characterized by their gender and race created a shared experience for these women (Few, Stephens, and Rouse-Arnett). Organizational affiliation facilitated a sense of camaraderie among them as educators and activists who wanted to change the conditions of not only educational institutions but other parts of society.

Several Black women were involved in the National Association for College Women (NACW). The organization initially began as the College Alumnae Club in 1910 in Washington, DC with ten Black women college graduates (Perkins). In 1923, it was recognized as an official national organization for the purpose of improving higher educational opportunities for Black women that would ultimately prepare them for leadership roles; above all, the organization sought to

improve facilities, faculty development, and curricula of Black colleges (Perkins). What is also important to note about NACW membership is the priority given to pursuing advanced degrees. The majority of the members had received degrees from predominantly white colleges and universities in the North and placed emphasis on obtaining PhDs and studying abroad (Perkins). Adopting «lift as we climb» as their founding principle, the NACW exemplified the solidarity, advocacy, and resilience that is critical for the success of Black women in academia today.

Intersectionality

Our work is informed by intersectionality, which helps to explain the distinctive ways that racism and sexism (among other "isms") shape the experiences of Black women in higher education. The concept of intersectionality informs our understanding of the unique position of Black women at primarily white institutions (PWIs) and our engagement with sisterhood. The term "intersectionality" was coined by Crenshaw in the 1980s and is used to examine the "interlocking" dynamics of race and gender in critical legal studies of antidiscrimination cases and antiviolence movements (Cho, Crenshaw, and McCall; Crenshaw). Crenshaw analyzes the dynamics of sameness and difference used in legal cases to minimize the unique concerns of Black women in comparison to white women and Black men. Intersectionality problematizes "single-axis" thinking, makes visible the power dynamics involved with marginalized and privileged identities, and allows scholars to examine the material consequences for disattending to dynamics of social identities.

In her 1989 book *Talking Back: Thinking Feminist, Thinking Black,* bell hooks reflects on her experiences as a graduate student and discusses how she was perceived in light of her intersecting identities (Black and female):

During my graduate school years, I dreaded talking face-to-face with white professors, especially white males. I had not developed this dread as an undergraduate because there it was simply assumed that black students, and particularly black female students, were not bright enough to make it in graduate

school. While these racist and sexist opinions were rarely directly stated, the message was conveyed through various humiliations that were aimed at shaming students, at breaking our spirit. We were terrorized. (56)

Sisterhood from an intersectional lens offers opportunities for our experiences as Black women to be shared and validated in academia, and our peer and near-peer interactions facilitated by fictive kinship can address educational and professional gaps.

Getting in Formation: Black Sisterhoods and Higher Education

For Black women, finding ways to balance scholarly pursuits and Black womanhood can mean the difference between success and failure while seeking an advanced degree. Black sisterhoods in higher education are quite ubiquitous across colleges and universities in the United States. One example of a well-known Black sisterhood that recently developed at Indiana University (IU) is "the Great 8." These eight women made national headlines as the largest group of Black women to graduate from the same school (education) in May 2016. Each of them acknowledged the support they received from their sister circle throughout their matriculation (Logue). They developed their circle as an informal means to discuss the highs and lows of the PhD process and aspects of their social lives.

The feeling of isolation and need for support that prompted the Great 8 to form their sister circle are all too familiar for Black women who pursue doctoral degrees. Black women value connections with other Black women on campus with hopes of bridging gaps that are present due to the lack of a critical mass and as coping mechanisms against race and gender inequity (Henry and Glenn). We become affiliated with cohorts of other women who can provide advice, encouragement, and authentic sisterhood (Patton and Harper). We join campus and community organizations—including sororities, Black graduate student groups, mentoring programs, and civic groups—that fill a void that we do not easily find in our academic programs. The networks we form are solidified and manifest as counterspaces for Black women to experience support, affirmation, and a sense of belonging on their campuses.

Daniel Solorzano and Octavio Villalpando posit that academic counterspaces allow African American students to facilitate their own learning in an environment that validates their cultural understanding and considers their experiences as important forms of knowledge. These formal and informal spaces serve different purposes, thus providing opportunities for us to explore parts of our identities that we deem salient in academic, professional, and social contexts.

Our Narratives

Acknowledging Black women's experiences as valuable representations of knowledge, we present our narratives, which include ways that we develop counterspaces as Black doctoral women. In the following excerpts, each of us details the ways in which we experience fictive kinship, particularly focusing on our network as a counterspace that facilitated our growth as scholars, as leaders, and as sistahs.

Harambee— "All Pull Together"[3]

I am Christina Wright Fields, one of the scholar mamas and the "elder" in our sistah circle, since I completed my doctoral degree a few years ago. My interactions with my sistahs were greatly influenced by my interactions with other sistah-scholars who encouraged me as I progressed through the graduate student pipeline. Within our sistah circle, I embraced a holistic approach that integrated "academic, cultural connection and development of personal responsibility, concern, and respect for the community, family, teacher, and peers" (Hopson et al. 785). My sistah-scholars and I held each other accountable. We expected each other to excel academically, professionally, and personally because we knew the impact it would have not only on ourselves but our families and communities.

Our sistah circle provided us with the cultural and academic knowledge to reorient our experiences at a PWI. Our network includes me (a faculty member and advisor for the IU Black Graduate Student Association [BGSA]) and three Black women doctoral students. We would share some of the microaggressions that affect us on a macro-level—including stories of being the "only one" in our classes or on committees—and vent about the challenges of our intersectionality,

being a Black female scholar or Black scholar-mamas. Oftentimes, our conversations would centre on the need for Black female graduate students to view ourselves as central in our own herstory and exceed even our own expectations.

Namaslay[4]— "The Slay in Me Recognizes the Slay in You"

I am Gloria (Glo) Howell, a graduate of the Higher Education and Student Affairs doctoral program at IU. Raised in the rural South by a village of strong Black women, Mississippi was all I knew. To be completely honest, I never thought I would leave. So when I was accepted into IU to pursue a doctoral degree in 2013, I was ecstatic about the opportunity. Scared, but ecstatic.

The first night I stayed in my new place, I cried myself to sleep because I was extremely homesick. Even though I didn't realize it, that moment marked the development of fictive kinship for me in a new environment. Katrina was the first friend I met in Bloomington. My uncle was her basketball coach when she attended Rust College, a historically Black college in Mississippi. Katrina was a doctoral student at IU, and he asked her to look out for me. My second day in the city, Katrina met me on campus, and we laughed and talked like old friends. She helped me get acclimated and introduced me to the BGSA. Katrina was president at the time, and she offered me a vacant position (secretary) within the organization. I was anxious to get involved and meet other Black graduate students, so I accepted. Membership in the BGSA provided me with opportunities to develop my sisterhood network. Not only did Katrina introduce me to the organization, but it was at a BGSA social event during my first semester that I met Francesca. I have always admired Francesca as a researcher and scholar-activist. She's a mover and shaker who simply does her own thing. In the BGSA, she and I, along with one of our other close friends who was on the leadership team, had an inside mantra for the work that we did: "We don't do loose." That's Francesca—extremely organized, thoughtful, and about her business. During the 2014–2015 academic year, I served as BGSA president, Francesca became secretary, and Katrina served as community service chair. In addition to the three of us, the entire leadership team was comprised of brilliant Black women. We were a force to be reckoned with.

In addition to developing kinship through organizational affiliation and leadership, another important aspect of our network is mentorship. Finding a mentor can be extremely difficult for Black women who attend PWIs (Patton). We often seek mentors who we identify with in some way and share similar cultural characteristics. Kijana Crawford and Danielle Smith assert that the essence of mentoring is to help an individual both personally and professionally. The mentoring relationship we have with Christina embodies these characteristics.

I met Christina first as she was my supervisor when I worked with a precollege program each summer. Christina was invested in my success, not only as an employee but also as a Black woman pursuing a doctoral degree in the same field. She provided me with valuable advice and opportunities to conduct research and present at national conferences. She also nominated me for a prestigious national award that I won. She had such a positive influence on me that I strongly recommended that the BGSA leadership ask her to serve as our advisor. In this role, Christina challenged us to develop programs and initiatives that could enhance the experiences of other Black graduate and professional students. As a newly minted doctoral degree holder, Christina shared with us nuggets of wisdom that we could utilize to make the BGSA bigger and better.

From the outside looking in, it would be easy to conclude that the sisterhood we share was bound to develop because we just happen to be in the right place at the right time—attending a BGSA meeting or social event or simply walking through the School of Education or the Neal-Marshall Black Culture Center. But I would argue that our circle was not created by happenstance. Each of us saw something in the rest of us that we admired. After all, "real recognize real." Namaslay!

Sawubona—"I See You"

I am Katrina Overby, or KO. I graduated with my PhD from the Media School at IU. Born and raised in Indianapolis, Indiana, the Midwest was not a geographical culture shock nor was attending a PWI as I received my master's degree from Oklahoma State University. What was different about IU was the lack of Black faces during my first week in Bloomington, Indiana. I spent days going to Wal-Mart to find Black people. Staying true to myself is very much influenced by who I am

able to surround myself with on a day-to-day basis. Thus, finding people who look like me—Black and Black and female—is always necessary in any space I'm in for an extended period of time.

I completed my undergraduate degree at Rust College, an HBCU in Mississippi. Blackness, unity, community, and Black sisterhoods were all around me at Rust. I was extremely involved in campus life and student and peer-mentoring organizations, was a five-sport athlete (I was connected to several sister teammates), and was a member of Alpha Kappa Alpha Sorority, Incorporated (AKA).

After two weeks at IU, I finally found some Black graduate students who were members of the BGSA, and I became involved on campus and in the community. I began attending Bethel AME Church with these students, and I discovered that a member of the church was also a member of my sorority and was initiated in the same city where my undergraduate institution was located. My sorority sister immediately connected me to the other members in the city and that was the first sisterhood that I was a part of in Bloomington. Typically, students involved in Black Greek-letter organizations are highly involved in other campus activities and are successful academically, socially, and in other leadership positions (Kimbrough). This is true in my case, as I helped our sorority chapter reactivate in Bloomington, became vice-president of BGSA during my second year and became an advisor for the Black Student Union (an undergraduate student organization).

After having such a difficult first year navigating Bloomington and becoming an involved student leader my second year, I made it my duty to help connect others to the Black community upon their arrival. Glo's uncle told me that she was a member of AKA and reminded me that we had led Sunday morning worship at her home church in Mississippi one basketball season. I contacted her and invited her to choir practice, to join the BGSA executive board, and to a sorority meeting. The rest is herstory. We later created a small Black women's writing group as an informal support structure as we navigated our programs.

I met Francesca (who I call "Moneybags") through the BGSA when she served as treasurer. We later had the opportunity to work in close proximity when I accepted an internship at the Center for Innovative Teaching and Learning at IU. Knowing that a sistah-scholar was close by made working there that much better. Finally, I met Christina through Francesca and Glo when she became our BGSA advisor. I

gravitated to her nurturing spirit that reminded me of the Black women who mentored me at Rust College.

"Sawubona" is an African Zulu greeting that means "I see you." The women in this sisterhood see me, and I see them. Our interactions, meetings, and exchanged smiles have meant the world to me and have propelled me toward success on this journey. I see you, sistahs!

On Being a Black Mama and Scholar

I am Francesca or FW, one of the mama scholars in the circle who straddles the line between supermama and exceptional scholar. As a mama, I've worked diligently to prioritize my family and studies, though not without challenges. Boundaries is one word that captures my experience and journey in doctoral studies. Most folks I met throughout doctoral studies, even before they know my name or field of study, know that I'm an advocate of boundaries and well-placed priorities. I'm quick to share my "two events per month" and "eight-to-five email" rules that help me clearly differentiate between academic work and the rest of my life. I show up to extracurricular events late and leave early so that I can at least stop by to support my sistah scholars from time to time.

For starters, many professional development opportunities, guest lectures, and sometimes coursework or research meetings take place after daycare closes. I occasionally end up asking my husband to take care of home, missing important events and meetings, or bringing the whole family along, praying my toddler doesn't need her diaper changed while we're on campus (I've yet to find a changing station on campus.) Before starting doctoral studies, I couldn't have anticipated some of the barriers I would face, particularly as a Black mama. I searched for articles and books about motherhood and academia to make sense of my experience only to find that they were often based on white models of motherhood and focused on faculty (e.g., Wolf-Wendel and Ward). Common issues faced by mothers in academia include fear of not being perceived as a serious student, feeling isolated from academic peers, finding a work-life balance, and receiving limited institutional support (e.g., family friendly policies), many of which I would be already prone to experience if I were a single Black woman without children (Anaya).

The African proverb "It takes a village" can be used to describe my journey in academia as a Black mama and sistah scholar. Through sisterhood, I've learned about some of the cultural aspects of being a Black mama and found Black women peers and faculty with whom I can talk through resisting the "strong Black woman" trope that dehumanizes us. They've offered family-related advice, such as which school and teachers are best for Black children in the area, cultural events for Black families, and practical strategies for work-life balance. With sistah-scholar peers, I have found a healing community that addresses my experiences with isolation. We write together and present at conferences together, my sistahs buy Christmas and birthday presents for my kids, and we bond over our shared and unique experiences as Black women. The Black mama and sistah-scholars in my village have been instrumental for creating a space wherein my identities, values, and commitments are accepted and affirmed.

Pamoja Tutashinda[5]: "Together We Will Win"

From identity-based organizations and writing groups to baby showers and sorority events, our sisterhood network has developed into an integral part of our wellbeing as Black women doctoral students and young professionals. Acknowledging our unique experiences, challenges, and needs, both prior to our doctoral journeys and now often means seeking spaces of affirmation and particular resources that are not readily available to us or do not exist at all. In these instances, we do what Black women have done time and time again in higher education and other societal institutions. When there's no room for us, we make room for ourselves. We find ways to create the environment that we need to be successful. As we matriculate through our programs and early stages of our professions, we encourage Black women to not only pursue doctoral degrees but to be intentional about forming networks with other Black women, thereby supporting each other in the process. Whether it's a peak, a valley, or somewhere in between, each of us can say, in the words of disco legends Sister Sledge, "I got all my sisters with me!"

Endnotes

1. The authors identify as cisgender, heterosexual women.
2. Three of the four authors were in PhD programs when they began this chapter. Since then, all have completed their degrees.
3. "Harambee" means "all pull together" in Kiswahili, Kenya's national language. It is the nation's official motto, and it encompasses a concept of placing the group before the individual.
4. Namaslay is a life philosophy that originates from the ancient yogic greeting, namaste, which means "the light in me acknowledges the light in you." It encompasses support, camaraderie, and in this case, sisterhood.
5. "Pamoja tutashinda" is a Kiswahili saying, meaning "Together we will win!" The term embodies the authors' commitment to support and look out for each other not for individualistic motives but for the collective.

Works Cited

Anaya, R. "Graduate Student Mothers of Color: "The Intersectionality between Graduate Student, Motherhood, and Women of Color in Higher Education." *Intersections: Women's and Gender Studies in Review Across Disciplines*, vol. 9, 2011, pp. 13-31.

Bell-Scott, P. "To Keep My Self-Respect: Dean Lucy Diggs Slowe's 1927 Memorandum on the Sexual Harassment of Black Women." *NWSA Journal*, vol. 9, no. 2, 1997, pp. 70-76.

Cho, S., K. W. Crenshaw, and L. McCall, "Toward a Field of Intersectionality Studies: Theory, Applications, and Praxis. *Signs: Journal of Women in Culture and Society*, vol. 38, no. 4, 2013, pp. 785-810.

Cook, D. A. "Disrupted but Not Destroyed: Fictive Kinship Networks among Black Educators in Post Katrina New Orleans." *Southern Anthropologist*, vol. 35, no. 2, 2010, pp. 1-25.

Cook, D. A., and T. Williams. "Expanding Intersectionality: Fictive Kinship Networks as Supports for the Educational Aspirations of Black Women." *Western Journal of Black Studies*, vol. 39, no. 2, 2015, pp. 157-66.

Crawford, K., and D. Smith. "The We and the Us: Mentoring African

American Women." *Journal of Black Studies*, vol. 36, no. 1, 2005, pp. 52–67.

Crenshaw, K. "Demarginalizing the Intersection of Race and Sex: A Black Feminist Critique of Antidiscrimination Doctrine, Feminist Theory, and Antiracist Politics." *University of Chicago Legal Forum*, vol. 139, 1989, pp. 139-67.

Davis, A. Y. *Women, Race, and Class*. Vintage Books, 1983.

Evans, S. Y. *Black Women in the Ivory Tower, 1850–1954*. University Press of Florida, 2007.

Few, A. L., D. P. Stephens, and M. Rouse Arnett. "Sister to Sister Talk: Transcending Boundaries and Challenges in Qualitative Research with Black Women." *Family Relations*, vol. 52, no. 3, 2003, pp. 205-15.

Fordham, S. *Blacked Out: Dilemmas of Race, Identity, and Success at Capital High*. University of Chicago Press, 1996.

Glen, P. "African Famine: 'I See You.'" *Huffington Post*, 9 Aug. 2011, www.huffingtonpost.ca/glen-pearson/africa-famine_b_922063. html. Accessed 11 Jan 2022.

Green, C. E., and V. G. King. "Sisters Mentoring Sisters: Africentric Leadership Development for Black Women in the Academy." *The Journal of Negro Education*, vol. 70, no. 3, 2001, pp. 156-65.

Harris-Perry, M. V. *Sister Citizen: Shame, Stereotypes, and Black Women in America*. Yale University Press, 2011.

Henry, W. J., and N. M. Glenn. "Black Women Employed in the Ivory Tower: Connecting for Success." *Advancing Women in Leadership*, vol. 29, 2009, pp. 1-18.

hooks, b. *Talking Back: Thinking Feminist, Thinking Black*. South End Press, 1989.

hooks, b. *Teaching Critical Thinking: Practical Wisdom*. Routledge, 2010.

Hopson, R. K. M., et al. "What's Educational Leadership without an African-Centered Perspective? Explorations and Extrapolations." *Urban Education*, vol. 45, no. 6, 2010, pp. 777-96.

Kimbrough, W. M., and P. A. Hutcheson. "The Impact of Membership in Black Greek-Letter Organizations on Black Students' Involvement in Collegiate Activities and Their Development of Leadership

Skills." *Journal of Negro Education*, vol. 69, no. 2, 1998, pp. 96-105.

Logue, J. "The Great 'Graduating' Eight." *Inside Higher Education*, 26 Apr. 2016, www.insidehighered.com/news/2016/04/26/great-eight-set-record-black-doctorates-indiana-university. Accessed 11 Jan. 2022.

"Namaslay." *Urban Dictionary*, 2018, www.urbandictionary.com/define.php?term=Namaslay. Accessed 11 Jan. 2022.

National Science Foundation, National Center for Science and Engineering Statistics. "Survey of Earned Doctorates." *NSF*, 2016, www.nsf.gov/statistics/2018/nsf18304/data/tab21.pdf. Accessed 11 Jan. 2022.

Patton, L. D. "My Sister's Keeper: A Qualitative Examination of Mentoring Experiences among African American Women in Graduate and Professional Schools." *The Journal of Higher Education*, vol. 80, no. 5, 2009, pp. 510-37.

Patton, L. D., and S. R. Harper. "Mentoring Relationships among African American Women in Graduate and Professional Schools." *New Directions for Student Services*, vol. 104, 2003, pp. 67-78.

Perkins, L. M. "The National Association of College Women: Vanguard of Black women's leadership and education, 1923–1954." *Journal of Education*, vol. 172, no. 3, 1990, pp. 65-75.

Solorzano, D., and O. Villalpando. "Critical Race Theory, Marginality, and the Experience of Minority Students in Higher Education." *Emerging Issues in the Sociology of Education: Comparative Perspectives*, edited by C. Torres and T. Mitchell, State University of New York Press, 1998, pp. 211-24.

Thomas, V. G., and J. A. Jackson. "The Education of African American Girls and Women: Past to Present." *The Journal of Negro Education*, vol. 76, no. 3, 2007, pp. 357-72.

Wolf-Wendel, L. E., and K. Ward. "Academic Life and Motherhood: Variations by Institutional Type." *Higher Education*, vol. 52, no. 3, 2006, pp. 487-21.

Chapter 10

#BlackGirlMagic:
A Coalition of Sisterhood

Cherell M. Johnson, Colette McLemore Dixon,
and LaTrina D. Parker Hall

The authors of this chapter each entered the doctoral program in higher education administration at Saint Louis University (SLU) with different individual goals, but it is safe to say they had the mutual intent of successfully completing each required component, including passing exams, writing a dissertation, and then graduating. These accomplishments proved to be easier feats when they decided to work together as a collective body. What follows is the collective narrative of how three African American women began a doctoral program at various starting points but intersected to begin a coalition that would foster into a sisterhood.

We started the doctoral program in different cohorts but came together in the trenches of preliminary exams and dissertation proposals. Through supporting one another during the program, we unknowingly constructed a coalition in a program typically designed for individualism rather than collectivism. In the process, we discovered a phenomenon of sisterhood that has continued to evolve well after our final edits were submitted to ProQuest. This coalition yielded the fortitude and energy needed to not only complete the doctoral program but to excel in many areas of our lives as well. We connected through the fire of studying and writing but molded into gold through our commonalities of strong family bonds, spirituality, and love of Black pop culture.

Our journey is reflected in the narratives of our experiences in our

doctoral program. Through stories and collective memories, we illuminate the ways in which we constructed our relationship while becoming doctors. The guiding question that inspired our chapter was how did three African American women with various backgrounds form a coalition to promote academic excellence? Narrative inquiry was the best methodology to explore this phenomenon. The Black pop culture empowerment movement reflects our journey. We got in "Formation" with Beyoncé, pulled up "A Seat at the Table" with Solange, and were reminded of our greatness as we stood in solidarity with Jesse Williams; these common themes emerged as we centered our approach to understanding this phenomenon within the framework of narrative inquiry.

Methodology

The aim for this chapter is to explore the lived experiences of three African American women during their journey through a doctoral program and how they came together to form the coalition affectionately named "Black Girl Magic." CaShawn Thompson coined the phrase "Black girls are magic" in 2013 to inspire the beauty, intelligence, and "magic" of Black women (Wilson). Since this chapter is positioned to explore experiences, qualitative designs are better suited for this examination. As discussed by Michael Patton, "qualitative inquiry is an especially resourceful tool to inductively explore fieldwork that is produced through interviews rather than by scientific measures and procedures" (39). Through observations and collective memories, this chapter captures the experiences and stories of the subjects and explores the complexities of finding meaning in developing a coalition.

Through the qualitative methodology of narrative inquiry, we positioned our chapter to retell our story and express an appreciation for our shared experience that helped to define and shape our sisterhood. Colette Daiute posits the following: "The power of narrative is not so much that it is *about* life, but that it interacts *in* life. Narrative is an ancient practice of human culture, enhanced today with technologies, personal mobilities, and intercultural connections" (xviii). Michael Connelly and Jean Clandinin often explore narrative inquiry in educational settings and argue that humans are storytelling organisms who, individually and socially, lead storied lives: "The study

of narrative, therefore, is the study of the ways humans experience the world" (Connelly and Clandinin 2). Through this approach, we explore our stories, and rather than looking for themes to emerge, we frame our story through meaningful, popular Black culture to situate our narratives. Through framing, we encapsulate our lived experiences to discover meaning in our coalition. Using personal journals and collective recollections through what JoAnn Franklin Klinker and Reese Todd refer to as "interviews with our memories," we uncover common themes of our experience before, during, and after forming the coalition that helped bind us as sisters (6).

Inquiry: Telling Our Stories

Cherell

I had already completed the master's program at Saint Louis University in 2009 and was also employed there at the time; so naturally, this would be a smooth transition. It had been on my mind to pursue the doctorate, but with being a first-generation college student, experiencing imposter syndrome, and having little support from my family to return to school (for an area that would not make me a millionaire), I struggled with the decision for a long time. After strong encouragement from my supervisor, with the potential to advance my career, I began the doctoral program in summer 2012. I was initially excited to be back in the classroom and thought this was the best choice personally and professionally. However, I did not expect that my educational pursuits would be so connected with my career advancements, and I quickly found myself in somewhat of a Pandora's box. I decided to completely withdraw from the program mid-semester, spring 2013, after completing only three classes. I figured I would cut my losses early on and just pursue another path for my education and career; however, my professor, who later became my mentor, suggested that I complete the course and then take a leave of absence from the program. I completed the leave of absence form for one year, signing it with the intent of never returning to complete my doctorate. I met with my mentor one final time, before the end of the semester, and she asked that during my leave of absence, I use the time to reflect on why I started the program, my research agenda, and what I wanted to gain personally in pursuing this degree without thinking about my

department's agenda. At the time, I had absolutely nothing to offer, as I could not see my potential without it being intertwined with the department. Out of respect for my mentor, I decided to use this time to challenge myself to attempt to answer these prompts.

Colette

January 16, 2007, a day after Dr. King's holiday, I began my career in higher education at Ohio University. On that day during my first meeting with my supervisor, she informed me that I needed to pursue my doctorate. It was my first day, and I was already being told that I needed to pursue a doctorate. I was mentally thrown and not sure how to take this information. I wanted to fully grasp my job responsibilities and learn the landscape of higher education before being told that I needed to go back to school. More importantly, I was a single mother that had a baby while earning my master's degree. I wanted to work and take time to enjoy my child before trying to balance work with raising my daughter and going back to school. My supervisor, who quickly became my mentor, saw a bigger picture for me that I did not understand at the time. She knew that as a single mother, I would need to maximize my earning and career potential and that by earning my doctorate, I would have the capacity to achieve more for my daughter and me. Over the next three years, I learned a great deal from her and listened to the reason why she wanted me to go back to school. My relationship with my mentor—an older white woman with a higher education career spanning over thirty years in higher education—had grown closer and more personal over time. After three years of employment at Ohio University, it was time for me to move back to St. Louis so that I could pursue my doctorate and have familial support. I promised my mentor that I would continue my education once I returned home; however, I was not exactly sure of my doctoral program of study. My mentor's final words before I left were "Whatever you pursue, make sure that it's a Ph.D. You want people to know that you did research and earned your degree."

It took me several years to figure out exactly what path I wanted to take. My master's degree was in counselling, and I thought about a doctorate in counselling. While I was researching doctoral programs, I took a couple of classes in spirituality with the thoughts of obtaining a degree in cultural studies and possibly teaching. Then I thought about

my dream position and what drew me to higher education, and it was the compassion of the deans of student affairs. I wanted to be like those people. So I reached out to people in those roles, and many had doctorates in higher education. I applied and was accepted to SLU's higher education program and began the journey in 2013.

LaTrina

It took me four years to commit to going back to school for a PhD after the first spark of an idea flickered in my mind. In 2009, during a summer class in my master's program, the first time I uttered out loud that I wanted to pursue the degree, imposter syndrome soon set in. A laundry list of reasons why it would not be a good idea to pursue graduate school ran through my mind like a ticker tape. It would take an internal tug of war, conversations with people, especially women who had already completed a doctoral program, and a written-out plan for me to take the leap not only to start the process of applying to a program but to also decide to enroll in the program that accepted me.

Once I stepped foot on the campus of Saint Louis University, I knew this experience would be like no other, but I had no idea how much my doctoral journey would shape my worldview. As a new doctoral student, balancing work, reading, writing, and social life was demanding, especially while doing it virtually alone. I did not know anyone at SLU, and although I challenged myself to meet people, that task became challenging, as I was one of the very few doctoral students in my program who did not work a fulltime job. As a graduate assistant in the Housing and Residence Life Department, I felt like I was being baptized by fire.

Pop Culture Frameworks

"A Seat at the Table"—Solange

The number of women in leadership positions in higher education remains relatively low despite the increasing number of women, including African American women, obtaining terminal degrees (Pratt-Clarke). Collectively, our purpose in obtaining doctorate degrees was so that we could secure leadership positions in the future. We all previously attended predominantly White institutions (PWIs), and many of our mentors were not people of colour, although they were

great resources and support systems. There was a desire within each of us to find mentorship from a woman of colour, specifically an African American woman in a leadership position, who would help us navigate this new adventure of the doctoral program and career advancement. We reached out to the upper-level administrators of colour and newly minted professors of colour to no avail. Either they were too busy to provide the mentoring we desired or just lacked interest in mentoring us at all.

Despite these failed attempts at mentorship, we did not allow this to discourage us but turned to our peers instead. We needed to create a different paradigm of mentorship, which resulted in finding what Menah Pratt-Clark describes as "sisters" and "other mothers." The shared goal of completing the doctoral program bonded our sisterhood. I met Colette during my brief sabbatical from the doctoral program through an introduction by my supervisor, and we collaborated on a diversity program initiative across our departments. Colette had begun the PhD program in 2013 and encouraged me to return, however, I could not yet see how my return could ever be possible. Nonetheless, through reflection, work-life balance, and even falling in love, I was able to restore my purpose and ambition. My time away from the program offered me an opportunity to set a research agenda directly connected to my personal and professional goals that made every milestone worth each mile. I came back fall 2014, entirely focused, full of potential, and centred in my own educational philosophy.

Solange's critically acclaimed album, *A Seat at the Table*, released at that time was said to "celebrate black culture, confront prejudice and explore the trauma of witnessing black people killed" (Shapiro). It simultaneously awakened within the three of us a fire and became our muse. What we did not plan on was the added impact of the work we would accomplish through our leadership on campus and in the higher education field, and the academic, cultural, and scholarly importance of our research agendas and findings. Through finding mentorship within our circle, we had established a seat at the table.

"Okay, Ladies, Now Let's Get in Formation"—Beyoncé

Surrounding yourself with likeminded people was essential to pursuing a doctorate degree. We had all taken a variety of classes together, through some combination, but never all three of us in the same course.

With LaTrina pursuing the program fulltime, she was ahead in most coursework and had moved on to the comprehensive exam and dissertation proposal stage, while Colette and I completed coursework. Colette and I began as accountability partners during some classes, sending reminders for upcoming projects and formulating ideas for the dissertation. LaTrina, ready to write her dissertation proposal, offered to create a writing group for Saturday mornings. Six people received the invitation, but only four people came to write or study. We wrote on several Saturday mornings for three to four hours to meet our writing goals for the week. So we began to build our community, and for the rest of the race, we had each other as we experienced every other stage of finishing this marathon called a doctoral program. It was also at that point that our trifecta of Black Girl Magic began to gel.

As various facets of the Black Girl Magic Coalition were being realized, it was clear that uplift, empowerment, and collective success were significant to the growth of the individuals. "Okay, Ladies, now let's get in formation," a line from *Lemonade*, Beyoncé's popular album at the time, became our mantra to inspire us to stay connected, organize the way we supported each other, and finish strong. For instance, we ensured that each of us was nominated for recognition for which we knew we deserved in the higher education field, on campuses, or at conferences. Likewise, we made sure that each member of the coalition signed up for opportunities that would enhance our skills and advance our development, such as dissertation writing boot camps and conference proposals, and if one could not make it, we made sure to share the knowledge. A large part of what Black Girl Magic meant to us was looking out for one another along our journey.

"Just Because We Are Magic, Does Not Mean We Are Not Real"—Jesse Williams

The journey of the doctoral degree is often like living in a mirage of analogies: "two steps forward and four steps back"; "the third degree"; and "fake it till you make it." Although these are euphemisms that make sense in their own context, they come very close to reality during a PhD program. The coalition secured the path that we could all finish this doctoral program together. As if divine intervention aligned us, the three of us started our research studies concurrently in early spring of 2017, and each defended her dissertation successfully on May

2, May 3, and May 10, and in the case of Colette, with honors. During the last few years in the program, we began to sprinkle magic at every turn. LaTrina and I were appointed to leadership positions within a higher education conference planning team and successfully executed an inaugural region-wide conference with amazing education sessions and notable Black women keynote speakers. Colette was recognized as "Woman of the Year" at Saint Louis University, and all three of us achieved successes through conference awards and presentations and being published in multiple publications. We had laid out the plan of the program, establishing all the goals and checkpoints, and the road appeared to be a "seamless integration" per the latest higher education buzzwords. Through the power of #BlackGirlMagic, we found the spirit and confidence to step out of those mirages and sprinkle our own magic.

Michelle Obama, Beyoncé Knowles-Carter, Misty Copeland, Serena Williams, and Ava DuVernay are just a few examples of extraordinary women who were charting the path to this social media movement of Black Girl Magic that would inspire and enlighten African American women for years to come. This was the exact inspiration we needed to move forward and persevere through the program and show our own Black Girl Magic. We changed our group text message name to #BlackGirlMagic. Every time we completed a milestone in the program, we celebrated each other in person and on social media with #BlackGirlMagic. We even gifted each other with wine glasses, t-shirts, and coffee mugs with #BlackGirlMagic imprints. At the end of everyone's dissertation defense, there was a special shoutout to Black Girl Magic.

Hallmarks of the Black Girl Magic Coalition

"Say It Loud…. I'm Black, and I'm Proud"—James Brown

Several catalysts precipitated the organic evolution of the Black Girl Magic Coalition and became hallmarks of the phenomenon. A significant hallmark was race. Race was an integral part of each of our identities; social identities, such as race and gender, can shape one's perceptions about realities (Evans et al., *Student Development*). The reality of race in St. Louis was that it was not only a significant undertone in the social dynamic of the city, but it was a construct

that was discussed uniquely in different corridors within the city. In some areas, race is not discussed or addressed directly, creating an uncomfortable atmosphere for those for whom race is a salient issue. Contrarily, in other regions, race was a major conversation and part of the rallying cry of many no matter their background. Discussions in the graduate courses about race poignantly promoted diversity and equity, but as a graduate assistant working in the Housing and Residence Life Department, LaTrina found racialized issues were always at the forefront in one way or another, whether it was discussed in programming with residents or training with resident advisors. Administrators on campus, including student affairs professionals with whom we all worked closely, were combating racially charged incidents on campus, which were analogous to more aggrandized racial issues in the city and the country.

This incongruence was unique to LaTrina as a new person to the city because the racial zoning, urban planning, and fair housing issues that, upon arriving she learned had shaped St. Louis, spoke volumes about the significance of race and racism in this metropolitan area. These effects were seen in the demographics of the city and university. For instance, Saint Louis University is situated in the heart of an urban area of St. Louis near downtown, and as of the 2010 US Census, the area was 47.6 per cent Black (US Census, 2010). The racial makeup of Saint Louis University students, however, did not reflect this number; in 2015–2016 enrollment numbers included 8,633 White students, 850 African American students, 1,113 Asian students, and 665 Hispanic students (Saint Louis University). A year after LaTrina and Colette started the doctoral program, Mike Brown, an eighteen-year-old unarmed Black man, was shot by a White police officer in the St. Louis suburb of Ferguson, sparking outrage not only in the metro area but also across the world. The incident, later widely known as "Ferguson," changed the global conversation about race, turned the St. Louis region upside down, and unequivocally shaped what would be the questions asked in each of our dissertations months later. It was within this context that race (and gender) was a salient identity for each of us. It was at this time that we clung to each other in our newly found support system even more.

"I Am Because We Are"—Ubuntu Theology

A widely recognized belief in African American culture is to ensure that family, whether biological or not, is taken care of through the sharing of resources, space, or knowledge (Littlejohn-Blake and Darling). Kinship, or a familial relationship between individuals not biologically related, describes the unique way that family is operationalized in many Black communities (Stewart). Within the coalition, we PhD students became sisters in the pursuit of not only a degree that is obtained at lower rates in the Black community (Pratt-Clarke) but also an educational and transformational experience that would shape us in many ways. This ideology became the foundation for another hallmark of Black Girl Magic Coalition, collective advising, which manifested in many forms.

In most academic programs, an advisor's style of advising and mentoring can affect what and how information is shared with students. Through many conversations, the three of us found that sometimes the information we received from our individual advisors was different, not necessarily contrasting, but one piece of information, for example, might have lacked an important detail found in another's advising session. We decided if we shared information we received from our individual advisors, we could maximize our knowledge; our new conversations proved to be very critical in us making sure we were learning about the same tips, strategies, deadlines, and resources. For example, as budding qualitative researchers, we were embarking on new territories for each of us; we were learning about research methodology and narrowing in on methods that aligned with our worldviews. Preparing to conduct ethical and meaningful research studies warranted that we implemented "collective advising" for ourselves that would help us not only successfully navigate research processes but also identify within our fields of research the gaps we needed to fill.

In a study of African American college students, participants illuminated what shaped their beliefs about college was a "need for self and group empowerment, which referred to the idea that the African American community at large benefits when one African American student is successful" (Carson 334). These college students valued receiving and imparting knowledge as part of the African American culture because of the perceived self-empowerment and community investment properties embodied within doing so: "Education was

important because it fostered a sense of liberation, control over their circumstances, and, for some, provided escape from negative life situations" (Carson 334). This same sentiment rang true through the collective advising experienced by this coalition of three Black women PhD students trying to harness Black Girl Magic to be successful.

"Relax, Relate, Release"—Whitley Gilbert

"Relax, relate, release" are the famous words quoted by Whitley Gilbert from "Hillman College" in the sitcom *A Different World*; this was also a lesson we had to learn as a coalition to endure the setups and comebacks that were yet to come. Pursuing a graduate degree is taxing on mental health and at times can become excruciatingly isolating. Feelings of isolation can lead to anxiety and depression, which is common among graduate students. (Evans et al., "Evidence"). We all found this to be true to some degree, balancing the stresses of the program while also trying to reach personal goals. Whenever someone hit a goal, it was a "praise report," even if it was only one article read in bed. Although this helped us bond and get things accomplished, we forgot to account for self-care, career exploration, family and relationship obligations, and imposter syndrome, which would slow the pace of this journey.

We had to rely on one another as accountability partners, not only to complete the work of the program but also to have a balance to maintain our relaxation time and practice self-care. Although we all shared the ultimate goal of completing our doctorates, we also all had different personalities and different coping strategies to complete this mounting journey. After a hard week of work, family obligations, and then dissertation writing, a Friday night would easily look very different for the three of us. The extrovert, Colette, could be found at an excellent jazz concert or a festival. The introvert, Cherell, was snuggled on the couch ready for a "Netflix and chill night" (but not by the *Urban Dictionary* terms). The ambivert, one who moves between both spectrums of an introvert and extrovert traits (Bernstein), LaTrina, could be anywhere in between walking her dog in the park to hitting the road for a quick trip. However, there was one commonality that we all equally shared and enjoyed: wine and Beyoncé; white or red; *Dangerously in Love* or *Lemonade*; chilled or room temperature; listening in one of our living rooms or going to the Formation tour concert.

This is where we became true sisters. This is where we could share our stories of families and friends and bond over tales from the classroom. Moreover, we could be transparent about walking in our imposter syndrome and tell our accounts of "fake it till you make it." Having the coalition provided not only a safe space but also a brave space for our mental health (Arao and Clemens). These spaces proved an environment in which we could freely talk about issues of oppression and marginalization, dream big, and not even think about having to codeswitch. These opportunities not only started our sisterhood but also cultivated our sisterhood. The coalition was our very own haven, and it became a sacred place where we could celebrate each other's victories but also fix each other's headscarves before walking out in public. As true doctoral students, we turned this journey of self-care and our coalition into a conference presentation: "Self-care Resources for Women in Student Affairs Utilizing Themes from Shonda Rhimes' Year of Yes: How to Dance it Out, Stand in the Sun, and Be Your Own Person."

Conclusion

Where would we be without #BlackGirlMagic? Divine intervention brought us together. If Cherell had not taken a sabbatical for a year, if LaTrina had succumbed to imposter syndrome, and if Colette had not moved back to St. Louis to be closer to family, this magical coalition would never have existed. Every step of the way, whether in writing mode or mommy mode, we sprinkled magic and celebrated one another.

The success of this social media campaign became deeper than celebrating the successes of Black women across the diaspora, but for us, it created a sisterhood. #BlackGirlMagic reminded us not only to reflect on the success of our sisters but also to understand that our successes were rooted in the commitment, sacrifices, and blessings of our ancestors, which is the magic that we continue to sprinkle today.

Works Cited

Arao, B., and K. Clemens. "From Safe Spaces to Brave Spaces." *The Art of Effective Facilitation*, edited by Lisa M. Landreman, Stylus Publishing, 2013, pp. 135-50.

Bernstein, E. "Not an Introvert, Not an Extrovert? You May Be an Ambivert." *Wall Street Journal*, 27 July 2015, www.wsj.com/articles/not-an-introvert-not-an-extrovert-you-may-be-an-ambivert-14380 13534. Accessed 12 Jan. 2022.

Carson, L. R. "'I Am Because We Are': Collectivism as a Foundational Characteristic of African American College Student Identity and Academic Achievement." *Social Psychology of Education*, vol. 12, 2009, pp. 327-44.

Connelly, F. M., and D. J. Clandinin. "Stories of Experience and Narrative Inquiry." *Educational Researcher*, vol. 19, no. 5, 1990, pp. 2-14.

Daiute, C. *Narrative Inquiry: A Dynamic Approach.* Sage, 2014.

Evans, N. J., et al. *Student Development in College: Theory, Research, and Practice.* 2nd Edition. Jossey-Bass, 2010.

Evans, T., et al. "Evidence for a Mental Health Crisis in Graduate Education." *Nature Biotechnology*, vol. 36, no. 3, 2018, pp. 282-84.

Klinker, J., and R. Todd. "Two Autoethnographies: A Search for Understanding of Gender and Age." *The Qualitative Report*, vol. 12, no. 2, 2007, pp. 166-83.

Littlejohn-Blake, S. M., and C. A. Darling. "Understanding the Strengths of African American Families." *Journal of Black Studies*, vol. 23, no. 4, 1994, pp. 460-71.

Patton, M. Q. *Qualitative Research and Evaluation Methods.* Sage Publications, 2002.

Pratt-Clarke, M. "Higher Education Leadership: One Black Woman's Journey." *Black Women in Leadership: Their Historical and Contemporary Contributions*, edited by J. D. Davis and C. Chaney, Peter Lang, 2013, pp. 145-59.

Saint Louis University. *2015-2016 Factbook. SLU*, 2016, www.slu.edu/provost/office-of-institutional-research/institutional-data/pdfs/2015-16-fact-book.pdf. Accessed 12 Jan. 2022.

Shapiro, Ari. "All Things Considered." *NPR*, 11 Nov. 2016, www.npr.org/2016/11/11/501165834/weve-always-had-a-seat-at-the-table-solange-on-conversations-that-heal. Accessed 12 Jan. 2022.

Stewart, P. "Who Is Kin? Family Definition and African American Families." *Journal of Human Behavior in the Social Environment*, vol. 15,

no. 2-3, 2007, pp. 163-81.

US Census Bureau. "U.S. Census Information: Quick Census Data." *Quick Facts*, 2010, quickfacts.census.gov/qfd/states/29/2965000.html#.TufeDKHrQAw.bitly. Accessed 12 Jan. 2022.

Wilson, J. "The Meaning of #BlackGirlMagic, and How You Can Get Some of It." *Huffington Post*, 12 Jan. 2016, www.huffingtonpost.com/entry/what-is-black-girl-magic-video_us_5694dad4e4b086bc1cd517f4. Accessed 12 Jan. 2022.

Chapter 11

Sister Circle: Guarding Sisterhood in Higher Education

Kalisha V. Turner-Hoskin, MaKesha Harris Lee,
and Arielle Weaver

Accdomccording to the National Center for Educational Statistics, in 2013 African American/Black women were the largest minority subgroup in higher education in the United States. However, Black women attending Predominantly White Institutions (PWIs) are exposed to numerous forms of exploitation and oppression (Phillips and McCaskill; Porter and Dean). Some of the specific challenges include racial battle fatigue (Hotchkins), isolation and alienation (Croom et al.; Winkle-Wagner), and racial microaggressive environmental indignities (Pierce; Sue; Hotchkins). Within these environments, it is important the perspectives of these women are captured and communicated in differing ways where their intersectional identities are captured with meaning and are not marginalized (Hotchkins).

The responsibility is not solely on the women of colour to navigate these obstacles and to make their voices heard; it is also the responsibility of the institutions. These institutions, especially PWIs, need to develop proactive coping objectives that aid in the women of colour holistic development, which helps to ensure positive experiences and retention (Davis et al.; Litchtenstein et al.; Hotchkins). Some examples of these proactive coping objectives include, but are not limited to, racially homogenous organizations, such as the National Pan-Hellenic

173

Council (Bonner; Hotchkins) and Sister Circles (Croom et al.). In these environments, the women can intermingle with other Black women who are students, faculty, and staff, where they can establish a supportive community and a sisterhood. To provide an environment that supports Black women in their development of racial identity, Sister Circle was created to serve first-year women of colour in university housing. This form of sisterhood allows women to share their lived experiences and establishes strong support systems to dismantle the feelings of isolation (Collins).

Through the act of sisterhood, Sister Circle provides Black women in higher education a brave space (Arao and Clemens) to not only explore and enhance their holistic development but to also build connections with other Black women. This organization uses Black Feminist Thought (Collins) as well as the Racial and Cultural Identity Development: Five Stage Model (Atkinson, Morten, & Sue) to give voice and illuminate the progression through racial identity development. Using the foundational knowledge of these theories, Sister Circle cultivates an environment for Black women to enhance their holistic development together through their community of sisterhood and defines sisterhood as a bond between women who share similar lived experiences. These similarities often include common career goals, personal interests, religious beliefs, and hometowns. Black Feminist Thought also encourages Black women to disconnect from negative stereotypes associated with their racial identity development.

Sister Circle is intentionally designed with two main program components: mentorship and holistic programming. The mentorship experience connects first-year women with an upper-class mentor and a facilitator. The holistic programming encompasses a myriad of topics to contribute to the overall growth of each woman and focuses on topics of social, cultural, and academic enhancement. The programming components also ensure regular communication between participants and facilitators, providing an opportunity to check in on the connections being built in the mentoring relationships.

Mentorship

Historical research explores the issue of women of colour having a hard time connecting to a mentor once they enter the workforce (Ragins and

Cotton). This issue also rings true for student women of colour in higher education (Croom et al.). The women who attend a PWI are often entering these universities unprepared to face many cultural and political differences (Hausmann, Schofield, and Woods). To address these differences, Sister Circle utilizes the mentorship component to build relationships within their community to help navigate the spoken and unspoken rules in higher education. One of the participants stated, "[Sister Circle] helped me have a support system and people I could reach out to."

Black women rely heavily on the support of one another (Porter and Dean). Sister Circle defines support as an act of encouragement over time, which includes the sharing of knowledge, advice, perspectives, constructive feedback, and overall empowerment. The Sister Circle's mentorship component is designed for each first-year student to be matched with an upper-class mentor who can be instrumental in their success. The mentors are trained and assigned a mentee based on various interests (e.g., major, hobbies, or hometown) (Bradley and Sanders). The goals of the training include how to create brave spaces, practice positive role modeling, and establish an effective mentor-mentee relationship. The pair is then assigned to a Sister Circle facilitator, who provides a second layer of mentorship as they navigate difficult challenges and their identity development. Support is critical to the persistence and satisfaction of the college experience (Outcalt and Skewes-Cox).

This second layer of mentorship was created so that the women could see other women of colour as role models who serve in campus leadership positions. The facilitators serving as role models, must exemplify the same positive interactions and growth that they want their students to actively display. According to one of the participants: "[The facilitators] served as an illustration of what a Sister Circle is supposed to look like. The way that you all interact ultimately laid the foundation for how we were to conduct ourselves." Another participant stated, "They just made us feel comfortable, and they always spoke to us even outside our meetings and just genuinely cared for us academically and personally." This structure also allows the facilitators to gain invaluable knowledge on student culture and challenges, empowering them to better serve as advocates for students in their professional duties. Even though the facilitators conduct monthly programs as large

groups, the students are highly encouraged to continue building authentic mentoring relationships with one another and the facilitators outside of the scheduled programming sessions.

Holistic Programming

Black women are less likely to benefit from the campus-wide traditional social integration at a PWI (Croom et al.; Winkle-Wagner). Programs like Sister Circle create an environment that minimizes these challenges and provides an avenue where Black women can be better integrated into campus life. The Sister Circle facilitators develop holistic programming around social, cultural, and academic topics to actively engage the women. These programming sessions aim to be brave spaces that are focused on listening to others, respecting, and challenging ideas, and learning from one another. A brave space is an environment in which the women are challenged to participate and are encouraged to expand their ways of thinking. The term brave space was first popularized by Brian Arao and Kristi Clemens in their book *The Art of Effective Facilitation: Reflections from Social Justice Educators*. The creation of the brave space in the programming sessions is done through setting ground rules, fostering authenticity when participating, welcoming conflicting viewpoints, and requiring confidentiality regarding what is shared during the conversation. According to a participant, "[Sister Circle] gives people a space to unload their problems and get help/advice from people who have been where they are." In the different sessions, the young women learn how to navigate and cope with sexist and racist environments they may encounter while attending a PWI (Croom et al.; Patton and McClure; Winkle-Wagner). Through intentional conversations, the women often discover that their shared lived experiences allow for them to have a more meaningful connection with one another.

It has been documented that a strong sense of belonging is tied to positive results, including increased persistence to finish a degree (Hausmann, Schofield, and Woods) and overall better psychological outcomes (O'Keefe). In this context, a sense of belonging is loosely defined as whether an individual feels included in the college community (Hurtado and Carter). Sister Circle offers programming that is social in nature and is designed to enhance the connection and

bond between the women. Many of the programming topics are suggested by the students and then implemented by the facilitators, which include real talks, meet, and greets with Black women faculty/staff on campus, and off-campus outings.

Additional programming is geared towards academics; the topics focus on study skills, campus resources, student/instructor engagement, home-to-campus transition, time management, goal setting, and campus-involvement opportunities. Other sessions introduce topics such as self-care, the portrayal of Black women in the media, and healthy relationships. According to the surveyed participants, over 87 percent found the topic discussions relevant to their experience, and 100 percent agreed or strongly agreed that program helped them to develop healthy relationships with other women of colour. Lastly, social media is used as a platform for the women to continue to connect with one another outside of the programming sessions to strengthen their relationship. These communication mediums also provide added opportunity for the women to support one another by sharing about their involvement in the community and around campus.

As stated by a participant, "Sister Circle is beneficial for students because it allows for other women of color to have a space where they can connect and help each other grow." The women find support in their mentors and facilitators who reinforce the lessons of life balance while pursuing a degree. Being in sisterhood with one another establishes an environment that encourages the success of each participant and provides the additional support needed to navigate and overcome the challenges they encounter at a PWI. In this brave space, in which the women are encouraged to challenge ideas and thoughts, the participants emerge more appreciative of their cultural identity and confident in their abilities. Overall, the women participating in the program learn the importance of creating sisterhood as well as the positive impact it can have on their development and success in higher education.

Note: This Sister Circle program is the winner of a regional Outstanding Project Award. All program assessment data shared in this chapter have been approved by the institutional review board.

Works Cited

Arao, B., and K. Clemens. "From Safe Spaces to Brave Spaces: A New Way to Frame Dialogue around Diversity and Social Justice." *The Art of Effective Facilitation: Reflections from Social Justice Educators*, edited by L. Landreman, Stylus, 2013, pp. 135-50.

Astin, A. W. *Assessment for Excellence: The Philosophy and Practice of Assessment and Evaluation in Higher Education.* Oryx Press, 1993.

Atkinson, D. R., G. Morten, and D. W. Sue. *Counseling American Minorities: A Cross-Cultural Perspective.* 5th ed. McGraw-Hill, 1993.

Bonner, F. A. "The Historically Black Greek Letter Organization: Finding a Place and Making a Way." *Black History Bulletin*, vol. 69, no. 1, 2006, pp. 17-21.

Bradley, C., and J. Sanders. "Contextual Counseling with Clients of Color: A 'Sista' Intervention for African American Female College Students." *Journal of College Counseling*, vol. 6, 2003, pp. 187-91.

Collins, P. H. *Black Feminist Thought: Knowledge, Consciousness, and the Politics of Empowerment.* Routledge, 2000.

Croom, N. N., et al. "Exploring Undergraduate Black Women's Motivations for Engaging in 'Sister Circle' Organizations." *NASPA Journal About Women in Higher Education*, vol. 10, no. 2, 2017, pp. 216-28.

Davis, R. J., et al. "The Impact of the Gates Millennium Scholars Program on College Choice for High-Achieving, Low-Income African American Students." *The Journal of Negro Education*, vol. 82, no. 3, 2013, pp. 226-42.

Hausmann, L. R., J. W. Schofield, and R. L. Woods. "Sense of Belonging as a Predictor of Intentions to Persist among African American and White First-Year College Students." *Research in Higher Education*, vol. 48, no. 7, 2007, pp. 803-39.

Hotchkins, B. "Black Women Students at Predominantly White Universities: Narratives of Identity Politics, Well-Being, and Leadership Mobility." *NASPA Journal About Women in Higher Education*, vol. 10, no. 2, 2017, pp. 144-55.

Hurtado, S., and D. F. Carter. "Effects of College Transition and Perceptions of the Campus Racial Climate on Latino Students' Sense of Belonging." *Sociology of Education*, vol. 70, 1997, pp. 324-45.

Musu-Gillette, L., et al. (2016). "Status and Trends in the Education of Racial and Ethnic Groups 2016 (NCES 2016-007)." *US Department of Education, National Center for Education Statistics*, 2016, nces.ed.gov/pubsearch. Accessed 13 Jan. 2022.

Outcalt, C., and T. Skewes-Cox. "Involvement, Interaction, and Satisfaction: The Human Environment at HBCU's." *The Review of Higher Education*, vol. 25, no. 3, 2002, pp. 331-47.

Patton, L. D., and M. McClure. "Strength in the Spirit: African-American College Women and Spiritual Coping Mechanisms." *Journal of Negro Education*, vol. 78, no. 1, 2009, pp. 42-54.

Phillips, L., and B. McCaskill. "Who's Schooling Who: Black Women and the Bringing of the Everyday into Academe, or Why We Started 'the Womanist.'" *Signs: Journal of Women in Culture and Society*, vol. 20, no. 4, 1995, pp. 1007-18.

Pierce, C. "Stress Analogs of Racism and Sexism: Terrorism, Torture, and Disaster." *Mental Health, Racism, and Sexism*, edited by C. Willie et al., University of Pittsburgh Press, 1985, pp. 277-93.

Porter, J. C., and L. A. Dean. "Making Meaning: Identity Development of Black Undergraduate Women." *NASPA Journal about Women In Higher Education*, vol. 8, no. 2, 2015, pp. 125-39.

Ragins, B., and J. Cotton. "Easier Said Than Done: Gender Differences in Perceived Barriers to Gaining a Mentor." *Academy of Management Journal*, vol. 34, no. 4, 2017, pp. 939-51.

Sue, D. W. *Microaggressions in Everyday Life: Race, Gender, and Sexual Orientation*. John Wiley & Sons, Inc., 2010.

Winkle-Wagner, R. "The Perpetual Homelessness of College Experiences: Tensions between Home and Campus for African American Women." *The Review of Higher Education*, vol. 33, no. 1, 2009, pp. 1-36.

Chapter 12

Sankofa Sisters: Returning to Sisterhood to Secure Our Progress

Angel Miles Nash, Tara Nkrumah, Rhonda Gillian Ottley, Kimberly L. Mason, and Devona F. Pierre

*Throughout this chapter, the italicized text indicates integrated autoethnographic narratives

Black women doctoral students are often treated like invisible members of the academy while they work in faculty, teaching, administrative, and classified staff roles in spaces that neglect their wellbeing. Their experiences include ostracism, isolation, and minimization as they attempt to navigate their academic journeys (Hotchkins). The lived realities of Black women doctoral students are often amplifications of the struggles that Black women higher education professionals encounter. Black women doctoral students have to endure the same oppressions (e.g., microaggressions, racism, and sexism) from faculty and peers while negotiating layers of institutionalized power (Robinson). Their experiences are further exacerbated because of the positions they are in as they pursue approval and acceptance of their scholarship in their academic programs.

As five Black women, situated in four southeastern predominantly white institutions (PWIs), we are affected by the perpetuation of challenges caused by racism, sexism, and the intersection of the two. Responsively, we developed a collective autoethnography (Cortes-Santiago et al.) to operationalize tenets featured in the racialized and gendered theory of Black feminist thought (BFT) (Collins, *Black Feminist Thought*). This method, chosen for its capacity to unite the

authors' voices across similar and unifying experiences, enabled us to develop scholarship that uplifts Black women. In doing so, we nurtured each other in transformative ways that secured our academic success. This contribution to current higher education literature is intended to become an example for future graduate students to establish their own networks of support and accountability. By strategizing ways to cultivate support and to connect across our far-reaching academic communities, we endeavour to guide Black women doctoral students who will traverse similar paths after us (Bertrand Jones et al.).

The tenets of BFT reify the experiences of Black women doctoral students in higher education. Patricia Hill Collins defines BFT as a then "emerging, cross-disciplinary literature [that] consists of ideas produced by Black women that clarify a standpoint of and for Black women ... [containing] observations and interpretations about Afro-American womanhood that describe and explain different expressions of common themes" (S15-S16). The need to establish a voice that situates Black women's unique experiences in the tapestry of higher education remains critical for women of colour in the academy. As Black women doctoral students and faculty navigate collegiate spaces that are majority white in numbers and traditionally patriarchal in nature, they endeavour and often fight to institutionalize their perspectives and value among those who are more dominant (Feagin; Harris).

In this chapter, we contextualize our experiences as Black women in the academy and as participants and a mentor in the Sisters of the Academy Institute (SOTA), Research BootCamp (RBC). We then situate our narratives utilizing BFT, before concluding with findings from our collective writing experiences.

Contextualizing Our Identities as Black Women

As authors, our participation in the 2017 RBC was the genesis of our sisterhood. Angel was a fourth-year PhD student in the Educational Administration and Supervision program. Tara was a third-year PhD student in the Educational Leadership and Policy Studies program. Kimberly was a third-year PhD student in the Counsellor Education and Supervision program, and Rhonda was a fourth-year PhD candidate in the Sport Management program. Devona was a higher education administrator with fifteen years of experience.

Black Women in the Academy

Research indicates that while 50.7 per cent of doctoral degrees conferred in the United States are given to women, only 4 per cent of those degrees are awarded to Black women (Kim). Young M. Kim cites American Education Council statistics showing how this proportion has remained consistently low over time. Between 1998 and 2008, this statistical ratio increased by only 0.5 per cent (Kim). As of 2017, 1.1 per cent of Black women held doctoral degrees (Espinosa et al.. The underrepresentation of Black women in advanced academic studies leads to similarly low figures in higher education faculty populations.

Statistics from the Integrated Postsecondary Education Data System illuminate the condition of Black women faculty in comparison to their colleagues. When disaggregated by social and professional identifiers, including race, gender, ethnicity, and academic rank, Black women in higher education faculty are only 3 per cent of all who occupy faculty positions (US Department of Education). Although there has been an increase in the number of Black women receiving doctoral degrees, the overall low totals across doctoral education and faculty populations suggest an ongoing need to fill the gap between completing the doctoral degree and gaining access to the professoriate. The consistent underrepresentation has resulted in an overwhelmingly diminished portrayal of Black women's success, which has prompted intentional efforts to promote and secure Black women's place in academic spaces that have traditionally marginalized them and their work. These efforts, including those made by SOTA, have been enacted by professional organizations, institutions, and individuals committed to increasing diversity across the academy.

As a result of the racism, sexism, and intersectional effects of oppression faced by Black women, they are often left navigating hegemonic spaces that do not include the essential advising they need to succeed (Bertrand Jones et. al.). The importance of socialization that includes empathetic guidance is an apparent result of the unique issues Black women have to negotiate to earn their doctoral degrees and secure academic positions (Blockett et al.). Whereas unique forms of socialization include self-initiated peer mentorship (Khalil and Edwards) and influential formalized advising networks, the institutionalization of such examples is less common (Shavers et al.).

One exemplar, SOTA, has a long-standing history of providing

advising and mentoring for Black women doctoral students in a nurturing, productive environment (Davis and Sutherland). Among its programs, SOTA offers a biennial RBC that guides participants through the development of a sound research agenda, the conceptualization of their research methodology, the successful completion of their dissertation, the development of manuscripts for publication, and advisement/mentorship through the tenure and promotion process. The week-long, holistic opportunity provides a critically conscious space for Black women doctoral students and junior faculty to grow and nurture their steadfastness towards producing scholarship. Dedicated faculty mentors, including the higher education administrator among us, fuel the program's success. This engaging environment has produced numerous scholars who have successfully represented the unique voices of Black women doctoral students, including four of the authors of this book chapter. Through this chapter, the aforementioned authors, joined by an RBC cofounder and mentor, collectively exemplify the vision of SOTA by developing this scholarship through collaboration.

The Research BootCamp was conceived during a sister circle of leadership team members; in the circle, there was a discussion of the critical components necessary to complete a doctoral dissertation, from proposal writing to dissertation defense. Additionally, advice for faculty member success as well as tenure and promotion were discussed. During the numerous sister circles and strategy sessions, a week-long program with a holistic (mind, body, and spirit) approach to address the needs of Black women in the academy was developed. The approach considered the lives Black women live at the intersection of race and gender as well as the responsibilities these women have in their own varying roles within their families and communities as well as within the academy. Although the overall objective of the RBC is to assist doctoral students and junior scholars in developing sound research projects, pursuing collaborative scholarship, creating community, and entering the academic pipeline to increase our presence throughout the academy were byproducts of this program.

Even though a growing amount of literature explores the strategies that Black women academicians use to develop and maintain their internal and external networks (e.g., Rasheem et al.; Shavers et al.; Turner Kelly and Winkle-Wagner), fewer articles explore the strategies

Black women doctoral students use to occupy the ranks of faculty. Since detrimental institutional social conditions (e.g., racism, sexism, and microaggressions) affect doctoral students (Rasheem et al.), it is of utmost importance that we record the processes, discourses, and accountability that led us to find success in the SOTA RBC pipeline program. The purpose of this chapter is, thus, to chronicle the perspectives of four Black women doctoral students as well as the mentor and cofounder of the RBC.

Situating Our Narratives

I (Angel) reflected on the origins of our sisterhood: the SOTA RBC. These thoughts validate the significance of giving our voices their due space:

> SOTA RBC is not simply an experience—it is an epiphanic movement. It is space in which I discovered, accepted, and embraced the fact that I am a part of a sisterhood that cares about and cherishes my scholarly advancement. At different points along the course of an intense week, I realized that the S in SOTA was on purpose. I rested in the sheer elation that before I was anything else, I was a sister among many sisters. I realized this in classes where I was finally unafraid to share my questions, in late-night suite meetings where I was free to offer my thoughts, in uninterrupted brainstorming sessions with senior scholars where I was able to share my frustrations, and in midnight ice cream runs where I was excited to share my dreams. SOTA is paramount to our success because in the large majority of every other part of our experience along our academic journey, we are reminded that we are strangers in the academy. Whether we face challenges with classes, colleagues, or faculty, we are constantly fed empty calories that tell us we are outsiders trying feverishly to make our way in. That is not the case in SOTA. SOTA equals nourishment. It is the equitable dose of attention and scholarly guidance that we need to succeed along the path to the goal of getting our first meaningful stamp of approval in the academy—our doctorate.

BFT

Utilizing a framework centring the lived experiences of Black women in collegiate settings, we explored one critical raced-gendered epistemology: BFT. It challenges the idea that Black women's lived experiences are identical to those of their white counterparts. Collins outlines the lack of other feminist theories that include Black women's perspective. These feminist theories force Black women to assimilate, ultimately resulting in reinforced oppression. BFT incorporates various aspects of Black women's identities, including race, gender, sexual orientation, socioeconomic status, political views, and educational background. Collins ascertains three key themes of BFT: (a) self-definition and self-valuation; (b) the interlocking nature of oppression; and (c) the importance of Black women's culture (Collins). All three of Collins's themes are evident in Black women's experiences in higher education.

Self-definition and self-valuation. Self-definition encompasses "challenging the political knowledge-validation process that has resulted in externally-defined, stereotypical images of Afro-American womanhood" (Collins S16). Black women in graduate programs and faculty roles contest assumed roles that relegate them to an undervalued inferior position in the academy (Harley). Conversely, self-valuation emphasizes "the content of Black women's self-definitions—namely replacing externally-derived images with authentic Black female images" (Collins S17). Collins charges Black women in the academy to identify then redefine their existence in empowering ways.

Interlocking nature of oppression. Scholars in such fields as sociology, law, and psychology acknowledge the multiple layers of marginalization that exist for Black women. Kimberlé Crenshaw identifies this phenomenon as intersectionality and defines it as a space in which "the experiences women of color are frequently the product of intersecting patterns of racism and sexism [that are not] ... represented within the discourses of either feminism or antiracism" (1243-44). This exclusion occurs on college and university campuses when Black women do not feel thoroughly supported by offices and programs that focus solely on one aspect of their identity (Jean-Marie et al.).

Importance of Black women's culture. In *Black Feminist Thought*, Collins acknowledges the influence of bell hooks's *From Margin to Center*, as she concludes with her acknowledgment of Black women

intellectuals' ability and responsibility to redefine their culture. Specifically, hooks expands on the history of Black women and the inclusiveness of intellectuals. The culture of Black women was not initially included in feminism. Although their identities were the epitome of feminist culture, they were ignored because they were not members of the white bourgeois (hooks). hooks reexamines and contextually explains sisterhood within Black feminist culture, whereas Collins describes components of the Black woman experience, such as sisterhood (Dill), that were less explored at the time. Sisterhood has now become an increasingly salient part of the way Black women doctoral students' lives are defined and researched (Harris). The "sisterly connectedness" that Black women share with one another through friendships and mentoring can motivate them to persist, which positively influences their academic career (Patton and Harper 69). Through our narratives, which express self-definition and self-valuation, we intellectually add to our culture in the ways that Collins and hooks prescribe. Our scholarship reflects the interlocking nature of oppression by presenting the commonalities across our lived experiences. Similar accounts detailed throughout literature explore Black womanhood.

Literature Review

Our autoethnography was grounded in two ideas, which have proved their importance in understanding Black doctoral women's experiences: critical friends' groups and sister circles. Critical friends' groups and sister circles formalize Black women's support of one another. The collective nature of these mechanisms is paramount to the survival of Black women in the academy.

Critical Friends Group

Critical friends' groups (CFGs) are professional learning communities consisting "of small groups of educators coming together voluntarily and regularly to have structured professional conversations about their work" (Gunbay and Mede 3056). Researchers have posited that the primary aim of CFGs is to foster a supportive environment in which one can make meaningful connections and expand their knowledge

and skillset (Appleton; Moore and Carter-Hicks). The approach is increasingly used as a mechanism for developing student-learning communities.

CFGs are essential in creating a framework that allows for critical feedback in a supportive environment; it offers the opportunity to exchange professional ideas and learn from peers. After reviewing the impact of CFGs, Ellen Key (2006) made four main claims relating to their effectiveness: they foster a culture of community and collaboration, enhance teacher professionalism through encouragement, facilitate a change in one's thinking and practice, and affect student learning because their needs are addressed. In their research focused on the Carnegie Project on the education doctorate, Valerie Storey and Rosemarye Taylor corroborate the efficacy of CFGs in higher education. Intrinsically, our interactions as doctoral students demonstrated the benefit of CFGs in the graduate experience. As a CFG, we operated as a small, professional learning community. Our work also illustrates the tenets of sister circles, which imply a sense of community, unity, and like-mindedness.

Sister Circles

Sister circles historically have been operationalized by Black community organizations, churches, and Black women's clubs as avenues to raise awareness about physical health (Neal-Barnett et al., "In the Company") and positively influence Black women's wellbeing in the academy. Recognizing sister circles' therapeutic influence has led to studies not only in health and social science but also in higher education as well as in work environments deemed hostile towards Black women (Croom et al.; Fries-Britt and Turner Kelly; Neal-Barnett et al., "In the Company"; Winkle-Wagner). Moreover, sister circles provide support that is fortified by existing friendships, fictive kin networks, and endemic community-building relationships among Black women (Neal-Barnett et al., "Sister Circles").

Addressing issues ranging from motivation to intervention to wellness, sister circles educate and teach Black women strategies to thrive (Neal-Barnett et al., "In the Company"). Natasha Croom et al. explored undergraduate Black womyn's (which they spell with a "y" to avoid sexism) motivation for engaging in sister circles, which included:

understanding how Black womyn coexist; seeking role models with shared experiences for purposes of receiving guidance; and having a place/space to commune freely in discussion about pertinent issues where they could be themselves and be understood. Likewise, in their study on retention methods, Sharon Fries-Britt and Bridget Turner Kelly reveal how Black women professors at predominantly white institutions form sister circles to overcome isolation and oppression. As documented in the literature, sister circles use sisterhood as a way to resist the social and political inequitable norms encouraged by racism and sexism. Sister circles enable Black women to combat the nuances of racism and sexism, including the negative stereotypes impressed upon them, the invalidation of their research, and the devaluation of their academic prowess in higher education as they pursue a more socially just academy.

Methods

As Black women continue to be understudied in literature centring graduate student experiences, we embarked upon an autoethnographic journey that included twenty-five weekly accountability meetings (ninety minutes to two hours each) conducted on an online video platform. During the 2017–2018 academic year, we used individual and collaborative written journaling to document our academic and professional progress. We read and coded one another's journal entries using a Google spreadsheet. This multi-level qualitative coding method (Saldaña) included the identification of relevant tenets that aligned with BFT. Our data, which included written narratives and analytic memos, evidenced our process of self-valuation and self-determination.

Reflecting on our shared experience emboldened us to articulate our collective definition of sisterhood. By examining the ways we connected over our week-long RBC experience and through subsequent weekly meetings, we identified themes that mirrored the essence of unique sisterhood. Tasked with detailing the components of sistering relationships, we separately explained what we believed. Subsequently, we developed a collaborative articulation of sisterhood anchored in each of our identified themes.

The Conceptualization of Sisterhood through Autoethnographical Narratives

The co-constructed definition of sisterhood is an amalgam of our reflections on the meaning of our collective experiences. We developed a trusted space over time grounded in nourishment, accountability, rejuvenation, and affirmation. Our resulting collective summary, proffered here, is inclusive of our thoughts and beliefs about our mutual bond.

Nourishment

Sisterhood provides *nourishment* as Black women *nurture and uplift one another, allowing the development of inclusive friendships in which one can voice her opinions without being judged, all while receiving encouragement.* In these *webs of support* within the academy, *optimism is gleaned,* and *resilience is personified.*

My (Rhonda) memories of my experiences at SOTA RBC include clear thoughts of how time with my coauthors fuelled my resolve to complete my dissertation while providing nourishment for my soul:

> I had never been surrounded by so many Black women before attending SOTA RBC, and they were all extraordinary. Just being around such brilliant minds was inspiring. I loved the personalities of my suite sisters. There were no egos and no confrontations, just camaraderie. The SOTA RBC was my first intensive writing bootcamp, and I had never met a group of women who were so empowering and encouraging; my suite sisters were, and have remained, music to my heart. We listen to one another, and offer different opinions, which are met with an open mind. It's refreshing to have a group of Black women praying that you succeed. This BootCamp was the beginning of a new chapter for me—one where I can foster positive relationships with Black women in academia that I never had before. Subsequently, I continue to receive encouragement from women experiencing the same struggles, even if in a different setting. I look forward to a rewarding future with these women, and by God's grace, I hope we continue to nourish each other.

Accountability

Sisterhood ensures *accountability* as friends *uphold each sister, emboldening her to flourish and intentionally succeed with purpose.* Likewise, the sistering relationships are a *bloodline privilege, as they are liberating rights that offer true belongingness that connect women across diasporic spaces and transcend boundaries in ways that are only understood by the women who share them.* Reminiscing on the genesis of our sister circle at SOTA RBC reaffirmed my (Kimberly) positive outlook on the power of shared accountability.

> *I was thankful that my suitemates decided we would have what she called a "sister circle." We would gather and discuss our updated research presentations. I was all for it because assistance is always needed, and these women proved to be smart. It was funny because I know smart Black women exist; it was just that my peers at my home institution did not fit these characteristics (as I was the only Black woman), hence my excitement. I forgot to consider my acceptance or rejection of their feedback to my research project. I began a mantra to keep my words at a minimum in an effort to control their responses. However, this mantra was irrelevant because there was a full embrace; they absorbed all that I shared, and we, as a circle, as sisters, debated on what I should do with my project. My sisters did not mind offering the time and attention they gave to my work. Symbolically, I gained additional family members, specifically sisters. For me, these suitemate sisters had their "ish" (stuff) together, and I was the one trying to keep up. During this circle, there was magic, at least for me. It was like I had known these women all my life; they didn't mind my language or my humour; they laughed with me.*

Rejuvenation

Sisterhood delivers *rejuvenation.* As women *guide, repair, and walk along their life journeys together,* they *evolve into their better selves.* This shared journey enables a *restorative ethos in which women nurture each other through encouragement and sustaining engagement.*

Recollection of the critical incident of rejuvenation during SOTA RBC enabled me (Tara) to tap into the spiritual power of sisterhood.

After a long day, I was touched by the selfless gestures of each sister's openness to meet in a circle and share her research during a late-night sister circle. Despite being fatigued, we made sure to fully engage in the process of providing constructive feed-back. As we asked Angel questions about her research, it was a group effort to refine her upcoming presentation. I took note of Kimberly's and Rhonda's participation; each became so passionate while rendering suggestions and ideas. Moved by their energy to secure her success, I attributed their personal investment to Angel as return payment. Over and over, Angel reached out to question if we were supported and to provide assistance. Jokingly, I declared, "Angel watches over us" as she unequivocally lived up to her name. At 12:25 a.m. one night, and not wanting to extend more into the early morning hours, we concluded our sister circle with my research. Being traumatized the day before because of my underestimation of presentation time, I appreciated the opportunity to share the components that I previously omitted. The way my research was received touched me. Instantly, Rhonda's, Kimberly's, and Angel's words awakened my purpose and gave me new life. It felt familiar. I had entered into a space of strength and endless possibilities.

Affirmation

Finally, sisterhood bestows *affirmation*. While on the journey to create a distinctive experience to demystify ascertaining success in the academy, SOTA has contributed to increasing the number of Black women completing their doctoral degrees and earning promotion and tenure. By capturing the unique bond that Black women have and including that essence in the programmatic components of the RBC, SOTA has led the way in improving academic and professional experiences for Black women:

My (Devona) work with the authors sparked fond memories of the sisterhood bonds that led to the creation of the RBC. SOTA endeavoured to create an experience for Black women that took into account our holistic identities as Black women. As a part of the team who founded the RBC, and being in the room with others who sought a remedy to the low numbers of Black women completing their doctoral degrees, I often wondered if we had the impact we

intended. The RBC was conceived during a sister circle of leadership team members. While in the circle, we discussed the critical components of doctoral dissertation completion and of faculty tenure and promotion. During the numerous sister circles and strategy sessions, we developed a weeklong program with a holistic (mind, body, and spirit) approach to address the needs of Black women in the academy. The approach considered the lives we live at the intersection of race and gender as well as the responsibilities we have in our varying roles in our families, communities, and the academy. While the overall objective of the RBC is to assist doctoral students and junior scholars in developing sound research projects and collaborative scholarship, the creation of community through sisterhood bonds like this are by-products of this program. This affirms the RBC goals have not only been met but exceeded.

Discussion

Building on the BFT framework, as well as CFGs and sister circles, the RBC was intentionally designed to support Black women through these lenses and by using these approaches. The collective approach is a consistent thread throughout the RBC experience, from the roommate/suitemate pairing to the senior scholar assignments and many points in between. An intentional collective mentality complements the individual's goals. For instance, although the authors in this chapter discuss their individual experiences, they often refer to their success relative to the collective and how the collective contributed to their goals. Through this shared experience at the RBC, they were able to define and cite examples of what sisterhood encompassed, including nourishment, accountability, and rejuvenation.

The RBC will continue to be not only an open space for Black women in academia to find support for their academic pursuits but also a place that facilitates the development of organic relationships and partnerships that extend beyond the academy. The authors of this chapter captured the essence of the RBC and tried to continue the holistic approach by providing nourishment, accountability, and rejuvenation through their CFG and sister circle.

Conclusion

Our scholarly collaboration was the result of an unprompted union galvanized by the RBC. The collective exchange led to a sisterhood that embodied nourishment, accountability, rejuvenation, and affirmation. Importantly, as our interactions continued, we sought comfort in the fellowship that nurtured our perseverance to achieve our academic goals. Conversations devoid of judgment and full of honesty assisted us in identifying one another's strengths, which in turn, energized our progress. Our unity did not minimize the fatigue often experienced in oppressive academic spaces, nor did it subjugate the layers of marginalization. Instead, our sisterhood provided a community to confide in one another and affirmed our ability to persevere.

During the development of our collective autoethnography, we realized several personal academic victories among the five of us. These successes included the completion of two dissertation proposal defenses, two conferred doctoral degrees, a tenure-track faculty position, a postdoctoral research associate, a national fellowship, and a National Science Foundation grant focused on broadening the participation of women of color in the academy. Our productive network continues to undergird our commitments to actualizing our goals by returning to the true essence of sisterhood and reifying the social change for which we strive.

Works Cited

Appleton, C. "'Critical Friends,' Feminism and Integrity: A Reflection on the Use of Critical Friends as a Research Tool to Support Researcher Integrity and Reflexivity in Qualitative Research Studies." *Women in Welfare Education*, no. 10, 2011, pp. 1-13.

Bertrand Jones, T., J. Wilder, and L. Osborne-Lampkin. "Employing a Black Feminist Approach to Doctoral Advising: Preparing Black Women for the Professoriate." *The Journal of Negro Education*, vol. 82, no. 3, 2013, pp. 326-38.

Blockett, R. A., et al. "Pathways to the Professoriate: Exploring Black Doctoral Student Socialization and the Pipeline to the Academic Profession." *Western Journal of Black Studies*, vol. 40, no. 2, 2016, pp. 95-110.

Collins, P. H. *Black Feminist Thought: Knowledge, Consciousness, and the Politics of Empowerment.* 2nd ed. Routledge, 2000.

Collins, P. H. "Learning from the Outsider Within: The Sociological Significance of Black Feminist Thought." *Social Problems,* vol. 33, no. 6, 1986, pp. S14-S32.

Cortes Santiago, I., N. Karimi, and Z. R. Arvelo Alicea. "Neoliberalism and Higher Education: A Collective Autoethnography of Brown Women Teaching Assistants." *Gender and Education,* vol. 29, no. 1, 2017, pp. 48-65.

Costa, A. L., and B. Kallick. "Through the Lens of a Critical Friend." *Educational Leadership,* vol. 51, no.2, 1993, pp. 49-51.

Crenshaw, K. W. "Mapping the Margins: Intersectionality, Identity Politics, and Violence against Women of Color." *Stanford Law Review,* vol. 43, no. 6, 1991, pp. 1241-99.

Croom, N. N., et al. "Exploring Undergraduate Black Womyn's Motivations for Engaging in 'Sister Circle' Organizations." *NASPA Journal About Women in Higher Education,* vol. 10, no. 2, 2017, pp. 216-28.

Davis, D. J., and J. Sutherland. "Expanding Access through Doctoral Education: Perspectives from two Participants of the Sisters of the Academy Research BootCamp." *Journal of College Student Development,* vol. 49, 2008, pp. 606-08.

Dill, B. T. "(Race, class, and gender: Prospects for an all-inclusive sisterhood." *Feminist Studies,* vol. 9, no. 1, 1983, pp. 131-50.

Ellis, C., T. E. Adams, and P. Bochner. "Autoethnography: An Overview." *Historical Social Research/Historische Sozialforschung,* vol. 36, no. 4, 2011, pp. 273-90.

Espinosa, L. L., et al. *Race and Ethnicity in Higher Education: A Status Report.* American Council on Education, 2019.

Feagin, J. R. "The Continuing Significance of Racism: Discrimination against Black Students in White Colleges." *Journal of Black Studies,* vol. 22, no. 4, 1992, pp. 546-78.

Fries-Britt, S., and B. T. Kelly. "Retaining Each Other: Narratives of Two African American Women in the Academy." *The Urban Review,* vol. 37, no. 3, 2005, pp. 221-42.

Gunbay, E. B., and E. Mede. "Implementing Authentic Materials through Critical Friends Group (CFG): A Case from Turkey." *The Qualitative Reporter*, vol. 22, no. 11, 2017, pp. 3055-74.

Harley, D. A. "Maids of Academe: African American Women Faculty at Predominantly White Institutions." *Journal of African American Studies*, vol. 12, no. 1, 2008, pp. 19-36.

Harris, F. C. "Community Service in Academia: The Role of African American Sisterhood in the 1990s." *The Journal of General Education*, vol. 47, no. 4, 1998, pp. 282-303.

Harris, T. M. "Black Feminist Thought and Cultural Contracts: Understanding the Intersection and Negotiation of Racial, Gendered, and Professional Identities in the Academy." *New Directions for Teaching and Learning*, vol. 2007, no. 110, 2007, pp. 55-64.

hooks, b. *Feminist Theory: From Margin to Center*. South End Press, 2000.

Hotchkins, B. "Black Women Students in Predominantly White Universities: Narratives of Identity politics, Well-Being and Leadership Mobility." *NASPA Journal About Women in Higher Education*, vol. 10, no. 2, 2017, pp. 144-55.

Jean-Marie, G., V. A. Williams, and S. L. Sherman. "Black Women's Leadership Experiences: Examining the Intersectionality of Race and Gender." *Advances in Developing Human Resources*, vol. 11, no. 5, 2009, pp. 562-81.

Key, E. "Do They Make a Difference? A Review of Research on the Impact of Critical Friends Groups." Paper presented to the National School Reform Faculty Research Forum, 2006.

Khalil, D. and D. Edwards. "Faculty Women of Color: Peer Mentoring in a Virtual Community of Practice." *Mentoring at Minority Serving Institutions: Theory, Design, Practice, and Impact*, edited by J. McClinton et al., Information Age Publishing, 2018, pp. 3-22.

Kim, Y. M. "Minorities in Higher Education." *Twenty-Fourth Status Report (2011 Supplement)*. American Council on Education, 2011.

Moore, J. A., and J. Carter-Hicks. "Let's Talk! Facilitating a Faculty Learning Community Using a Critical Friends Group Approach." *International Journal for the Scholarship of Teaching and Learning*, vol. 8, no. 2, 2014, pp. 1-17.

Neal-Barnett, A. M., et al. "In the Company of My Sisters: Sister Circles as an Anxiety Intervention for Professional African American Women." *Journal of Affective Disorders*, vol. 129, no. 1, 2011, pp. 213-18.

Neal Barnett, A., et al. "Sister Circles as a Culturally Relevant Intervention for Anxious Black Women." *Clinical Psychology: Science and Practice*, vol. 18, no. 3, 2011, pp. 266-73.

Niskode-Dossett, A. S., et al. "Sister Circles. A Dialogue on the Intersections of Gender, Race, and Student Affairs." *Empowering Women in Higher Education and Student Affairs—Theory, Research, Narratives, and Practice from Feminist Perspectives*, edited by P. A. Pasque and S. Errington-Nicholson, Stylus Publishing LLC, 2011, pp. 194-212.

Patton, L. D., and S. R. Harper. "Mentoring Relationships among African American Women in Graduate and Professional Schools." *New Directions for Student Services*, vol. 2003, no. 104, 2003, pp. 67-78.

Rasheem, S., et al. "Mentor-shape: exploring the mentoring relationships of Black women in doctoral programs." *Mentoring & Tutoring: Partnership in Learning*, vol. 26, no. 1, 2018, pp. 50-69.

Robinson, S. J. "Spoke tokenism: Black Women Talking Back about Graduate School Experiences." *Race Ethnicity and Education*, vol. 16, no. 2, 2013, pp. 155-81.

Saldana, J. *The Coding Manual for Qualitative Research*. Sage, 2013.

Shavers, M. C., J. Y. Butler, J and J. L. Moore III. "Cultural Taxation and the Over-commitment of Service at Predominantly White Institutions." *Black Faculty in the Academy*, edited by F. Marbley, et al., Routledge, 2014, pp. 51-62.

Storey, V., and Taylor. R. "Critical Friends and the Carnegie Foundation Project on the Education Doctorate: A Café Conversation at UCEA". *Journal of Alternative Perspectives in the Social Sciences*, vol. 3, no. 3, 2011, pp. 849-79.

Turner Kelly, B., and R. Winkle-Wagner. "Finding a Voice in Predominantly White Institutions: A Longitudinal Study of Black Women Faculty Members' Journey toward Tenure." *Teachers College Record*, vol. 119, no. 6, 2017, pp. 1-36.

US Department of Education "Full-Time Faculty in Degree-Granting Postsecondary Institutions, by Race/Ethnicity, Sex, and Academic Rank: Fall 2013, Fall 2015, and Fall 2016." *NCES*, 2016, https://nces.ed.gov/programs/digest/d17/tables/dt17_315.20.asp?current=yes. Accessed 14 Jan. 2022.

Winkle-Wagner, R. "The Perpetual Homelessness of College Experiences: Tensions between Home and Campus for African American Women." *The Review of Higher Education*, vol. 33, no. 1, 2009, pp. 1-36.

Black Sisterhood Created, Maintained, and Protected at an Anti-Black Institution

Ashley N. Gaskew, Jacqueline M. Forbes,
Jamila L. Lee-Johnson, and Ja'Dell Davis

W e attend a public research university, one of the least racially diverse among similar institutions in the nation. These conditions necessitate cultivating a supportive community of Black graduate students for our academic progress and well-being. Similar to other campuses, the climate at this predominantly white institution (PWI) is often hostile and always anti-Black.[1] Our group, Jarumi formed as place of refuge and restoration for Black graduate students, especially Black women graduate students who founded the group and comprise the majority membership. Jarumi, a Hausa approximation for the group's actual name, frames our active engagement in the often contentious interactions of our graduate studies. Jarumi reminds us that we can be ourselves and suspend, if only temporarily, the Black superwoman schemas (Shahid, Nelson, and Cardemil, Watson and Hunter) or the need to be strong and an "everyone woman." We represent sisterhood through the support cultivated in Jarumi, which is a community of intentional care for the multiple selves that inform the primarily academic endeavours that brought us together. A true sisterhood has formed—one that creates the conditions to centre Black women and their epistemologies. Furthermore, the experiences of the authors testify to the conditions that we form to do the type of undervalued, personal, and "research as responsibility" (Dillard) work

that we set out to do as Black women researchers.

In this chapter, we present four vignettes that embody an endarkened feminist epistemology (EFE) (Hurtado, Militiz-Frienklink, Staples, and Wright). The vignettes demonstrate voice, agency, and vulnerability. Drawing on the essence of Cynthia Dillard's "life notes," it is our intention to represent our meaning in ways that embrace our socioculturally based expressions (Dillard, p. 664). To explore EFE, we use four themes in this chapter: Blackness; account-ability and academic support; chosen community and chosen peers; and trust and camaraderie. These themes illustrate how a group of Black women at a PWI maintain a community of trust, support, and accountability, personally and professionally. We begin the chapter with a discussion of how EFE and how our Jarumi are sustained and then proceed to the vignettes.

EFE

EFE challenges truth production, legitimacy, and sustainability (Dillard, Hurtado, Militiz-Frienklink, Staples, and Wright). It pushes those who employ it to challenge what truths they believe and why and to regain truths and parts of them-selves that have been stolen and taken away. By enacting EFE, the narratives of Black women and their epistemologies are centred, and by doing so, they create the conditions needed to do work that is often personal and necessary yet undervalued as "research as responsibility." EFE is the liminal space where we fully and consciously navigate a space that would deny our very selves. EFE work helps us bring our whole selves to our work and not to compartmentalize who we are:

> Regardless of the identity position claimed (e.g., Black, white, male, female, etc.), from an endarkened feminist epistemological standpoint, the researcher would necessarily and carefully examine their own motives, methods, interactions, and final research 'reports'—and seek understanding and meaning making from various members of the social and/or cultural community under study (Dillard, p. 663).

With EFE, Dillard focuses more on how researchers employ discourse to address equity and social justice. Researchers encourage

listening and permission to enter creative dialogue and solidarity (Hurtado, Militiz-Frielink, Patton and McClure). Bringing our whole selves to our research requires that we maintain and nourish the self. In our university context, we recognize a balancing act—one in which we are fully ourselves yet consciously navigating a space that would deny us those very selves. Jarumi is critical in the self-maintenance required to conduct our research.

Cultivating Jarumi

Jarumi is a protective space for its members. The process to become an official member is reflective of the level of commitment and care needed to consistently participate in the group. To join Jarumi, potential members must identify as Black[2] and maintain enrollment in a graduate school program. Once potential members meet the initial qualifications, they must be invited into the group by a current member and must attend three meetings before current members vote on admitting a potential member. Members of Jarumi are protective of the space because of the emotional and intellectual vulnerability displayed by members, who provide critical feedback on each other's work, share ideas with one another, and celebrate and commiserate in informal settings with one another. On a campus where Black graduate students share that they are often misidentified as custodial staff, Jarumi is a safe space that honours, supports, and protects the existence of Black intellectualism in spaces where it is customarily dishonoured, discarded, and unrecognized.

Blackness: Seeking the Familiar in an Unfamiliar Place

"I found ALL THE BLACK PEOPLE. And we talk and study together and they make me feel sane."

In the first six weeks of my second year as a PhD student, a series of events reoriented my understanding of how I could engage in my doctoral process and keep my whole self intact. Through journaling, I often checked in with myself about how I was handling being a Black woman in the white city, neighbourhood, university, and department to which I relocated. At the beginning of my program, I

processed mostly alone. And then, one evening, I "found all the Black people." I was so grateful that I had to document it.

My journal entry was short, but it spoke directly to what I was missing, even as I noted engagement with students of colour in my department and Black women professors who took time and deeply engaged with me around my research ideas. What I found were Black graduate students and professionals working throughout the city. I met them all by chance one night at an event that I attended unexpectedly. In a city where the visibility of Black folks is diffuse, having Black people in one place, intentionally and as a critical mass, was shocking and electrifying. I said so in another moment of processing:

"I feel electric. I feel elated, not with a specific source of happiness, but a deep feeling of gratitude and joy. Yesterday was the best day I've had ... full of connections, affirmations of friendships and ideas, new friends and relations, and just a shit-ton of beautiful, loving, free Black people. I danced. I sang. I laughed. I'm nursing a wonderful hangover because I went to a second location with these beautiful Black people, and I regret nothing."

It is through this event that I was introduced to members of Jarumi. I understood that Jarumi was a space for and by Black graduate students at our university. Blackness as a foundation for this group communicated a shared understanding of our unique experiences inside and outside of academe. Jarumi actively fostered an appreciation for our intragroup variation around regional origin, ethnicity, and self expression. Jarumi are Midwestern, Southern, East Coast, and every part of the diaspora; we are queer and questioning, married and mothers, Historically Black colleges and universities (HBCUs) alumni, alumni of PWIs, and Black Greeks. After a full year of seeking Black spaces, I had found Black people to consistently talk and study with, folks who would affirm my experiences as a Black woman doctoral student—Black folks who let me know I am sane.

The Jarumi serves as a critical intellectual space that affirms the intrinsic value in cultural expressions as a necessary component of a

scholarly training and research. Embodied in this first vignette is an example of voice and agency that is inherent in the life notes of EFE. The first vignette shows how the intersections of Black identities were allowed to exist in a sacred space. The interpersonal relationships fostered allowed Black students to be themselves. Their different backgrounds are united under a common identity of Blackness, yet these multiple identities incorporated within Blackness are nevertheless validated.

Collective Care as a Source of Support and Accountability

"After spending fifteen years working with students, I had the harebrained idea to actually become one."

I vividly remember my first semester as a doctoral student. When we did rounds of introductions in our first class meetings, the vast majority of my classmates talked about interests in educational equity or issues related to diversity. I was thrilled to be in the right place with a group of people who wanted to engage around salient issues in education.

As time went on, I began to notice that we would go entire class periods without mentioning race or equity if I did not bring it up. When these topics did arise, there seemed to be consensus around problematic approaches to race and education. Things started to feel... off. I found myself trying to calibrate within this dynamic by challenging the ideas I heard, but I didn't get the kind of support I expected I would get from other students. My classes started to feel isolating. I became hesitant, unsure, and disconnected from the intellectual space. I did not know whether or not I made the right choice to pursue a doctorate at my university because it didn't seem like my ideas fit.

A few weeks into my first semester, I joined the Jarumi. I was unfamiliar with writing groups and did not know what to expect from being in this one. Over time, Jarumi became an important source of academic support and a critical supplement to the lack of engagement that I was feeling in my classes. My fellow group members were probative about my academic interests in ways that

felt genuine. Whether it was suggesting readings, facilitating introductions to other scholars, or helping with articulating ideas clearly, each member found ways to support my academic progress. The validation that I got from the group was a gentle reminder that my ideas were relevant, thoughtful, and had meaning—even in isolating, hostile spaces. It was exactly the type of support I thought I would get from my classmates.

Jarumi became a place that broadened our collective ideas of academic support to include accountability, self-care, and protection. Group members take academic progress seriously and follow up with group members before deadlines for accountability. Academic support takes on a comprehensive meaning that also includes an acute awareness of the unique ways that race and gender intersect to make the campus an unsafe place for Black women. Group members provide academic accountability while simultaneously offering personal safety checks for group members. Safety—another concept that takes on a comprehensive meaning—includes ensuring that group members are free from physical and mental harms that often follow Black women graduate students as well as ensuring that members are enacting proactive self-care strategies in the midst of a hostile environment.

EFE challenges the presence of objectivity in research, noting that truly transformative knowledge production happens when research, the researcher, and research participants are all understood as partners and contributors to the collective work of understanding our world. Research becomes positioned as a complex series of responsibilities (Dillard) to the communities in which we work, which in the case of the second vignette shows up as a responsibility to bring one's whole and cared-for self into the work of research. This is the self that the Jarumi affirms and sustains for the Black graduate student members.

As demographic trends in higher education go, Jarumi remains comprised of mostly Black women doctoral students.[3] Black women play a central role in the maintenance of Black communal spaces, and Jarumi reflects this tendency. The work crucial to the group's functioning—scheduling study rooms, organizing the shared calendar, running check-in meetings, ensuring accountability—is carried out by Black women. The social functions of the group, from kickbacks to vision boarding, are also managed by Black women. Most importantly, the emotional aspects of academic community that prioritize social

wellbeing are initiated and facilitated by Black women. In the Jarumi space, Black women have created and continuously shape a community of safety as a space where we are heard, motivated, and most importantly protected on a spiritual, emotional, and academic level.

Chosen Community Chosen Peers

"I am lost, and I feel alone here on campus. I need support … I need help."

In the fall of 2014, my grandmother passed away. I felt alone and lonely. I needed a space that would allow me to grieve and support me. Jarumi. This group of allows me a place to be me. Jarumi is my chosen community.

I entered this space with complete honesty. "Why do you want to be a part of the Jarumi," I was asked. I responded: "I'm going through a really tough time personally that is impacting all areas of my life. I need a local community that can hold me accountable, and I need a space where I can be myself unapologetically and a space that will allow me grow and heal." All these things and more have been provided to me in this space. In return, I support other students, and that space is what I make it. Jarumi provides a space where I can grow in many aspects of my identity. It is a community of mutual respect, encouragement, and accountability.

Since we live and learn in a predominantly white space that is incredibly hostile to the presence of Black women, Jarumi is a protected Black space that is highly guarded and valued. In this space, I am allowed to take a breath and collect myself. My speech, my voice, my hair, my physical attire, and my way of being and doing are not policed, scrutinized, or objectified. In this space, the intersectionality of my identities is valued. I am supported. I am protected. I am validated.

There is a delicate balance in creating and sustaining an environment in which a person's whole self can be fully and wholly acknowledged and supported. Dillard discusses how Black spaces give validation and meaning to one's life in different aspects. The above vignette explores

how meaning and emotional support came at a time of loss and allowed for the continuance of personal and professional work. The Black women in Jarumi provided space for me to grieve and be a scho-lar. What binds us is love, support, accountability, and respect. Due to the sacred space being created that gives sense and meaning to our lives, we are allowed to enter this space just as we are—with joy in personal accomplishments or pop cultural frivolity or in tears from personal and academic attacks on our identities. An EFE reading of these experiences shows how community spaces transcend educational learning. Jarumi is a space of encouragement and uplift, allowing us to continue engaging in the academic work that we came to the university to do. To be a member of this group means to give of oneself in ways that are not identifiable. This space gives us the confidence to speak out when our identities are under attack. In the next vignette, Black spaces, especially for women, were intentionally created to edify and support their existence against a backdrop of oppression, racism, and hate.

Building Trust and Camaraderie

"I am looking for real, honest colleagues.... I am looking for colleagues who will understand why many Black women do not separate our 'academic' work from the rest of our life's work, from advocacy work on behalf and in the very communities of color and women who nurture us, who take us in, who patch us up after what feels like a lifetime of struggle to survive the often brutal realities of the professoriate" (Dillard 668-69).

In the spring of 2014, I arrived for my campus visit. There, I met a group of young, Black, intelligent women that called themselves Jarumi. As I met with graduate students and members of the faculty, the first piece of advice everyone gave me was to join a writing group. At the time, I didn't really understand what exactly that meant. I just knew I needed to join a writing group, cause that's what doctoral students do. That fall, when I finally arrived on campus and begin to witness everything that a graduate student is expected to do and not do, I knew immediately I needed to find a space where I could be accepted, find friendship, get advice, and

encouragement all around. I wanted to be a part of something where I could dress up one day or rock a dashiki and Air Max 95's the next and still hear from my peers YASSSSS!!!

That group for me was Jarumi. After going through an interview process by members of Jarumi, I was invited to be a part of the group. Some may think that the process for joining our writing group is tedious. However, after being a member for several years, I have learned that this group is something that I hold near and dear to my heart, and outside of us studying together, the Jarumi are my friends and graduate school family. The first year of being in Jarumi I was given the nickname "Moxie," which means a person full of encouragement, courage, and determination. Being a member of Jarumi has given me just that.

Finding supportive space while being a Black woman in graduate school can be a daunting experience (Wingfield). Often the needs of Black women are not met when they become clumped together with other women of colour. This can cause division because the specific experiences of Black women on campus and in the classroom cannot be generalized to all women. Jarumi allows us to build trust and camaraderie among Black women on our campus and provides an environment in which we are comfortable with sharing ideas and feedback with one another. Because of this trust, we can speak freely with one another and encourage meaningful collaboration.

Conclusion

Our experiences are an example of "research as a responsibility," which is critical to EFE. Our identities permeate every aspect of our research. Our support group helps us with personal and professional navigation. We question and justify how we are entering academia, what we are prepared to gain, and potentially what we are prepared to sacrifice.

By coming to the Jarumi space authentically, we are receiving and giving the support that we need in order to be supportive of one another. Jarumi has allowed us to have a space to laugh, dance so boldly in confidence, and wear our hair so naturally that we gain the confidence to tackle our classes and face the day. We have cried and hugged

each other so deeply that our sisterhood will last long beyond our time in Jarumi.

Our social differences help to highlight the various aspects of Blackness and of sisterhood. These differences in how we interpret events illuminate the need for spaces to be created and sustained on PWIs for us to explore who we are in connection to our research without penalty. It is important that PWIs create spaces like this, but when they do not, we can feel empowered to create them for our mental, emotional, and academic health and stability to survive and thrive. We have created a space in which we can know who we are and explore our individual and interpersonal dynamics safely and with support.

Endnotes

1. Anti-Black and anti-Blackness is the rejection of Black people and Black culture. Anti-Black is often hostile towards Black people with the aim of assimilating them and often erasing their identity and culture for the gains of others (Dancy II, Edwards, and Davis, 2018).

2. For the purpose of group membership, "Black" is defined as having African ancestral heritage stemming from anywhere in the global Black diaspora.

3. According to the National Center for Education Statistics (NCES) 2018 report, fall 2016 data shows that "female students made up 59 percent of total [post baccalaureate] enrollment (1.8 million students), and male students made up 41 percent (1.2 million students)" (1). Projected enrollment based on these fall 2016 data indicates that these trends of higher female enrollment will remain the same through 2027. NCES data from 2014 examine these trends by race and indicate that Black women make up 70 per cent of post-baccalaureate student enrollment in degree-granting institutions.

Works Cited

Dancy II, T.E., K. T. Edwards, and J. E. Davis. "Historically White Universities and Plantation Politics: Anti-Blackness and Higher Education in the Black Lives Matter Era." *Urban Education*, vol. 53,

no. 2, 2018, pp. 176-95.

Dillard, C. B. "The Substance of Things Hoped for, the Evidence of Things Not Seen: Examining an Endarkened Feminist Epistemology in Educational Research and Leadership." *International Journal of Qualitative Studies in Education*, vol. 13, no. 6, 2000, pp. 661-81.

Dillard, C. B. *On Spiritual Strivings Transforming an African American Woman's Academic Life*. State University Press, 2006.

Hurtado, A. "Theory in the Flesh: Toward an Endarkened Epistemology." *International Journal of Qualitative Studies in Education*, vol. 16, no. 2, 2003, pp. 215-25.

Militiz-Frienklink, S. (2017). *Endarkened feminist epistemology: A case study in higher education*. Doctoral dissertation. University of Illinois, 2017, indigo.uic.edu/articles/thesis/Endarkened_Feminist_Epistemology_A_Case_Study_in_Higher_Education/10851230. Accessed 15 Jan. 2022.

Musu-Gillette, L., et al. "Status and Trends in the Education of Racial and Ethnic Groups 2017." *NCES*, 2017, nces.ed.gov/pubs2017/2017051.pdf. Accessed 15 Jan. 2022.

National Center for Education Statistics. "Postbaccalaureate Enrollment." *NCES*, 2018.

Patton, L. D., and M. L. McClure. "Strength in the Spirit: A Qualitative Examination of African American College Women and the Role of Spirituality during College." *The Journal of Negro Education*, vol. 78, no. 1, 2009, pp. 42-54.

Shahid, N. N., T. Nelson, and E. V. Cardemil. "Lift Every Voice: Exploring the Stressors and Coping Mechanisms of Black College Women Attending Predominantly White Institutions." *Journal of Black Psychology*, vol. 44, no. 1, 2017, pp. 3-24.

Staples, J. M. "'There Are Two Truths': African American Women's Critical, Creative Ruminations on Love through New Literacies." *Pedagogy, Culture, & Society*, 20(3), 2012, pp. 451-83.

Watson, N. N., and C. D. Hunter. "'I Had to Be Strong': Tensions in the Strong Black Woman Schema." *Journal of Black Psychology*, vol. 42, no. 5, 2016, pp. 424-52.

Wingfield, T. "(Her)story: The Evolution of a Dual Identity as an Emerging Black Female and Scholar." *Black Feminism in Education:*

Black Women Speak Back, Up, and Out, edited by V. E. Evans-Winters, Peter Lang, 2015, pp. 80-93.

Wright, H. K. "An Endarkened Feminist Epistemology? Identity, Difference, and the Politics of Representation in Educational Research." *International Journal of Qualitative Studies in Education*, vol. 16, no. 2, 2003, pp. 197-214.

SECTION III
Digital Sisterhood

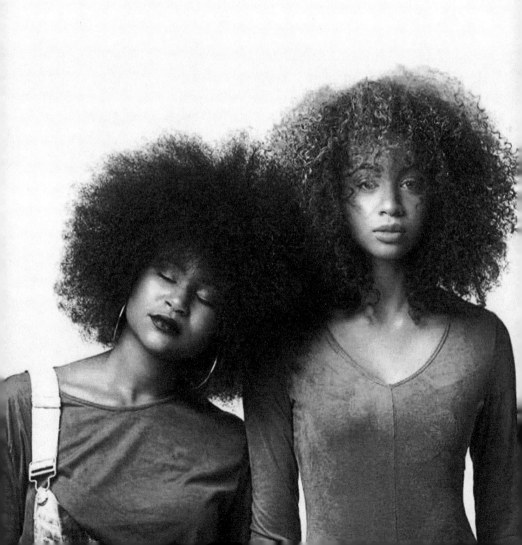

Chapter 14

In a Racist Kind of World, I'm Glad I've Got My Girls: Creating Black Feminist Digital Sisterhoods through Digital Platforms

Lisa Covington, Jelisa Clark, and Veronica A. Newton

In the theme song for the 1990s show *Living Single*, Queen Latifah (1993) raps:

> Keep your head up, what?
> Keep your head up, that's right
> Whenever this life get tough, you gotta fight
> With my homegirls standing to my left and my right
> True blue, it's tight like glue.

Although the show centres around the lives of friends, both men and women, living in New York, the theme song extols having your girlfriends. Within the academy, we,[1] Black women, sometimes need the reminder to "keep your head up." There are times when you fight bureaucracy or fight to be seen and heard in a space built without you in mind. Having your homegirls—to the left and right—allows us to not only survive but to flourish; it provides an opportunity to be seen and heard. Historically, Black women have been denied entry and excluded from higher education (Banks), and when Black women enter these spaces, they report feelings of isolation, marginalization, and

othering in academia (Newton; Winkle-Wagner). Even literature on education fails to acknowledge the barriers and challenges Black women face (Patton; Robinson).

Black women's experiences in higher education are based on their position on the matrix of domination as raced and gendered beings (Collins). Evelynn Ellis's work has shown how Black women view their experiences differently than Black men and white women graduate students. Black women report feeling more isolated and less satisfied with their departments. Other studies found that Black women feel intellectually devalued and hindered from growing professionally and academically (Moses). Additionally, Black graduate women have been denied access to career development and advising opportunities and have not had their accomplishments and achievements recognized (Bertrand Jones et al.). Therefore, Black women who do not receive adequate mentoring must seek and develop alternate avenues for support.

In this chapter, we explore how Black women in the academy use social media and digital platforms as a survival strategy and to develop sisterhood. Digital platforms have allowed for Black women to operationalize Black feminism, connect, and collaborate with one another across the country (Brock; Sobande et al.). Networking, writing groups, Twitter chats, and a host of other mechanisms within digital platforms demonstrate an active Black feminist praxis. This chapter centres the survival strategies of three Black women who developed a digital sisterhood through the digital platform and application Marco Polo (MP). The audio-visual application served as foundational tool for informal networking, friendship development, and ultimately strategic development of maintaining the self in higher education.

Black Women in Higher Education

Historically predominantly white institutions (HPWIs) were both white and male institutions created by and for white males only (Newton). Even as they expanded to include white women and people of colour, these institutions continue to function as patriarchal and white supremacist structures (hooks). Although educational attainment for Black women between the ages of twenty-five and twenty-nine has increased, the percentage of Black women with a master's degree

remains below that of white women (National Center for Education Statistics). Black women's educational attainment remains impacted by gendered racism—a form of oppression experienced by women of colour at the intersection of race and gender (Crenshaw; Essed).

Controlling Images and Microaggressions

Black women in higher education encounter a barrage of controlling images, such as the Jezebel, the Mammy, and the strong Black woman (Collins). These controlling images function to impose a narrow range of identities (Winkle-Wagner). Importantly, the trope of the strong Black woman contributes to the perception that Black women can handle the stress of college without support (Banks). Moreover, Black women also experience gender racial microaggressions on college campuses as a salient, daily part of their doctoral socialization at PWIs (Patterson-Stephens et al.). Derald Wing Sue describes gendered racial microaggressions as explicit derogatory communication, microinsults, microinvalidations, as well as sexual and embodied objectification. Black women doctoral students experience gendered racial micro-aggressions—such as not being recognized for accomplishments (Parkman), not receiving support from their department or university when requested (Banks), having their research challenged or ignored by both faculty and peers (Gildersleeve et al.); and being assigned role of 'spoke*tokenism*,' (160) or being responsible to share nondominant perspectives and challenge inequities (Robinson).

Navigating Patriarchy and Racism in Doctoral Programs

Advisors and mentors play a large role in doctoral students' success in PhD programs (Dixon-Reeves); however, students of colour report difficulty identifying and sustaining mentoring relationships (Barker; Brewer; Patton). Although research has suggested that Black faculty who share this racial identity with students provide unique oppor-tunities and offer culturally responsive advice, there are a limited number of Black women faculty available to serve as mentors (Dixon-Reeves; Holmes, et al.; Patton). In light of these challenges Black women must and do find or create their own support systems with one

another (Banks; Winkle-Wagner; Newton). However, creating on-campus support networks may be challenging for Black graduate women at HWPIs (Dixon-Reeves, 2003; Robinson, 2013). Black women graduate students have identified virtual support networks as integral to their success (Patterson-Stephens et al.). Social media, such as Twitter and Facebook, provide an avenue for sharing information, developing connections, and providing recognition (Brock; Couldry; Hepp; Latour and Wiebel).

Theoretical Framework: Black Feminism

In order to understand how social media is used to foster digital sisterhood and support Black women in the academy, we utilized Black feminist theory (Collins; Combahee River Collective [CRC]) and Black identity development theory (Jackson III) to recognize the intersecting nature of racialized and gendered identities without sacrificing one's identity. The CRC identifies Black feminist theory as a framework for challenging patriarchy within white supremacist cultures. Black feminist theory identifies controlling Black images and creates space for Black women's self-definition (Collins). Specifically, the CRC argues that being connected through shared ideas of antiracism and antisexism allows Black women to develop oppositional knowledge, collective wisdom, and situated standpoints for resistance.

Black identity framework defines the psychological approach to racialized socialization and identity development. The five sequential psychological developmental stages of racial identity development are: (1) the ability to not recognize racial difference (naïve); (2) an internalization of negativity regarding Black folks and conformity to white sociocultural standards (acceptance); (3) recognizing patterns of racial situations that can be painful and take place over time (resistance); (4) understanding that overt and covert issues of race are present throughout social institutions (redefinition); (5) and internalization. Concerning internalization, Bailey Jackson III writes, "Black people at the Internalization stage no longer feel a need to explain, defend, or protect their Black identity, although they may recognize it is important to nurture this sense of self" (45). In applying sociological and psychological theories, we create a digital space that values Blackness while recognizing the importance of gender equity

and empowerment. This praxis allows for us to craft an affirming space outside and within the academy.

Methods

We, the authors of this study, first met in 2015 at the annual meeting of the Association of Black Sociologists and connected over shared research interests. We met annually at the conference, which functioned as a homecoming. In 2017, as we prepared to leave the conference, we began to lament on how we would miss each other. Lisa then asked, "Y'all have the Marco Polo app?" and Veronica responded, "Polo." We all laughed, then committed to use the app to stay connected.

Marco Polo

Marco Polo (MP) is a visual-audio application that allows for group video communication. Only one person can speak at a time while the others watch and wait to respond. It becomes digital Double Dutch, where two people are watching or turning the ropes while the other person is speaking or jumping Double Dutch. MP allows for each person's narrative and experiences to be centred when they are speaking. This is important, since Black women's voices are silenced or ignored in academia; therefore, MP is used as a Black feminist space to centre Black women's lived experiences, a key principle of Black feminism.

Collaborative Autoethnography

To investigate the utility of digital spaces to craft sisterhood, we relied on collaborative autoethnography (CAE). CAE is well suited for centring the voices of those on the margins of the academy and exposing our situated standpoints. Autoethnography, rooted in ethnography, allows researchers to examine themselves in connection to society (Ngunhiri et al.; Reed-Danahay; Wolcott). As Black women PhD and PhD students, we are outsiders within and are uniquely positioned to unveil the contradictions in higher education as well as the challenges Black women face. We also offer examples of resistance and resilience (Collins).

We adopted a concurrent model of CAE for data collection (Geist-Martin et al.), consisting of converging and diverging narratives. As a collective, we established four guiding topics to identify a reflexive process of CAE: defining sisterhood, value in the academy, challenges in the academy, and the utility of MP. We diverged and independently responded to topics. We uploaded our responses to a shared document and individually read our collective responses to identify essential topics and data points. Finally, we met virtually to share, discuss, and probe (Ngunjiri et al.). During our virtual meeting we created a joint analytic log, in which we documented and categorized salient themes and theoretical concepts (Allen-Collinson; Saldaña).

Positionality

Each of us identifies as Black feminists, critical race scholars, and Black sociologists. We also share research interests attuned to intersections of race, gender, and education. Veronica's research focuses on Black women undergraduates. Lisa's research is centred on Black girls and girlhood. And Jelisa's research examines educational experiences of Black boys and men. We each draw on Black feminist methodology and epistemology in our research and praxis. Our research interests were the initial basis of our relationships; however, we soon were able to connect over experiences within our graduate programs.

Findings

Three themes emerged from our converging narratives: defining and enacting sisterhood, building community for Black women in the academy, and sister scholars as your armour and mirror. Each theme and its importance for digital sisterhood are discussed in subsequent sections.

Defining and Enacting Sisterhood

Sisterhood is a specific relationship that evokes familial ties in which we take responsibility for communicating our interpersonal needs and ensuring our general wellbeing. It is comprised of three components: sharing, intentionality, and recognition of a collective struggle and

empowerment. These aspects are crucial to how we define and enact sisterhood. Lisa explained the importance of sharing: "Sisterhood is an informal commitment among women who want to be in community with each other through bonding, sharing difficult life circumstances. The space of sisterhood has allowed for sharing to be the norm. Regardless of our individual experiences, collectively, we are able to support each other and problem solve in an informal manner." Similarly, Veronica added: "Sisterhood is the ability to understand your sister's journey or experiences based on your own lived experiences. It is the ability to relate to your sister's life while also providing support, suggestions, and truth. This relationship is reciprocal, and it goes both ways or multiple ways." Lastly, Jelisa noted sharing experiences within a sisterhood as different: "Unlike friendships, women engaged in sisterhoods recognize their shared realities and work to ensure their shared success." In creation of sisterhood, sharing is a central theme. Reciprocity serves as a feature of sharing we do within our sisterhood. Sharing in a private, confidential space regularly establishes sharing experiences as unspoken mores within the digital sisterhood. Furthermore, this sharing is the basis for bonding, and provides an outlet for emotional support. Finally, sharing creates possibilities for celebrating successes and accomplishments that may not otherwise receive recognition.

Collective Struggle and Collective Empowerment

In addition to sharing, the recognition of collective struggle and empowerment is essential to how we define and enact sisterhood. As a result of meeting while in graduate school—a space that is inherently disempowering for Black women students (Newton)—we collectively struggle through the development of an empowering digital space. As Veronica explained: "My sister scholars validated my experiences by showing and discussing that not only did they understand the situation, but they understood my feelings and perspective of my situation. They also gave supportive feedback that validated my feelings and let me know that I was not crazy for feeling the way I felt about an experience of gendered racism that happened to me." Similarly, Lisa shared: "Sisterhood is an informal commitment among women who want to be in community with each other through bonding. Sharing difficult life

circumstances. This bonding process allows for women to celebrate and uplift each other during times of happiness while also mourning together during challenging times." Lisa and Veronica define digital sisterhood as contingent upon ongoing, interpersonal exchanges. The context of a digital sisterhood allows for one to anticipate expression, validation, and feedback. We provide validation for emotions expressed, which directly counters experiences that deny Black women the entitlement to feel emotions fully (Harris-Perry). Digital sisterhood functions as a sounding board for tribulations and celebrations albeit personal, communal, or professional.

Intentionality

Sisterhood involves understanding and sharing life experiences. Inherent in this relationship is a commitment to one another. Jelisa stated the following: "Unlike friendships, women engaged in sisterhoods recognize their shared realities and work to ensure their shared success. By calling someone your sister, you are saying this is a relationship you cannot simply walk away from. You are committing to be vulnerable, honest, transparent, and to engage in reciprocal accountability and support." Sisterhood is undertaken as a conscious decision and rooted in the tradition of fictive kinship in the African American community (Collins; Harris-Perry). Commitment ensures that sisters hold one another accountable and are devoted to a psychologically complex, social-emotional relationship. Fictive kinships or sisterhood allowed for us to build our own community, further discussed in the next section.

Building Community for Black Women in the Academy

Yvette Lee Browser, creator of *Living Single*, explained that after *A Different World* went off air, she no longer saw herself represented in television, which spurred the creation of *Living Single* (Terrell). Similar to Browser, each of us experienced feelings of isolation and invisibility, which encouraged us to create a digital sisterhood. Jelisa was the only Black woman to enter her program during six years of enrollment. For Veronica, feelings of isolation were grounded in the microinvalidations she experienced:

I have experienced a lack of support from the faculty in my department as well as the other students in my department. There was a continuous lack of recognition for my accomplishments and achievements for my research. In other words, my experience reflects what scholars call micro-invalidations, where professors and students would praise white male students on their achievements but would not say anything or congratulate me on mine.

Lisa also experienced isolation: "The academy is an isolating space that encourages individual achievements, which is not culturally congruent with my values and upbringing of community and collectivism. Sisterhood creates a space of belonging and encouragement."

Not only are Black women a numerical minority in higher education, which can contribute to feelings of isolation, but also, as Lisa explained, our cultures and values are often at odds with those of HPWIs, leading to their devaluation. Many Black youth grow up with close communal and familial ties and rely on extended family and fictive kinfolk for personal and professional support (Brooks et al.; Collins). As Black women move up the educational ladder families become disconnected from our realities, making digital sisterhood crucial to our survival in academia.

Developing a digital sisterhood was also rooted in our growing distance within existing social networks. Despite remaining supportive, our families increasingly did not understand our challenges in academia (Robinson). Jelisa recalled preparing for comprehensive exams:

I remember being exhausted, stressed, and anxious about comps. In my eyes, these exams were a potential barrier to my goals. I was discussing this with my mother, sister, and grandmother. My grandmother said something along the lines of 'I don't know why you're stressed; you're smart.' Her attempt to reassure me was frustrating because there are plenty of smart people who don't complete their doctoral degrees.

Similarly, Veronica discussed the following:

I could talk to my mom about it [her experiences in academia], and she could listen, but she did not understand the experience,

and so her feedback was unhelpful at that time. However, being able to tell my experience, vent, and discuss my experiences of being invalidated in my program to my sister scholars, my experiences of being othered, were completely understood, which is refreshing on its own.

Jelisa and Veronica expressed the importance of familial support for success, but they also recognized family was not always attuned to the nuances and struggles associated with a PhD, with Veronica describing her mother's advice as "unhelpful." For Jelisa, the advice was frustrating because in trying to reassure her, her grandmother inadvertently invalidated Jelisa's concerns. Because of the widening gap between us and our families, we began to rely on one another for support. MP allowed us to create a community that drew on social and cultural values reflecting collectivism.

Sister Scholars as Your Armour and Mirror

As we recognized the limitations of seeing one another annually, we decided to invest more time into our sister circle through MP, creating opportunities for us to connect over our shared lived experiences as Black feminist sociologists who study Black students in education. Digital sisterhood has provided us with a protective shield, or armour, against feelings of isolation we experienced within our programs. While we shared practical advice for navigating the academy, the overarching utility of our sisterhood lies in affirming one another's lived experiences as Black women scholars in the academy. Additionally, each of us discussed experiences that called for assurances we were not crazy (Gildersleeve et al.). Availability of sister scholars to interpret and reflect on our experiences is critical to developing a sister circle as armour. Jelisa stated: "In our experiences, a sister circle has been used as a sounding board. Sometimes we, as Black women, have experiences and interactions that call into question the role of our intersecting identities as Black women. For example, did XYZ just happen because I am a Black woman? This [space] is a place where you can vent, and if necessary be called on your BS." Jelisa went on to recount an experience when an officemate walked into their shared office and asked if she was waiting for "Jalissa." Not only did the man

not recognize someone he shared an office with, but he also mispronounced her name. These types of microaggressions are common for Black women in the academy. Importantly, Jelisa recognizes there are times when she may need a sister call in on MP; this is how sisterhood may also function as a mirror.

Lisa echoed Jelisa's sentiments about use of MP:

> MP has allowed for me to interact with my sisters in real time. Immediately after something happens, I am able to hop on and tell them what happened. Being able to share our experiences through the app allows for community building. It also seems like one of us may have experienced something similar, and we can share ways to address macroaggressions, differential treatment, and isolation.

The ability to see and speak to one another on MP immediately is useful, especially when you are othered by students in your department, combating gendered, or being microaggressed by colleagues. Digital sisterhood allows for us to share our common experiences, have our experiences validated, and receive emotional support.

hooks discusses the importance of Blacks having a "space of agency where we can both interrogate the gaze of the Other, but also look back, and at one another, naming what we see" (116). When we share our experiences on MP, we are looking at two mirrors. Sister scholars recognize all aspects of who you are based on our location on the matrix of domination (Collins) and position in academia. In other words, my two sister scholars are a reflection of me, and I am a reflection of them. Being recognized and getting recognition from others who understand you are crucial to our sisterhood.

Discussion and Conclusion

As Black women in the academy, we often receive the message: We do not belong. Having sister scholars allows you to be seen and heard in spaces of marginalization, such as classrooms, academic conferences, and professional associations. A sisterhood based on intentional engagement that recognizes collective struggle and collective empowerment creates a community for Black women scholars, which functions as a mirror and armour. We identify sharing, intentionality, and

recognition of collective struggle and collective empowerment as central tenets for digital sisterhoods.

Within the academy, we are trained to use objective methods and dispassionate language that do not recognize our positionality. However, Black women's situated standpoints are the basis for oppositional knowledge and resistance (Collins). Black digital sisterhood allows for us to recognize shared standpoints and engage in collective self-definition. Psychologically, we are within similar identity stages on the Black identity development scale. Each of us individually has reached or is closely approaching the internalization stage, wherein we are not compelled to defend or explain our identities. By virtue of sharing our narratives, we had an outlet for expression, validation, and feedback, which allows us to resist the oppressive forces of academia. Furthermore, we are exposed to a range of expression of Black womanhood, which can allow us to resist controlling images and develop a positive sense of self and identity. The strong Black woman trope suggests Black women should suffer in silence or figure it out on their own. However, in developing a mutual support system, we recognize that our strength as Black women lies in our collective empowerment.

Our creation of a digital community based on our collective identity as Black women scholars draws on the tradition of fictive kin networks (Brooks et al; Collins). By seeing one another as sisters, we are able to thrive in the academy and maintain a communal identity as members of African American communities committed to challenging oppressions rooted in racism and sexism. Sisterhood with women at similar intersections of race, class, and gender is particularly important because increased education and upward social mobility can produce widening gaps between Black women and their families, who may not understand their lived experiences.

Within our narratives, we each noted the validation sisterhood provided, which supports positive Black identity development. MP functioned as a digital counterspace that supported movement towards the internalization stage (Jackson III). Counterspaces "counter the hegemony of racist and other oppressive ideologies of the institution and its members" (Carter 543) and are particularly important because they allow us, as Black women, to share our concerns and experiences free of judgement and surveillance of white male power structures that sexually objectify us, fail to recognize our accomplishments, and

neglect our requests for help.

Black women are often denied the experience of being centred both within and outside academia. By using this digital space, we are able to be fully seen and heard. We can share and centre our concerns, gain support, and uplift and affirm one another and ultimately find a shared sisterhood bond. Importantly, because only one person may speak at a time, the structure of MP allows for us to centre one another as Black women. Overall, our digital sisterhood supports and sustains us in academia, stimulates resistance, and supports a positive sense of self and identity. Utilizing the MP digital platform as a survival strategy is key to our digital sisterhood, growth as Black feminist scholars, and development as Black women sociologists.

Endnotes

1. Both Collins and CRC identify the importance of utilizing collective language, such as "we" and "us." We make the decision to use "we" when discussing Black women, indicating our shared identities and experiences.

Works Cited

Allen-Collinson, J. "Autoethnography: Situating Personal Sporting Narratives in Socio-Cultural Contexts." *Qualitative Research on Sport and Physical Culture*, edited by K. Young and M. Atkinson, Emerald Group Publishing Limited, 2012, pp. 191-212.

Banks, C. A. *Black Women Undergraduates, Cultural Capital, and College Success*. Peter Lang, 2009.

Barker, M. J. "An exploration of Racial Identity among Black Doctoral Students Involved in Cross-Race Advising Relationships." *African American Identity: Racial and Cultural Dimensions of the Black Experience*, edited by J. M. Sullivan and A. M. Esmail, Lexington Books, 2012, pp. 387-414.

Bertrand Jones, T., J. Wilder, and L. Osborne-Lampkin. "Employing a Black Feminist Approach to Doctoral Advising: Preparing Black Women for the Professoriate." *The Journal of Negro Education*, vol. 82, no. 3, 2013, pp. 326-38.

Brewer, R. M. "Giving Name and Voice: Black Women Scholars, Research, and Knowledge Transformation." *Black Women in the Academy: Promises and Perils*, edited by L. Benjamin, University of Florida Press, 1997, pp. 68-80.

Brock, A. *Distributed Blackness: African American Cybercultures*. New York University Press, 2020.

Brooks, J. E., and K. R. Allen "The Influence of Fictive Kin Relationships and Religiosity on Academic Persistence of African American College Students Attending an HBCU." *Journal of Family Studies*, vol. 37, no. 6, 2016, pp. 814-32.

Carter, D. J. "Why the Black Kids Sit Together at the Stairs: The Role of Identity-Affirming Counter-Spaces in a Predominantly White High School." *Journal of Negro Education*, vol. 76, no. 4, 2007, pp. 542-54.

Couldry, N. *Why Voice Matters: Culture and Politics after Neoliberalism*. Sage, 2010.

Collins, P. H. *Black Feminist Thought: Knowledge, Consciousness, and the Politics of Empowerment*. 2nd ed. Routledge, 2000.

Collins, P. H. *Black Sexual Politics: African Americans, Gender, and the New Racism*. Routledge, 2006.

Combahee River Collective. "A Black Feminist Statement." *Home Girls: A Black Feminist Anthology*, edited by B. Smith, The Feminist Press, 1982, pp. 264-74.

Crenshaw, K. "Mapping the Margins: Identity Politics, Intersectionality, and Violence against Women of Color." *Stanford Law Review*, vol. 43, no. 6, 1991, pp. 1241-99.

Dixon-Reeves, R. "Mentoring as a Precursor to Incorporation: An Assessment of the Mentoring Experience of Recently Minted Ph.Ds." *Journal of Black Studies*, vol. 34, 2003, pp. 12-27.

Ellis, E. M. "The Impact of Race and Gender on Graduate School Socialization, Satisfaction with Doctoral Study, and Commitment to Degree Completion." *Western Journal of Black Studies*, vol. 25, no. 1, 2001, pp. 30-45.

Essed, P. *Understanding Everyday Racism: An Interdisciplinary Theory*. Sage, 1991.

Fotopoulou, A. "Digital and Networked by Default? Women's Organ-

isations and the Social Imaginary of Networked Feminism." *New Media & Society*, vol. 18, 2016, pp. 989-1005.

Geist-Martin, P., et al. "Exemplifying Collaborative Autoethnographic Practice via Shared Stories of Mothering." *Journal of Research Practice*, vol. 6, no. 1, 2010, www.researchgate.net/publication/49611626_Exemplifying_Collaborative_Autoethnographic_Practice_via_Shared_Stories_of_Mothering. Accessed 15 Jan. 2022.

Gildersleeve, R. E., N. N. Croom, and P. L. Vasquez. "'Am I Going Crazy?!': A Critical Race Analysis of Doctoral Education." *Equity & Excellence in Education*, vol. 44, no. 1, 2011, pp. 93-114.

Harris-Perry, M. *Sister Citizen: Shame, Stereotypes, and Black Women in America*. Yale University Press, 2011.

Hepp, A. *Connectivity, Networks, and Flows: Conceptualising Contemporary Communications*. Hampton Press, 2008.

Holmes, S., L. D. Land, and V. Hinton-Hudson. "Race Still Matters: Considerations for Mentoring Black Women in Academe." *Negro Educational Review*, vol. 58, no. 1-2, 2007, pp. 105-129.

hooks, b. *Black Looks: Race and Representation*. Routledge, 2015.

Jackson III, B. W. "Black Identity Development." *New Perspectives on Racial Identity Development: Integrating Emerging Frameworks*, edited by C. L. Wijeyesinghe and B. W. Jackson III, New York University Press, 2012, pp. 33-50.

Latifah, Q. "Living Single Theme Song." *Living Single: Music from and Inspired by the Hit Tv Show*, Warner Bros., 1993.

Moses, Y. T. *Black Women in Academe: Issues and Strategies*. Association of American Colleges, 1989.

National Center for Education Statistics. *The Condition of Education 2019*. United States Department of Education. National Center for Education Statistics, 2019.

Newton, V. *Gendered Racism: The Lived Experiences of Black Undergraduate Women at an HPWI: Microaggressions, Space, and Culture*. Unpublished Doctoral dissertation, The University of Missouri, Columbia, 2018.

Ngunjiri, F. W., K. A. C. Hernandez, and C. Chang. "Living Autoethnography: Connecting Life and Research." *Journal of Research Practice*, 6(1), 2010, jrp.icaap.org/index.php/jrp/article/view/241.

Accessed 15 Jan. 2022.

Parkman, A. "The Imposter Phenomenon in Higher Education: Incidence and Impact." *Journal of Higher Education Theory and Practice*, vol. 16, no. 1, 2016, pp. 51-60.

Patterson-Stephens, S.M., T. B. Lane, and L.M. Vital. "Black Doctoral Women: Exploring Barriers and Facilitators of Success in Graduate Education." *Higher Education Politics & Economics*, vol. 3, no. 1, 2017, doi:http://doi.org/10.32674/hepe.v3i1.15.

Patton, L. D. "My Sister's Keeper: A Qualitative Examination of Mentoring Experiences among African American Women in Graduate and Professional Schools." *The Journal of Higher Education*, vol. 80, no. 5, 2009, pp. 510-37.

Reed-Danahay, D. E. "Leaving Home: Schooling Stories and the Ethnography of Autoethnography in Rural France." *Auto/ethnography: Rewriting the Self and the Social*, edited by D. E. Reed-Danahay, Berg, 1997, pp. 123-44.

Robinson, S. J. "Spoke Tokenism: Black Women Talking Back about Graduate School Experiences." *Race Ethnicity and Education*, vol. 16, no. 2, 2013, pp. 155-181.

Saldaña, J. *Thinking Qualitatively: Methods of Mind*. Sage Publications, 2015.

Shavers, M. C., and J. L. Moore III. "Black Female Voices: Self-Presentation Strategies in Doctoral Programs at Predominantly White Institutions." *Journal of College Student Development*, vol. 55, no. 4, 2014, pp. 391-407.

Sobande, F., A. Fearfull, and D. Brownlie. "Resisting Media Marginalisation: Black Women's Digital Content and Collectivity." *Consumption Markets & Culture*, vol. 23, no. 5, 2019, pp. 413-28.

Sue, D. W. *Microaggressions in Everyday Life: Race, Gender, and Sexual Orientation*. Wiley, 2010.

Terrell, A. G. "Living Single Cast and Creator Reflect on Legacy 20 Years after Series Finale." *The Root*, 1 Jan. 2018, www.theroot.com/living-single-cast-and-creator-reflect-on-legacy-20-yea-1821591332. Accessed 15 Jan. 2022.

Williams, M. S., and J. M. Johnson. "Predicting the Quality of Black Women Collegians' Relationships with Faculty at a Public Histor-

ically Black University." *Journal of Diversity in Higher Education,* vol. 12, no. 2, 2019, pp. 115-125.

Winkle-Wagner, R. *The Unchosen Me: Race, Gender, and Identity among Black Women in College.* Johns Hopkins University Press, 2009.

Wolcott, H. "The Ethnographic Autobiography." *Auto/Biography,* vol. 12, 2004, pp. 93-106.

Chapter 15

She's My Sister, but We've Never Met Offline: Exploring the Relationship of Digital Black Sisterhood with PhD Students in Online Message Boards and Independently Owned Websites

Erin L. Berry-McCrea and Briana Barner

In 2016, a group of eight Black PhD students made history when they all graduated from the Indiana University School of Education. The women nicknamed, the "Great 8," created a sister circle of sorts to support one another during their respective doctoral journeys. A representative from the school stated in an interview (Gilmer) that, normally, the school graduates two or three students of colour in a year. The Great 8 made headlines not only because of this historic accomplishment but also because of their deliberate community building to ensure the success and matriculation of each student in the group. According to the National Center for Education Statistics, 10.5 per cent of PhDs were conferred to Black women in 2016 in the United States. They were the true embodiment of the adage "It takes a village." In an interview, Great 8 member Nadrea Njoku stated: "The sister circle gave us a space to talk about what was going on beyond class. We were

able to affirm each other, encourage and bounce ideas off each other in a safe space" (qtd. in Gilmer). This community was an integral part of navigating higher education as women of colour.

According to the National Center for Education Statistics, 10.5% of PhDs were conferred to Black women in 2016. Although support was a key factor in the success of the Great 8, what happens when physical support is not available to Black doctoral students? This chapter explores digital communities that can stand in when physical communities of support are not present. The authors of this chapter are two doctoral students who first connected in an online private group exclusively for feminine identified graduate students of colour.[1] The group has provided extensive support to both of the authors, who attend predominantly white institutions. First, we will give a brief review of the literature, in the section titled "It Takes A Village: Digital Black Sisterhood." In this section, we provide historical insights about online and offline sister circles as well as their implications for future communication and engagement. Our methodology section titled, "Writing Truth to Power: Black Feminist Autoethnography," includes a description of our methodology—Black feminist autoethnography (Griffin). Within this section, we provide our own individual narratives. Briana's narrative is titled "Alone No More," in which she discusses the role of closeness and community experienced through her participation in private/closed Facebook groups. Erin's narrative follows and is titled, "Where My Girls At?" Erin's narrative also explores themes of community and closeness within online groups from the perspective of sociocultural support systems where the use of emojis, likes, and comments on posts have provided her with collective and ever-evolving sister circles. Both narratives discuss the positive impact of these online groups on doctoral program success in their respective programs. Lastly, we provide a discussion and analysis of the importance of our particular narratives and how they speak truth to power in the section titled "Discussion and Conclusion: Reclaiming Our (Digital) Space."

It Takes a Village: Digital Black Sisterhood

Black Women Creating Space for Themselves

Sister circles have been an important aspect of Black womanhood over the last 150 years (Neal-Barnett et al.). They can include Black

sororities, sewing guilds, health groups, church societies, and book clubs (Carver). Angela Neal-Barnett et al. define sister circles as "support groups that build upon existing friendships, fictive kin networks, and the sense of community found among Black women" (267). These groups tend to have a specific interest in common, such as the Great 8's status as graduate students at Indiana University. In a 2017 article, PhD student Patricia Carver writes about her own sister circle at a predominantly white institution, saying that she would not be able to complete her PhD without the sister circle and lamented the fact that the group came together separate from any guidance from the university. She viewed this as a concern because the support of students of colour seemed to not be a priority for her school. There were newer Black female students in the program that were not part of the sister circle due to Carver's inability to perform the labour to connect them with the group. This meant that these students could potentially be at risk to not complete the program due to a lack of mentorship and connection to their peers. The absence of community has an even greater risk if the student is first generation or the first in her family to receive an advanced degree.

Susan Gardner and Karri Holley found that one third of PhD students identify as first-generation graduate students, and half of Black, Hispanic and American Indian PhDs identified as first-generation graduate students. First generation graduate students have unique obstacles that can make receiving the PhD even more challenging than it would be for their non-first-generation peers. These challenges include relying on their own financial resources to support themselves during graduate school and, in turn, taking a longer time to complete their degree—Black students in particular have the lowest ten-year completion rate of PhDs. Important factors for completing the PhD include family encouragement, institutional financial support, mentoring/advising, and socialization, which is the extent to which students engage in productive relationships with faculty and peers (Gardner and Holley).

Carver was right to worry about the Black graduate students who were not part of the sister circle, as those connections, according to the above study, are important factors in their success as grad students. There are many informal factors that are part of a department or overall university's culture that may or may not be made available to

all students, which of course greatly benefits those who do have this knowledge while putting those who don't at a disadvantage. This culture includes the "importance of cultural capital to informing students about college enrollment, degree options and demands of a college curriculum" (114). Informal networks, such as sister circles or Facebook groups, can provide the much-needed support and knowledge that first-generation graduate students would not receive in a typical graduate class, particularly if these networks are not university sponsored or supported. Black women have had a history of carving out spaces for themselves within larger, white-dominated spaces.

Olga Davis makes the connection between enslaved Black females who were relegated to the kitchen and the dining rooms where they were forced to serve white people to spaces of empowerment and disempowerment. The dining room was considered more formal and exclusive as well as a space that reflected hegemonic practices. The kitchen, however, was a space where dignity and humanity could be restored. As Davis writes, "[The] kitchen provided a space within which Black women during and after slavery transformed their oppression into resistance and transformed an institution of White dominance" (371). The importance of a space where white dominance is not centered and where Black women can convene and discuss strategies to navigate systems of oppression cannot be overstated. Davis's juxtaposition of the dining room and kitchen can be extended to understand how Black women not only navigate higher education (dining rooms) but make spaces for themselves where they are affirmed (kitchen). Davis writes: "Black women's creativity and nurturance enabled Southern plantation kitchens to become the black dominated spaces, spaces that enabled enslaved women to struggle toward equality and to develop creative strategies for self-empowerment through transformation" (368).

The online group discussed in this chapter can be viewed as an extension of the kitchen. It is a space exclusively for women of colour graduate students[2] to discuss their experiences at institutions that can be hostile, toxic, and that may perpetuate systemic oppression and racism. Online groups for women have become more popular, particularly in the wake of the current political climate. For Black women in particular, the privacy of the secret groups can help to counter the online harassment that many experience, even in groups

solely intended for women. In a 2017 *Ravishly* article, Ananda Leeke, author of the book *Digital Sisterhood,* discusses the benefits of groups intended for women of colour: "[They allow] people to share their concerns and not be attacked. It weighs you down when people are constantly asking you to explain yourself, they don't get what you're saying."

Groups that are specifically for women of colour can help alleviate what Leeke calls "the white woman's privilege voice." Race, along with many other intersecting identities, affects how women of colour move through the world. This is not to dismiss that whiteness is a racial construct as well, but since it is viewed as the superior or dominant race, white women are not racialized in the same way as women of colour. A group specifically for women of color removes white women and the need to explain things to an "outsider" (Crenshaw). Tasbeeh Herwees (2016) makes an important point that the privacy of these secret groups differentiates Facebook from other social media platforms, such as Twitter and Reddit, which make topics and conversations easily visible and searchable. This does not mean that important conversations that reflect the politics of the kitchen do not exist on these platforms. The hashtag #GirlsLikeUs, which centres trans women, was the subject of a study done by Sarah Jackson et al. (2018). The study found that such factors as community building and creating change were important factors in the community built by trans Twitter users. There is little research on secret online groups for Black women, presumably due to their not wanting to be surveilled (Charmaraman et al.). Hashtags are ideal objects of study because they can be searched with relative ease and yield a large number of data (depending on the popularity of the hashtag). This particular research hopes to add to the literature, without compromising the privacy of the members of the group.

Writing Truth to Power: Black Feminist Autoethnography

Acknowledging the discursive spaces that Black women often utilize to make room for their research, work, and lived experiences, the authors of this chapter have decided to engage in their own autoethnographic work to explain their experiences and embarking on sister circles. Autoethnography is a qualitative methodology that allows one the

opportunity to discuss and analyze their experiences and observations as a point of study (Berry-McCrea). Researchers who do autoethnographic research often do so from a phenomenological stance, which allows a researcher to interrogate all parts of what they observe and experience. Autoethnography allows researchers to "capture the essence of an experience and invite the reader into your thoughts" (Boylorn and Orbe 13). In autoethnography, the phenomenological stance "is one that is obviously private, but it is also public because it allows ... reflexive opportunity within all aspects of one's intersectional experience" (Berry-McCrea 364). Thus, autoethnographic work is best facilitated through phenomenology. The work of Rachel Griffin and Robin Boylorn provided us with a guidepost of how to craft autoethnographic stories for our research and teaching in ways that empower us instead of contributing to our marginalization. Studying the work of Black women's autoethnographies allows us access to stories that are similar and dissimilar to ours. As we explored autoethnography as a methodological space, we found it to be transparent and transformative, therefore allowing us to share our personal and public experiences with readers that extend beyond the academy. We recognized the work of Boylorn and Griffin as gifts to us—providing the opportunity to build on those gifts with our own stories as the gift that keeps on giving. Recognizing our roles as educators and doctoral students provides us with a particular space and opportunity to voice our lived experiences in digital Black sisterhood as insiders and outsiders. What follows are our individual narratives that showcase the ways in which we have created and maintained digital sisterhood via the internet.

Briana's Narrative: Alone No More

Sister circles are a concept that I am very familiar with. For four years, I was surrounded by the love and warmth of sister circles during my time at one of only two historically Black colleges for women. I was affirmed daily and inspired by the hundreds of Black women that I encountered. I knew going into graduate school that the experience would be an isolating one, but I wasn't prepared for the extent to just how lonely it would be. Due to the rising costs of living in the city where my university is located and a familial obligation that limits where I can move, I have a commute that can be anywhere from one to almost two hours one way. This has added to the isolation—I have to be

strategic with my time on campus. This also means that I miss many of the networking events, which tend to be after 5:00 p.m. I already felt like an outsider within my department, as the only Black PhD student when I began my program, and not being able to network exacerbated my feelings that I do not fit within my program's culture. Casting that aside, I also often feel anger and rage about my department's seeming apolitical stance or willingness to truly explore the complexities of media outside of what is mainstream (read: white-centred media), except in "special topic" courses centred around marginalized media. It gets tiring to constantly ask about the missing critical lens, so often I remain silent. I also remain silent out of fear—the fear of being viewed as an angry Black woman, the fear of being further isolated, and the fear that my anger could potentially be used against me when being considered for opportunities. But anger, Rachel Alicia Griffin insists, can be useful and purposeful. Speaking truth to power can be healing. With this knowledge, I share my experiences with this digital sisterhood.

I belong to several private online groups for women of colour. Within these groups, I've noticed a common thread. The women share experiences that angered or frustrated them. In the moment, they did not feel comfortable enough to express that anger, for many of the reasons that I listed above. But the privacy and intentionality of the group encouraged them to speak up.

There have been many instances where I have questioned if something that happened to me was a microaggression, or if it was something that I should brush off. The agony and anxiety of constantly being on edge, anticipating the next microaggression, is exhausting. But with the sisters in the group, I can be brave and vulnerable. I decide not to go through it alone. It is then that I realize the importance of this space. It is a space to express anger and hurt. It is a place to receive acknowledgement that yes, that was a microaggression. No, it was not okay. But even more important than that, we offer solutions, alternatives, and ways to heal from these microaggressions and racist antics. We acknowledge that we are navigating a system not intended for us but that must make room for us anyways. Like the kitchen (Davis), it is a space of resistance. In this community, we discuss tangible ways to not only exist but to thrive within these universities. I am reminded that with the goal of thriving comes a responsibility to pay attention to

my whole self. We share ways to prioritize self-care, which Audre Lorde reminds us is a radical act. Within this digital sisterhood, I find a community of scholars of colour that can be hard to find at my institution.

Although the group is virtual, it has helped guide me to Black women in other departments at my university that I may not have met otherwise. My university is large, with close to fifty thousand students, of which only 4.5 per cent are Black, and these numbers include both undergraduate and graduate students. The campus is also large, so it is easy for me to be on campus all day and see maybe only a handful of people who look like me. I'm from Chicago, one of the biggest and most diverse cities in the country, so I'd never really experienced the shock of not seeing Black faces. I also attended college in the state that has the most historically Black colleges and universities; there are two, including my own, in my college town. It still takes me by surprise when at the end of the day, I realize that I'm either the only Black woman, or one of a few Black women, in many of the spaces I occupy. The city where my university is located is one of the fastest growing cities but with a steadily declining Black population. I feel the isolation in the classroom and when I venture out into the city.

So even though these groups are virtual, it is comforting to log on and see faces that look like mine. I root with them as they share their wins, and I smile with them when they do the same for me. I hurt when there is yet another post about toxic mentors. I relate when they discuss the financial hardships that come with being a first-generation graduate student.

Through these groups, I've also learned that many of the members are also the only Black or student of colour in their program. It has been really helpful to discuss what that has meant for me, as I don't always feel comfortable discussing this with people in my department. It also just feels good to acknowledge that it bothers me. I recognize that it would probably be an awkward thing to discuss with my department. When is the right time to bring up that there are no other Black PhD students in my department? As if they weren't already aware of this. So I discuss it with the groups. This doesn't bring any solutions, but it does validate my feelings and gives space to share coping mechanisms. I am also in a field that is predominantly white, so it has been helpful to connect with fellow Black women who are

studying media, like my coauthor. I was even able to meet sisters who were going to the same conference as me. I have been able to network within these groups in ways that I cannot do within my department.

It has been freeing to find other parents and married students. Within the group I've even been able to meet students who also have horrible commutes. Being able to discuss these other aspects of my life is important. I feel that in academia, there is a huge push to focus on the work and ignore the human behind the work. I don't have that option—as a Black feminist, so much of my work is intertwined with who I am. For me, the personal is political, and the work is personal. Being a wife and mother certainly impacts the work I do. It is difficult to find other student parents at my university because there is no structure in place that facilitates us meeting and convening. Maybe it's because the assumption is that students' personal responsibilities are separate from their academic ones. This couldn't be further from the truth. Parents, particularly those of young children, have unique circumstances that impact their ability to complete the degree. Sharing resources and advice with the parents in the group has been beyond valuable and helpful. Tips on how to get through my commute and the anxiety that it induces has made it bearable. In making space for our whole selves, the group has encouraged me to prioritize a work-life balance. They model for me that it is possible.

Erin's Narrative: Where My Girls At?

The digital landscape has always been an important part of my life. Beginning with Blackplanet in the late 90s and Myspace in the early 2000s, followed by Facebook, Twitter, and Instagram, I have enjoyed communicating across the digital. Crafting pages allowed me to share all parts of my personal and public identity in ways that were comfortable for me. I contacted people and conversed with them in ways that built community. Although I had a community of family, friends, and classmates, social media provided me the opportunity to expand that community and redefine my understanding of difference. My creation of networks with folks that I had and hadn't met allowed me access to ideas, events, and experiences that I would not have been as open to due to my localized experiences in the rural south.

Within the last ten years, I've found online groups to be most beneficial in and outside of the classroom as they've served as a digital

communal space. I grew up in North Carolina and attended college there, too. My world expanded when I decided to attend graduate school for my master's degree. In my graduate program in Maryland, my classmates and I decided early that it would be helpful to engage in conversation about classes and life that existed in online groups. This proved to be helpful, as we exchanged class notes and information about internships, jobs, and best happy-hour locations. I felt connected interpersonally and also digitally as I worked through my graduate program. Once folks began graduating though, I found that the digital tribe that I had been a part of slowly dissolved. It was clear that once folks graduated or successfully completed courses, they no longer used the groups with as much enthusiasm as when they seemed to need support or resources. I and another colleague kept the group running for a year or so after we left the program, as we led comprehensive exam study sessions and editing workshops for students who were writing theses.

This seemed helpful as long as we were running the groups and posting content, but when we were ready to step away from this service, we found that none of the graduate students that we mentored were interested in taking over the group. Disheartened and a bit disappointed, we provided access to the group account to faculty members and the program director so that they could at least have access to this as a tool for outreach. Unfortunately, not much was done with it. Although I'm not sure if the new cohort of graduate students were disinterested, I knew that many of them worked fulltime and had busy lives outside of the program; thus, I assumed that this is what kept them from wanting to take on yet another responsibility, as graduate school is already time consuming enough.

Fast forwards to May 2016. As I was leaving one job in the academy and moving to another, I received a group notification from a mutual friend inviting me to another online group. This group was primarily for women graduate students of colour and had at that time over one thousand members. I felt as though I hit the jackpot. I saw names of folks that I knew, as well as folks that I did not, and I was elated to see that through the simple transmission of a friend request and suggested group add that I was being asked to participate in a sister/sista circle that existed totally online. Being able to participate in asynchronous discourse online with other women who share in a collective experience

has been invigorating, humbling, empowering, and liberating. Through this group, I'm able to enter into and exit conversations as much as I'd like, and when I'm not ready to enter a conversation, or feel as if I don't have much to add, I can still participate by viewing what's been shared, although sometimes a click on the "like," "love," "haha," or "angry" emoji post response suffices just fine.

As a doctoral candidate and visiting instructor, I've found these groups to be most beneficial in providing sociocultural support and resources. This group provides me with sociocultural support in reminding me that I'm not alone as a Black woman who is journeying through a doctoral program while also carrying a full teaching, advising, and service load at a local university. Encountering microaggressions and blatant forms of racism, sexism, and ageism are all parts of my intersectional experience as I move from students to teacher throughout the day, which can become isolating. Through participating in the digital collective, I am reminded of my special positionality in the world and the ways that I have agency and can speak truth to power. Being reminded of your worth when the world constantly reminds you of your unworthiness is freeing, even more so when this is coming from women who don't even know you but want to support you anyways because they know of your experience and can identify with it. As a resource, online groups have provided me with access to literature that I may not have come across on my own searches, which have supplied my dissertation and extracurricular work. Additional resources have been shared about how to navigate the academy from the perspective of a Black woman, which is essential for my wellness in and outside of the classroom. Resources from popular culture—such as the quotes, pictures, memes, and gifs—are shared throughout this group as a means of making meaning of lived experiences in the form of fun and frustration. Most recently, a member shared the lyrics to a few songs that were sources of encouragement for her as she participated in the end-of-the-semester grind. This sort of resource sharing is just as beneficial to me as lesson plans, advice, and texts for research, since they have assisted me in maintaining balance as whole person who is an academic.

These resources have been helpful, as they are informative and entertaining, and many seem imperative to comprehend as I move in and out of different types of academic spaces.

Understanding that many of my white counterparts and colleagues receive some of the same type of information and access to resources from their mentors reminds me of the true value of online groups because this digital space creates a unique mentoring model that provides access and support for Black women. Online groups and sites, such as blogs, provide "an opportunity for a [B]lack woman to share her opinion on a multitude of topics" (King 146). I'm constantly awed by the digital sisterhood that has been created online through this group and am always appreciative of the colleagues, friends, and sisters that I have met through the digital landscape.

Discussion and Conclusion: Reclaiming Our (Digital) Space

Digital spaces created for women of colour have provided much-needed support for graduate students navigating white institutions (Steele). In analyzing our ethnographic narratives, we have found that this digital support has been invaluable to our graduate school experiences. Online message boards and independently owned sites in particular have helped facilitate this support, and we hope it will be studied more closely. And, of course, other social media platforms, such as Facebook, can be used to offer similar support systems. However, online message boards and independently owned sites have the ability to provide privacy, collaboration, and autonomy among its users along with a sense of community. These sites allow members to truly create, build, and maintain a space suitable to the needs of its community members.

Since these online groups are not facilitated through any of the most common social media platforms, creators and moderators can manage membership, anonymity/confidentiality controls, and access to member content by nonmembers. This is an extremely important function and helps to truly make the space feel safe. This is also crucial to maintaining the space as one for women of colour, which can be monitored by the moderators and administrators, who then approve potential members. Within these online groups, members can make posts about whatever topic they seek guidance on. We have seen posts that vary from seeking advice on applying to a prestigious doctoral fellowship specifically offered to students of colour, to recommendations for low-cost transcription software, to venting about relationship woes. With a

group so large, it can be intimidating at times to post particularly vulnerable topics, but it is through these transparent moments when the digital sisterhood has truly held its weight. As first-generation graduate students, we may often feel guilty about our social mobility as we progress through our respective graduate programs—talking about this with other first-generation students has been cathartic and healing. However, we do not seek to present this group or others as harmonious, monolithic spaces. Women of colour (and nonbinary folks) are a diverse group of people with unique sets of issues, concerns, and needs. The group makes space for nonbinary folks, but future research could also explore what a digital sisterhood means for them, particularly if the term "sisterhood" feels inclusive for them. Due to the digital capabilities of the group, tensions can be negotiated and addressed in real time. Identities are not stable and shift over time, which could potentially cause friction within the group. Administrators and moderators can help facilitate these conversations when they become fraught and remind group members of the rules and guidelines for the group and, if needed, remove anyone who no longer serves the space.

Online message boards in particular are useful platforms for digital sisterhood because of their particular capabilities and affordances. The independently owned sites we use in the digital space have features that allow files to be uploaded. Members can upload job application materials, resources for applying to grants and fellowships, and lists of publications so that members can cite one another's work. This feature is especially important, particularly if members' universities do not provide professional development support of this nature. The groups can also facilitate informal mentoring, as more seasoned graduate students can mentor newer or potential graduate students. Support like this may not be possible at universities. Members can seek advice regarding the job market, important milestones related to the completion of their degrees, and navigating graduate school culture. The Facebook group was also the catalyst for our friendship and professional writing collaboration. This digital sisterhood has the potential to enhance the professional and personal development of its members. Specific career-related benefits that both of us have experienced have come in the form of formal mentoring opportunities with faculty members, invitations to participate in conference panels and

publications, as well as free review of job and funding application materials, which are all helpful for Black women navigating the academy. The benefits of participation in this practice of digital sisterhood have assisted us in persisting through our individual doctoral programs and getting access to the resources that we need to support our goals of matriculation and employment.

In August 2018, Erin accepted a tenure-track position in North Carolina, followed by a successful dissertation defense in October. She cites her digital support system as being a resource to assist her in navigating the processes inherent in preparing for job interviews, preparing for her dissertation defense, and balancing newlywed life and parenthood in the academy. Erin received tips, strategies, and reminders of best practices for navigating through these areas. Briana defended her dissertation and accepted a post-doctoral appointment at a University in Maryland. She notes that the tips and strategies that she received from others in these digital sisterhood spaces have provided her with unique experiences that allow her to participate in academia as a wife and parent to young children.

We have sought to localize the lived digital experiences of two PhD students who have participated in and maintained community through social media groups. As mentioned throughout this chapter, we have decided to share our experiences with online message boards and independently owned websites geared toward Black women in the academy. We have centred using our individual autoethnographic stories because we view these experiences as intersectional experiences that we have taken control of and have shared in the spirit of honesty and transformation. To facilitate this autoethnographic work, our work is grounded in phenomenology. Phenomenological approaches are localized in the personal knowledge of the subjective (Spradley; Schutz). Through the phenomenological approach, we have shared personal knowledge and experiences that provide context for our online and offline perspectives. Therefore, we have purposefully shared our stories in this way so that we can be in charge of the framing and dissemination of an otherwise marginalized experience, which operates as a powerful form of resistance to narratives that reaffirm stereotypical lived experiences instead of embracing diverse ones.

Endnotes

1. To protect the identity and integrity of the online groups that we have participated in, we will not be disclosing the name of the groups or anyone connected to them. It is our intention to share how impactful these groups have been to us as doctoral students and to highlight our own personal experiences.

2. We want to acknowledge that this group also includes nonbinary identified graduate students of colour.

Works Cited

Berry-McCrea, E. L. "'To My Girls in Therapy, See Imma Tell You This fo Free...' Black Millennial Women Speaking Truth to Power in and across the Digital Landscape." *Meridians: Feminism, Race, Transnationalism*, vol. 16, no. 2, 2018, pp. 363-72.

Boylorn, R. M., and M. P. Orbe. "Critical Autoethnography as Method of Choice." *Critical Autoethnography: Intersecting Cultural Identities in Everyday Life*, edited by R. M. Boylorn and M. Orbe, Left Coast Press, 2014, pp. 13-26.

Boylorn, R. M. A Story & a Stereotype: An Angry and Strong Auto/ethnography of Race, Class, and Gender." *Critical Autoethnography: Intersecting Cultural Identities in Everyday Life*, edited by R. M. and M. Orbe, Left Coast Press, 2014, pp. 129-43.

Carver, P. "Women of Color Ph.D Candidates Thrive in Sister Circles." *Stem Diversity Network*, 15 Nov. 2017, stemdiversity.wisc.edu/featured/women-of-color-ph-d-candidates-thrive-in-sister-circles/. Accessed 16 Jan. 2022.

Charmaraman, L., et al. "Women of Color Cultivating Virtual Social Capital: Surviving and Thriving." *Women of Color and Social Media Multitasking: Blogs, Timelines, Feeds, and Community*, edited by K. E. Tassie and S. M. B. Givens, Lexington Books, 2015, pp. 1-19.

Crenshaw, K. "Mapping the Margins: Intersectionality, Identity Politics, and Violence against Women of Color." *Stanford Law Review*, vol. 43, no. 6, 1991, pp. 1241-99.

Cuen, L. "Secret Women-Only Facebook Groups Are Revolutionizing Feminism." *Ravishly*, 5 May 2017, www.ravishly.com/secret-

women-only-facebook-groups-are-revolutionizing-femi nism. Accessed 16 Jan. 2022.

Davis, O. I. "In the Kitchen: Transforming the Academy through Safe Spaces of Resistance." *Western Journal of Communication*, vol. 63, no. 3, 1999, pp. 364-81.

Gilmer, M. C. "This 'Sister Circle' of 8 Indiana Women Is Making History." *Indy Star*, 5 May 2016, www.indystar.com/story/life/ 2016/05/05/great-eight-earn-phd-degrees-iu-school-education /83879468/. Accessed 16 Jan. 2022.

Griffin, R. A. "I AM an Angry Black Woman: Black Feminist Auto-ethnography, Voice, and Resistance." *Women's Studies in Communication*, vol. 35, no. 2, 2012, pp. 138-57.

Herwees, T. "The Curious Rise of Secret Facebook Groups." *Good*, 24 Aug. 2016, www.good.is/articles/the-secret-facebook-groups-where-women-commune-and-heal. Accessed 16 Jan. 2022.

Holley, K. A., and S. Gardner. "Navigating the Pipeline: How Socio-Cultural Influences Impact First-Generation Doctoral Students." *Journal of Diversity in Higher Education*, vol. 5, no. 2, 2012, pp. 112-21.

Jackson, S. J., M. Bailey, and B. Foucault Welles, "GirlsLikeUs: Trans Advocacy and Community Building Online." *New Media & Society*, vol. 20, no. 5, 2018, pp. 1868-88.

King, M. L. "A Blog: A Bittersweet Mess, and Black and White Identity." *Women of Color and Social Media Multitasking: Blogs, Timelines, Feeds, and Community*, edited by K. E. Tassie and S. M. B. Givens, Lexington Books, 2015, pp. 145-61.

National Center for Education Statistics. "Digest of Education Statistics," *NCES*, 2017, nces.ed.gov/programs/digest/d17/tables/ dt17_324.20.asp. Accessed 16 Jan. 2022.

Neal-Barnett, A., et al. "Sister Circles as a Culturally Relevant Intervention for Anxious Black Women." *Clinical Psychology: Science and Practice*, vol. 18, no. 3, 2011, pp. 266-73.

Schutz, A. *On Phenomenology and Social Relations*. Chicago University Press, 1970.

Spradley, J. P. *The Ethnographic Interview*. Holt Rhinehart & Watson, 1979.

Steele, C. K. "'Signifyin,' Bitching, and Blogging: Black Women and Resistance Discourse Online." *The Intersectional Internet: Race, Sex, Class, and Culture Online*, edited by S. U. Noble and B. M. Tynes, Peter Lang, 2016, pp. 73-93.

Steele, C. K., "Signifyin', Bitching, and Blogging: Black Women and Resistance Discourse Online," the Intersectional Internet: Race, Sex, Class and Culture Online, edited by S. U. Noble and B. M. Tynes, Peter Lang, 2016, pp. 73–93.

Chapter 16

Digital Sister Circles: Collectivity and Comradery in Natural Hair Online Communities

Joseanne Cudjoe

Black women have a history of creating safe spaces for themselves.
A "homeplace" constructed by Black [people] women for restoring,
affirming, and uplifting each other. A haven, a community of
resistance where Black [people] women could affirm one another and
by so doing, heal many of the wounds inflicted by racist domination

—bell hooks, *Yearning: Race, Gender, and Cultural Politics*, 42

From Facebook to YouTube, Black women are carving out spaces to make themselves at home in the digital neighbourhoods of the internet. Rejecting the identity as a casualty of the digital divide, these Black women with the means and skill to navigate the internet establish digital enclaves where they can meet, organize, and create bonds around issues that collectively impact their intersectional lives. Nevertheless, it is crucial to note that the digital divide continues to exist, disenfranchising those unable to afford access to the Internet, which alienates them from participating in digital media production—an activity that has become critical to twenty-first-century citizens' ability to advocate for themselves. Still, recent statistics have revealed

that Black women are making strides towards closing this gap. In 2014, the Pew Research Center published a special issue focused on the use of technology by African Americans. The issue identified Black women as the second-highest user segment of all social media platforms.

The explosion of Black women's digital usage has not gone unnoticed, as feminist theorists and media scholars have advanced scholarship that examines the role of the internet in the political, emotional, and social lives of Black women (e.g., Williams; Neil and Mbilishaka; Phelps-Ward and Laura). This chapter sits in conversation with this growing scholarship by focusing on the digital labour of Black women that propels the digital Black natural hair movement (DBNHM)—a movement typified by creating social media natural hair groups (SMNHGs) in which these women discuss and celebrate their natural hair in counterhegemonic ways. Ultimately, I argue that the behavioural norms within these SMNHGs mirror the community building tenets inherent to traditional Black sister circles because these groups provide the opportunity for geographically displaced, Black women to forge fictive sisterhood relationships. These women foster these sisterhoods by building comradery around their shared ethnic and gendered identities and by negotiating around their similar experiences with the destructive hegemonic ideologies about Black natural hair that have long served as a source of emotional and psychological trauma levelled against Black bodies.

Furthermore, these women make use of these communities to participate in acts that yield mutual benefits, and in so doing, they establish bonding practices that echo the culture of support native to Sister circles—a culture that has for generations emboldened Black women to overcome trauma through bond practices and collective strategizing. To support these arguments, in the following sections, I present some of the findings from a comprehensive, IRB-approved digital interpretive content analysis of four SMNHGs.

The DBNHM

Black women have always invested their labour into building themselves spaces of resistance (hooks). These are essential spaces, hooks notes, where Black women can restore the dignity mainstream society denies them (42). These spaces allow Black women to collectively

engage in countering the racial and gender oppression they endure. The desire to create such spaces has not fallen away in the technological era. Black women have continued to erect these spaces, with some choosing to employ internet technologies as a means for virtual connectivity and community building.

The DBNHM provides a vibrant locale for observing these practices; it is the digital incarnation of the growing contemporary Black natural hair movement and a movement that has been championed within the last eight years by Black women who are employing virtual vicinities to establish communities and engage around their shared identities as Black women who wear their hair in its natural state (known as "naturalistas"). Unimpeded by geographic distance, naturalistas use blogging sites, social media, and networking groups to meet and negotiate around the politics of Black natural hair.

The Politics of Black Hair

Head hair is by no means inconsequential in western societies because hair serves as a significant marker of gender, femininity, and beauty. It is imperative not to dismiss the significance of possessing a body deemed physically appealing as a vain concern. After all, beauty is a form of human capital that is tradeable in the economic marketplace and everyday life (Holla and Kuipers 291). Women with Black natural hair, thus, occupy a precarious position in the dominant beauty market, given the tendency of restrictive prevailing norms to relegate these textures at the bottom of hegemonic beauty hierarchal structures. Yolanda Michele Chapman emphasizes this point when she argues that there are social rewards for having straight hair, as it is connected with the dominant culture, which translates into power and resources (32-33).

The media and beauty industries have played significant roles in upholding problematic beauty standards. Scholars have provided a rich canon of work highlighting how the media industry's cultural reproduction of harmful mediated messages about Black natural hair continues to contribute to the acrimonious relationship between the dominant US culture and Black women (e.g., Rooks; Collins, *Black Feminist Thought*). These scholars highlight how media industry executives' casting decisions and production choices contribute to the

normalization of the perception that Black natural hair is dirty, untamed, unprofessional, and in need of fixing. By othering Black women's hair, purveyors of the beauty norm diminish the potential for some Black women to gain the power attached to beauty. This often tenuous relationship Black women's natural hair shares with mainstream US beauty norms is central to the discourse within the SMNHGs, as members use these spaces to share their experiences about the micro- and macroaggressions they face as naturalistas. These SMNHGs are thus not mere socializing locales; they also serve as therapeutic enclaves for these naturalistas to escape into, commiserate, and jointly produce pro-Black natural hair digital content. Therefore, the SMNHGs function much in the same ways as traditional Black sister circles, providing Black women with a commune to build intimacy and foster comradery through discourse and interaction (Niles-Goins).

Sister Circles Are Not Luxuries

Beginning in girlhood, Black women learn the sacred power of Sister circles. Within them, Black mothers, neighbours, and aunties share advice full of humor and sarcasm and rich in cultural wisdom; they support one another, laugh through pain, and create a community that organizes, resists, and fights for collective freedoms. Forging Sister circles is a form of everyday resistance undertaken by Black women to overcome the "matrix of domination" (Collins, *Black Feminist Thought*) that attempts to limit the possibilities of their lives. Within such "homeplaces" (hooks) is a cherished system of support that serves as a site for collective negotiation and knowledge sharing that has the potential to enhance the emotional and social capital of each member. Familial ties are not prerequisites for joining these sisterhoods, as members are not biologically related. Instead, these fictive family relationships are comprised of women brought together by their mutual respect and shared experiences (e.g., Chatters et al; Stewart).

In addition to these informal embodiments of Sister circles, scholars have argued that formalized Sister circles in African American communities first flourished within the Black church, the Black women's club movement, and Black sororities (e.g., McDonald). These formal structures function as support groups that draw upon the

strength and courage found in African American women's friendship networks. Africana scholars, such as Obioma Nnaemeka, have also noted that contemporary American incarnations of Sister circles can trace their genesis to the women's collectives established by pre- and early colonial West African women. Such collectives were forged by these women to negate patriarchal attempts at subjugating their social position. By situating these collectives as precursors to contemporary Sister Circles, these scholars foreground the political and counter-hegemonic nature embodied within these types of publics, thereby presenting them as social organisms in which Black women can harness their power towards their joint preservation and elevation (McDonald 47). Sister circles are, thus, not luxuries; they are essential healing, liberating, and nurturing spaces, where Black women go to find rest, compassion, validation, and the strength to navigate their lives in a world that often refuses to recognize their humanity.

Not surprisingly, many studies that examine Black women's interpersonal relationships focus the role of Sister circles as an intervention tool that can counteract the daily trauma experienced by Black women. For example, in Toni Denton's study of friendships between Black professional women, she highlights the importance of verbal and nonverbal communication in peer-to-peer support for Black women who occupy white-dominated spaces. Yet, like Denton, many of these studies have almost exclusively focused on communities of women who share close physical proximity. However, this study explores how internet technology has redefined how Black women are now able to establish and maintain fictive kinships. The study raises the question of whether sisterly practices of offering emotional support and participating in joint action can emerge within digital communities.

Collectivity and Digital Sisterhood

Black women frequent all avenues of the internet's landscape. These SMNHGs, however, are some of the most popular locations in which they digitally congregate—strangers fused into collectives forged by the shared experiences of daring to embrace their kinks, coils, and curls. Some may dismiss the notion that these women sharing loose ties can develop into a sisterhood that is impacting and beneficial. However, the types of interactions observed during the study of these

communities suggest that they can because the shared identity among the members often catalyzes engagement practices that have the potential for collective progress. These acts of solidarity undertaken by these women closely resemble those Patrick Hughes and Amy Heuman note are emblematic of Black sisterhoods. Drawing upon the works of several scholars, (Collins, *Black Feminist Thought*; Denton; Gilroy; Niles-Goins), I argue that interactions within SMNHGs exemplify three essential tenets of Sister circles, each rooted in the notion of collectivity and solidarity. Their presence in these communities confirms that the women who sustain the DBNHM have employed the group-affirming (Sherman et al., 2007) behavioural practices of traditional sister circles.

The first tenet notes that sister circles allow for Black women to engage and discuss a multitude of issues of collective interest and concern. In her study of Black women friends, Marnel Niles-Goins found that the discourse within these types of circles covers the gamut of their lives, including such topics as family, finances, appearance, men, sex, and race (Niles 97). A cursory scan of the comment section within these SMNHGs reveals hair tutorial videos and product reviews sitting alongside requests for advice on how to deal with teenage kids, ex-lovers, microaggressions in the workplace, or collective calls for political boycotts. The shared racial and gender affiliation these Black women share not only stimulates their desire to form a community with one another but also allows them to recognize and validate the shared social stressors they experience as Black women (Denton). For example, many of the interview respondents describe their SMNHGs as cathartic spaces. One of those respondents noted the following: "It is a great place to vent, kinda like the beauty salon; we talk about our lives, share advice, and make each other laugh.... Recently, I got some great advice about how to deal with my daughter's struggles with low self-esteem." By framing these groups as locations in which to access counsel, this respondent demonstrates that although it may be their need for hair care advice that initially drives members to join these communities, their similar life experiences as Black women may serve as a conduit for additional bonding behaviours.

The second tenet concludes that like other fictive kinship networks, sister circles are culturally relevant spaces. In their study of the role of these circles in treating Black women with anxiety, Angela Neal-

Barnett et al. found that since they incorporate practices and strategies unique to the participants' lives as Black women, cognitive behavioural therapy practitioners can more effectively treat their patients. This finding is not shocking, given the fact that some scholars long argued the importance of a shared culture among group members. Alberto Melucci, for example, suggests that in groups in which a strong sense of commitment exists, members often use social conventions (e.g., rites of passage, language, and dress) as boundaries to intentionally create social distance between themselves and nonmembers. Similarly, David McMillan and David Chavis find that creating and using a common symbol system can create and maintain a sense of community (11). By using colours, emblems, gestures, or a shared cultural lexicon, members can communicate and exhibit their membership, which can delineate and strengthen the parameters of fictive kinship relationships.

I found that within the SMNHGs, there is a presence of a shared culture, which is first evident by the frequent usage of an informal lexicon inspired by a mixture of Black vernacular English, Patois, and popular culture references. Additionally, the members affirm themselves as indigenous to the prevailing group culture by their knowledge and use of the extensive vocabulary of acronyms, phrases, and terms central to the Black natural hair grooming culture. Next, in addition to the shared lexicon, the members of SMNHGs demonstrate their fictive kinships by engaging in behavioural practices replicated from Black cultural spaces, such as beauty salons. As noted in the interviewee's quote above, interactions within these SMNHGs mirror those typical to beauty salons. Africana studies, such as Noliwe Rooks, have argued that beauty salons play a vital role in socializing Black women. These culturally rich conclaves are places of retreat that afford Black women temporary solace from the intersecting pressures of identity politics. Hence, as members of these SMNHGs duplicate the behavioural practices inherent to those Black, feminized spaces, they further avow their adherence to a shared culture.

Furthermore, the members frequently use the terms "sis," short for sister and "sib," short for sibling, when engaging with each other, terms that are inspired by what sociologist Paul Gilroy calls the trope of kinship. Quoting Gilroy's work, Patricia Hill Collins notes that the trope of kinship permeates Black understandings of culture and community to the point that African Americans largely accept the

notion of race as family and function accordingly within their inter-personal groups ("It's All in the Family" 77). This perception that one's shared Black racial identity can be the basis of forging familial bonds resonates in the work of Katrina Bell et al., who note that Black women hold an expectation of sisterhood from each other (46). Thus, using "sis" and "sib" does not only serve to solidify member's in-group identities, but it suggests that these practitioners of the DBNHM have moved beyond merely expecting sisterhood towards normalizing behavioural practices that foster fictive kinship connections. Collective action among members is the final and, for this chapter, the most crucial tenet of traditional sister circles found within these SMNHGs.

To identify collective action in these spaces, I drew upon Denton's study, in which she identifies three types of collective bonding activities inherent to intimate Black female relationships. The first activity emphasizes supportiveness, which is characterized by encouragement and a high commitment to one another (452). One of the most distinctive ways in which these women demonstrate supportive action is through their purchasing behaviours. Both the discourse and their actions highlight the importance of buying Black-culture products within these groups. In each of the four communities studied, the moderators designated specific days in which business owners advertise their products to the community. As a true testament to support for entrepreneurship within these groups, the moderator of one of the communities established a subsidiary Facebook group dedicated to small business promotions. The next identifiable bonding activity in these communities focuses on instrumental help, which includes the pragmatic helping behaviours of problem solving and task help (Denton).

As mentioned above, members of these communities often share aspects of their private lives, not only practical advice and emotional support. On occasion, they fuse their social and intellectual resources to intervene in cases of emergency. One example that demonstrates this problem-solving method emerged when a young woman posted a video in which she asked for advice on escaping an abusive relationship. Within minutes of the post going live, several hundred comments appeared. Members identifying themselves as directors of women's shelters, pastors, police officers, and lawyers responded. These members pooled together their knowledge and resources and shared

advice. Within a week, through their emotional, physical, and financial support, the young lady had moved into a new apartment. This example is, by far, not unusual. Throughout the comprehensive, digital interpretive content analysis of the four SMNHGs under study, similar emotionally charged posts served to activate joint acts of intervention and problem solving.

The final bonding activity focuses on social companionship, underscored by comradeship and social activities. As demonstrated by the previous example, members have transferred their digital relationships into the physical world. In two of the four communities studied, members host monthly brunches, whereas in another community, an international travel club was planning their fifth summer trip. Although these digital meeting spaces continue to be the primary locations in which these women interact, their willingness to engage in offline interactions signifies a desire to deepen the established sisterly relationships.

Countercollective Behaviours

It is imperative that as we consider how the culture of traditional sister circles has shaped the engagement and discourses of these digital sisterhoods, that we do not romanticize these groups. At times, members exhibit anticommunity-building behaviours that impede the formation of traditional sister circles. Lisa Nakamura argues that contrary to the belief that cyberspace offers a way to escape gender, race, and class as conditions of social interaction, woven into online discourse are stereotypical notions of identity politics. It is then not surprising that even though users reject oppressive ideologies about their bodies within these spaces, there are still instances of internalized anti-Blackness and the rejection of intersectional thought. Countercollective behaviours threaten these spaces; for example, the internalization of anti-Black ideologies, such as colorism, by some members of these communities also diminishes the potential for sisterhoods to flourish. Tracey Owens Patton defines colorism as a hierarchy system, which labels Black men and women with hair textures and skin tones closer to Europeans as more beautiful and more desirable (38).

Colorist language is emblematic of antisisterhood behaviours, which can result in fractured relationships and feelings of mistrust among

Black women. Additionally, elitist, classist, xenophobic, homophobic, and religiously intolerant comments routinely arise within these communities, serving to disturb the congenial atmosphere within them. Although the potential for sisterhood to flourish remains high, these occasional countercollective behaviours can threaten the groups' solidarity. It is then critical that the movement's participants denounce these practices because as these divisive behaviors thrive, they can create a toxic atmosphere that hinders these groups' ability to serve as successful models of digitalized homeplaces.

Conclusion

Despite the presence of countercollective behaviors, the normative behavioural practices observed within the SMNHGs study demonstrate that members have successfully digitalized the three essential tenets of sister circles. In doing so, these women mirror the types of action that Hughes and Heuman found to be so critical to Black sisterhoods. As a result, these women germinate the fertile soil required for fictive sisterhood relationships to flourish. These women use new technologies to reimagine the notion of the community, one not tethered to physical contact. As they converge and converse around the realities of navigating life in Black, female bodies, they simultaneously support one another, which is evidenced by their willingness to transfer into their virtual communities some of the supportive and life-affirming elements of traditional sister circles that have sustained Black women for centuries. Created and maintained by Black women and for Black women, these SMNHGs allow for collective engagement and the creation of alternative media texts that celebrate Black natural hair and reject dismissive, whitewashed standards of beauty. Given the limited mainstream media production power held by Black women, these SMNHGs provide an opportune space for these Black women to define themselves for themselves without fear of becoming crushed (Lorde). Within them, they gain pleasure, power, and wisdom from those with whom they commune.

As these Black women chisel out parts of the cyberworld to discuss their shared identities, they are simultaneously constructing digital fictive sisterhoods that allow them to affirm their humanity, special-ness, and right to exist (Collins, *Black Feminist Thought* 102). By being

supportive, offering help, and engaging in activities focused on bringing about mutual benefits, these users' digital labour resembles some of the behaviours of other Black women internet users. For example, Sherri Williams highlights how Black women Twitter users make use of the viral nature of social media platforms to share information and bring attention to often overlooked issues that focus on the concerns of Black women. Like those Twitter users, SMNHGs users draw upon their collective identities to create what Michelle Wright calls "digital rooms of their own" (48). Hence, although these digital spaces cannot replicate all aspects of traditional sister circles, they provide the potential for fictive sisterhoods to emerge. By making adequate use of the interactive social media tools available to them, the users can bond across their shared lived experience of navigating through the world while facing a collective form of domination and injustice at the intersection of racism and sexism.

It is vital to not solely attribute the emergence and impact of SMNHGs to the exceptionalism of the internet. Instead, because Black women have long established a precedent for carving out spaces for restoring, affirming, and uplifting each other (hooks 42), these groups are the fruits of the labour of twenty-first century Black women who have successfully transitioned longstanding modes of fellowship into a new medium.

Works Cited

Bell, K. E., et al. "Accepting the Challenge of Centralizing Without Essentializing: Black Feminist Thought and African American Women's Communicative Experiences." *Women's Studies in Communication*, vol. 23, no. 1, 2000, pp. 41-62.

Chapman, Y. M. *"I am Not my Hair! Or am I?": Black Women's Transformative Experience in their Self Perceptions of Abroad and at Home.* Master's thesis, Georgia State University, 2007, scholarworks.gsu.edu/anthro_theses/23. Accessed 16 Jan. 2022.

Chatters, L. M., R. J. Taylor, and R. Jayakody. "Fictive Kinship Relations in Black Extended Families." *Journal of Comparative Family Studies*, vol. 25, no. 3, 1994, pp. 297-312.

Collins, P. H. "It's All in the Family: Intersections of Gender, Race, and Nation." *Hypatia*, vol. 13, no. 3, 1998, pp. 62-82.

Collins, P. H. *Black Feminist Thought: Knowledge, Consciousness, and the Politics of Empowerment*. 2nd ed. Routledge, 2000.

Denton, T. "Bonding and Supportive Relationships among Black Professional Women: Rituals of Restoration." *Journal of Organizational Behavior*, vol. 11, no. 11, 1999, pp. 447-57.

Gilroy, P. *Small Acts: Thoughts on the Politics of Black Cultures*. Serpent's Tail, 1993.

Holla, S., and G. Kuipers. "Aesthetic Capital." *International Handbook for the Sociology of Art and Culture*, edited by Hanquinet, Laurie, and Michael Savage, Routledge, 2015, pp. 290-304.

hooks, b, *Yearning: Race, Gender, and Cultural Politics*. South End Press, 1990.

Hughes, P. C., and A. N. Heuman. "The Communication of Solidarity in Friendships among African American Women." *Qualitative Research Reports in Communication*, vol. 7, no. 1, 2006, pp. 33-41.

Lorde, A. *Sister Outsider*. Crossing Press, 1984.

McDonald, K. B. *Embracing Sisterhood: Class, Identity, and Contemporary Black Women*. Rowman & Littlefield, 2006.

McMillan, D. W., and D. M. Chavis. "Sense of Community: A Definition and Theory." *Journal of Community Psychology*, vol. 14, no. 1, 1986, pp. 6-23.

Melucci, A. "The Process of Collective Identity." *Social Movements and Culture*, edited by H. Johnston, Routledge, 2013, p. 100.

Nakamura, L. *Cybertypes: Race, ethnicity, and identity on the Internet*. Routledge, 2013.

Neal-Barnett, A. M., et al. "In the Company of My Sisters: Sister Circles as an Anxiety Intervention for Professional African American Women." *Journal of Affective Disorders*, vol. 129, no. 1-3, 2011, pp. 213-18.

Neil, L., and A. Mbilishaka. "'Hey Curlfriends!': Hair Care and Self-Care Messaging on YouTube by Black Women Natural Hair Vloggers." *Journal of Black Studies*, vol. 50, no. 2, 2019, pp. 156-77.

Niles, M. *Safe Space: A Small Group Perspective on Black Women Friendships*. 2007. The University of Alabama, Master of Arts Thesis.

Niles-Goins, M. "Playing with Dialectics: Black Female Friendship Groups as a Homeplace." *Communication Studies*, vol. 62, no. 5, 2011, pp. 531-46.

Nnaemeka, O. *Sisterhood, Feminisms, and Power: From Africa to the Diaspora*. African World Press, 1996.

Patton, T. O. "'Hey Girl, Am I More Than My Hair?': African American Women and Their Struggles with Beauty, Body Image, and Hair." *Feminist Formations*, vol. 18, no. 2, 2006, pp. 24-51.

Pew Research Center. "African Americans and Technology Use: A Demographic Portrait (Rep.)." *Pew*, 2004, www.pewinternet.org/ 2014/01/06/african-americans-and-technology-use/. Accessed 16 Jan. 2022.

Phelps-Ward, R. J., and C. T. Laura. "Talking Back in Cyberspace: Self-Love, Hair Care, and Counter-Narratives in Black Adolescent Girls' YouTube Vlogs." *Gender and Education*, vol. 28, no. 6, 2016, pp. 807.

Rooks, N. M. *Hair Raising: Beauty, Culture, and African American Women*. Rutgers University Press, 1996.

Sherman, D. K., et al. "The Group as a Resource: Reducing Biased Attributions for Group Success and Failure via Group Affirmation." *Personality and Social Psychology Bulletin*, vol. 33, no. 8, 2007, pp. 1100-12.

Stewart, P. "Who Is Kin? Family Definition and African American Families." *Journal of Human Behavior in the Social Environment*, vol. 15, no. 2-3, 2007, pp. 163-81.

Tate, S. "Black Beauty: Shade, Hair, and Anti-Racist Aesthetics." *Ethnic and Racial Studies*, vol. 30, no. 2, 2007, pp. 300-19.

Williams, S. "Digital Defense: Black Feminists Resist Violence with Hashtag Activism." *Feminist Media Studies*, vol. 15, no. 2, 2015, pp. 341-44.

Wright, M. M. "Finding a Place in Cyberspace: Black Women, Technology, and Identity." *Frontiers: A Journal of Women Studies*, 26(1), 2005, pp. 48-59.

Chapter 17

I Am My Sister: Exploring Black Womyn's Membership in Sister Circles Created Via Social Media

Adrianne Jackson and Leah P. Hunter

Sister circles have been in existence in some form or another since the seventeenth century (Davis). We look at the development of sister circles over history and move this framework into a digital landscape. This chapter argues that the creation of digital sister circles extends the literature on Black womyn's social activism into the realm of higher education. Chronicling the rise of Black womyn's social activism dating to the mid-nineteenth century provides the historic framework that birthed contemporary digital sister circles. Groups of Black womyn have assembled via their sororities, civic societies, book clubs, sewing circles, and church organizations to discuss issues crucial to their survival in the United States, especially the peril of being a Black woman in a white, male-dominated world (McKay). There is scholarship that includes ethnically diverse womyn, and their findings indicate friendship can enhance these womyn's health and mental wellbeing (Greif and Sharpe). Female friends are integral to Black womyn's socialization, survival, and growth (Person).

The consistency of the sister circle model experienced a boom during the early twentieth century with the formation of such groups as the National Association for Colored Women (NACW). Well into the mid-twentieth century, the NACW formulated national programming to

263

support Black womyn's social and political activism. To this end, sister circles connected lay women, activists, and professional women. It is here that we locate the power and longevity of sister circles and extend them to a contemporary digital framework.

For this project, sister circles are those digital spaces that centre race and gender of womyn who have similar experiences in an effort to provide an outlet to collaborate, find mentorship, and to become their best selves (Croom, et al.). The dynamic significance of social media on influencing activism has been readily studied, although little scholarship exists on digital sister circles in higher education. Throughout this work, "Black" is used to describe womyn who are American and identify as Black. As such, it reinforces a diasporic understanding of both the longevity and brevity of digital sister circles.

Black womyn have attended college since 1862, when Mary Jane Patterson matriculated at Oberlin College. By the 1980s, Black womyn inside and outside of the academy produced a wave of scholarship that centred on the establishment of sister circles. In the twentieth century, Black womyn earned opportunities to make their mark as faculty members in the academy (McCandless). These womyn found themselves as the only Black woman or one of a few in predominantly white institutions. They often felt alone and found that their worth was constantly challenged by their white counterparts as well as by students. Having to justify everything from their research agenda to their actual presence and position in the academy, these womyn found each other at their universities and noted the similarity in their experiences. In an effort to support each other in these situations, Black womyn formed sister circles.

While these sister circles grew, the womyn knew there were others who needed this connection; they might have been located in different universities, but they were still close geographically. Professor Nellie McKay recounts the beginnings of the Black Women and Work Collective, a Ford Foundation-funded symposium. Before the organization was formed, these womyn searched for one another at conferences, helped one another with research and, eventually, created the collective (Harley).

This connection that Black womyn have with one another across geographic, education, and class lines is what Patricia Hill Collins theorized in *Black Feminist Thought: Knowledge, Consciousness, and the*

Politics of Empowerment. Collins developed the theory of Black feminist thought as a reaction to the hegemonic ideologies that keep us as Black womyn in subordinate positions and threaten our existence. As a critical social theory, it challenges oppressive ideals that affect Black womyn in the workplace, at home and in relation to others. According to Collins (*Black Feminist Thought*), there are safe places where Black womyn have traditionally been able to come together and develop both individual and collective thought. In formal organizations, such as Black churches, sororities and other womyn's organizations, Black womyn put forth an agenda that would assure their position in the larger community is not ignored.

In addition to the formal organizations, personal relationships with our mothers and girlfriends provide everyday knowledge that is essential to our survival (Collins, *Black Feminist Thought*). Young Black womyn's identities are often formed through interactions with their mothers. With girlfriends, in contrast, Collins shares that "sisters and friends affirm one another's humanity, specialness, and right to exist" (*Black Feminist Thought* 113). The role that these womyn play in one another's lives is powerful. What is more amazing is that this affirmation and acknowledgment can exist among womyn who do not really know one another. For many Black womyn, there is a commonality with other sisters that allows us to recognize ourselves and see our corporate value.

Although we see value in ourselves, identifying the value of Black womanhood depicted within the media is not always easy. Part of the challenge involves resisting negative images put out via the mainstream media. This includes stereotypes, such as the Mammy and the Black lady, which depict us as overly aggressive, devoid of morals, and emasculating of Black men (Collins, *Black Feminist Thought*). Black feminist thought, then encourages Black womyn to collectively resist these images and, in turn, emboldens us to create new, empowering images. This is particularly effective in the current, social media-driven culture where negative imagery abounds. With the advent of the internet and the growth of such sites as Facebook, Twitter, and Instagram, it has been easier for likeminded individuals to meet. Social media sites now facilitate connections that may not be plausible in the real world. With no cost for travel and the ability for asynchronous discussions, social media is a viable option to connect for some.

ADRIANNE JACKSON AND LEAH P. HUNTER

Furthermore, social media allows for the creation of friendships and sister circles across the world, which are essential in combating the negative narratives that are often associated with Black womyn.

It Is #BlackGirlMagic

Black womyn combat a range of internal stereotypes and work to alter these narratives through collaborative digital frameworks, such as #BlackGirlMagic. We often hear negative narratives when it comes to Black womyn and their ability to build and maintain relationships (Collins, *Black Sexual Politics*), such as "Black womyn do not get along" and "Black womyn are mean toward one another." The stress Black womyn encounter is unique because we are often dealing with issues related to race, gender, sexuality, and class. Intersectionality explains the complexities that Black womyn face (Collins, *Black Sexual Politics*; Crenshaw).

As Black womyn work to navigate spaces filled with whiteness, patriotism, and misogyny, it is important that they build relationships with womyn who have personal experiences that mirror their own (Cooper; Davis; Harris-Perry). Scholars have all determined that the social support that Blacks can provide one another is one response to the environmental stressors of living in a white racist society (Denton). However, Black womyn connecting is not just for social support. Meaningful friendships can be a means of survival for Black womyn in a world that often tells them that they are not enough (Bryant-Davis). Toni Denton has proposed the idea that bonding relationships are an adaptive response to the exhaustive dynamics generated by the combined race-gender affiliation of Black womyn, as they need the support that other Black womyn provide, both individually and as a group.

In social work, the strengths perspective encourages us not to focus on the problems or the powerlessness of service users with diverse backgrounds and needs but to discover their strength (Saleebey). Strength is not only found in resilience; it is also evident in resistance and strategies for survival despite the adversity faced (Guo and Tsui). Black womyn provide support to one another by utilizing a strengths-based perspective (Fries-Britt and Kelly). The ability to understand the nuances and the issues that are specific to being Black and a woman is

a personal one.

It is often more difficult to connect to other Black womyn locally because of time constraints as well as the need to be in the home to rear children and to take care of spouses and significant others (Bryant-Davis). Social media has become an outlet used by Black womyn to vent, to have a place of refuge, and in many cases to meet womyn who understand and identify with their concerns and challenges. These primary components of digital sister circles extend the diasporic framing to cover the variance of experience across geographical boundaries.

Black womyn are often seen as being trendsetters, community leaders, and brand builders (Pearson-McNeil and Ebanks). In the United States, sixty-nine per cent of Black womyn believe embracing and supporting their ethnic culture is important, and 59 per cent of Black womyn expect companies they support to give back to their communities in a meaningful way (Pearson-McNeil and Ebanks). This connection to community and culture lends to our desire to connect with other Black womyn because of our common values, (Bryant-Davis), and in the digital age, these commonalities are what lead Black womyn to develop new ways of bonding.

There should be no surprise that Black womyn are also always heavily connected on social networks, as Black people are often at the centre of cultural production and regulation. Eighty per cent of Black womyn own smartphones, a rate eight per cent higher than non-Hispanic white womyn ("Reaching Black Women"). Black womyn's high ownership of mobile technology gives them access to a multitude of apps and sites (including social networks) and is evidence of the amount of time they spend consuming social media ("Reaching Black Women"). Facebook (72 per cent) is the top social media networking site used by Black womyn. YouTube, Instagram, Twitter, and Google+ are also visited more frequently by Black womyn than by white womyn ("Reaching Black Women"). With those numbers, it is easy to see why the media facilitates the creation of meaningful connections between Black womyn. Notably, digital spaces provide transparency and intimacy for a connection that is often not experienced in higher education spaces, where many Black womyn are the only Black person in their department.

In its ability to overcome vast physical distances, social media has

offered Black womyn another avenue for creating meaningful and supportive connections (Wade). Since the late 1980s, Black online communities have been thriving (Byrne). Facebook, Twitter, LinkedIn, and many other platforms bring together those who if not for the internet would not be able to establish a community. Black womyn are generally brought together online because of shared acquaintances, interests, professional roles, and even sense of humor, and these social media sites offer a different place for Black womyn to connect and build meaningful relationships via sister circles.

How do Black womyn create these sister circles? What are the benefits of them? In order to understand the phenomena of sister circles via social media, we will explore the personal experiences of the authors of this chapter and other Black womyn who have created sister circles via social media.

Melody

In an interview with Melody (L. Hunter, personal communication, October 20, 2018), she discussed some of the Facebook groups of which she is a member. When first interacting with these groups, Melody was concerned about the level of intimacy and whether she would be comfortable interacting with womyn she did not personally know. She likened those initial interactions to a game of Double Dutch. While you are trying to learn the ropes, there are two people on the end who are also there to help turn the turns so that you can jump with grace and rhythm. She finally found her rhythm in the group "Move and Shake: Academic Women Connecting in the Journey." It is a Facebook group created primarily for womyn of colour who are in academia, and the membership is largely African American. As Melody explains.

> One of the benefits that I found was when I was in graduate school ... I was having a "time" ... I'll say that. Specifically, because they weren't a lot of Black womyn, or Black womyn support networks at Northwestern on the graduate level. And ... I say this to this day: "Move and Shake" truly saved my academic life at Northwestern. Just because there was so much support. There were so many resources that we shared internally, even from a fun standpoint. They continue to lift us up as we moved on

in our academic lives. I really thank "Move and Shake" for that.

Sister circles can be conduits of self-care that allow Black womyn to have safe places and connect with good people who have similar experiences (Bryant-Davis). For Black womyn, finding support through social means leads to healing and empowerment. In addition, sister circles can be a method by which Black womyn discuss the importance of self-care. Melody continues:

> I'm also in a couple of other online circles. One is called "Sis, You Belong Here." It's really more about self-care, taking time for self-care and being purposeful about it ... the process of actually taking time for self-care still feels like something that we're sneaking to do. "Sis, You Belong Here" really makes space and checks in. What have you done today? Have you had your water today? What did you read today that helped you with your thinking? Mantras, vision boards, memes, all sorts of beautiful images for our eyes and ears. So I really appreciate that. The leader of "Sis, You Belong Here" is a licensed psychotherapist who helps young, African American womyn find their way. And she's used that training to help those of us who are more seasoned than young.

The experience that Melody shares is not uncommon for Black womyn who are regular and active users of the Facebook platform.

Adrianne

As a member of several Facebook groups, I was able to create sister circles and meet several mentors via the online platform. A Facebook friend whom I have known since childhood posted about a friend—Dr. Yarneccia Dyson, a University of North Carolina-Greensboro social work faculty member—and the presentation she was working on. As the current program director of the bachelor of social work (BSW) program at Florida Agricultural & Mechanical University (FAMU), I decided that it would be beneficial to connect directly with her. We began conversing via the Facebook messenger and within the first conversation, Dyson inquired about my attendance at several social work conferences, and I disclosed to her that I was pursuing my PhD.

In that conversation, which was extensive, Dyson said, "Please let me know how I can support you, phdiva." Dyson, a womyn I barely knew, was more than willing to help and serve as a mentor because she contended that we all have to stick together and support one another because she believes in "lifting as she climbs."

Through membership in Facebook groups centred around Black womyn in the academy and interacting on Twitter with accounts, such as BlackWomenPhDs, I have been able to build connections with other Black womyn who have similar research agendas and who are looking for support navigating the academy as doctoral students and junior faculty members.

Leah

The relationships that Black womyn form with one another via social media often go beyond the professional and into personal support. After I was abruptly let go from an academic position, I turned to one of my sister circles on Facebook for advice. Like Melody, I am a member of "Move and Shake," a Facebook support group created and managed by the Rev. Dr. Alisha Lola Jones, who was also interviewed for this chapter. Although I did not personally know many of the womyn in the group, knowing Alisha assured me that I and my discussion would be protected. Over the course of the discussion, not only did I receive legal advice, but I was also linked to job opportunities in both the academic and nonacademic world. Most importantly, the womyn offered prayers, kind wishes, and an ear for whenever I needed it. This was both important and reaffirming to me. These positive reinforcements were crucial because many womyn of color struggle with imposter syndrome, and to lose a job so abruptly made me reconsider my place in academia. But they reminded me of my worth and that I play a crucial part in the academic world.

The validation that I received from her group provided a means of moral and mental support during my difficult time. On the show "Fix My Life," the host Iyanla Vanzant has stated several times while supporting womyn on her show, "I am not my sister's keeper, I am my sister." This quote speaks to the level of empathy that many black womyn feel toward each other within these sister circles.

Alisha

Not only is Alisha a member of a sister Circle, but she is also a founder of one as well, "Move and Shake." In an interview (L. Hunter, personal communication, October 21, 2018), Alisha explained why she felt there was a need for this group: "'Move and Shake' was started in 2011 as a result of a series of conversations that I had with womyn in my life who were doing really meaningful things around the world. I felt a need to really talk about those meaningful things unapologetically among ourselves. And so it seems like the format of the group of Facebook was an ideal way to cultivate that." Alisha also remarked on the pervasive stereotypes that Black womyn must face: "There's this sort of imagined disfigurement of specifically womyn of colour when they do extra-ordinary things, that they are hard to bear, that they are not nice; they're treacherous. However, that has not been my experience. And if there are those who believe that is the route to take, I wanted to provide exposure to really amazing people who disprove that stereotype."

"Move and Shake" has been as much a support centre for the founder as it has been for the members. When recalling what motivated her to start the group, Alisha said the following:

> I started the group while completing doctoral research, not realizing I was the first in my program. So the sense of isolation was very real. I really wanted to be able to know what others in my program were not telling me. Was it because they had people who had gone before them? They had people in their families and alums who were part of their affinity-group-sharing identities. I noticed there were really good and intentional connections being made along affinity and heritage lines.

Whether discussing medical, spiritual, or social issues, Sister circles have become essential in the survival of Black womyn while navigating the academy. These friendships and relationships help to form a found-ation that allows Black womyn to hopefully thrive in adverse situations.

Benefits of Sister Circles

Black womyn's friendships and relationships are important (Collins, *Black Feminist Thought*). Homegirl interventions (Cooper) have the

ability to challenge you and to change your life in meaningful ways. Sister circles created via social media are able to provide a counterspace to interlocking systems of oppression by providing Black womyn a place of support and refuge (Croom et al). In the current political climate, sister circles are needed more than ever (Walters). Attacks on Black womyn and Black culture in general create stress and anxiety. Although some of that stress comes from social media, these sites also allow us to check in on our sisters and make sure that they are not crumbling under the weight of this patriarchal society. Sister circles serve as a way to navigate the perils of racism and sexism (Bryant-Davis; Croom et al.). Perhaps this sentiment is best expressed by Melody: "We are all in different parts of the country, all in different cities.... We need this [space] to make sure we know that we are not alone. Because there are some sisters, right, who are in the middle of nowhere, and just to reach out online and know that they are okay. They can connect with someone else who is like, 'Yes, I see you. You don't have to be afraid.'"

Alisha agreed with this sentiment and spoke about the ways that these groups—despite the negative energy that can be found of social media sites—can change lives in a positive way.

> Black women, womyn of colour don't want to have fight with each other. They don't want to have tensions. They want to illustrate the beauty of these connections between [the] same gendered identities. Really, [these connections can make changes] in people's lives through thinking together on the interworking of various processes of promotion and life changes. It really does speak to how you can use social media in good system-engaging and system-deconstructing ways.

Conclusion

There is a lot going on in social media, politically and socially, that can be a source of stress, negativity, and anxiety. How reaffirming, then, is it to know that there are womyn who are committed to helping others get through it all. In this chapter, Black womyn shared their personal experiences about what motivated them to participate in online sister circles and to build relationships via social media. Their collective

experiences centre around connectedness and the support Black womyn desire in order to excel while in the academy. An additional benefit lies in the personal relationships that are developed along the way.

Sister circles created via social media are safe spaces, such as those discussed by Collins (*Black Feminist Thought*), which allow Black womyn to build relationships with other Black womyn and assure them that they are more than worthy and that their existence is important. Existing in spaces that are designed for Black womyn and by Black womyn is important in order to create a place where self-care is nurtured and mentorship and friendship are received. In an ever-changing society, where digital media is becoming a way for people to interact and to keep in touch, for Black womyn, joining online sister circles can provide supportive environments that can reach other Black womyn in different parts of the country and world.

For those Black womyn who need to find these groups and have been unsuccessful, search relevant hashtags and keywords on social media sites in order to locate your tribe. Ask other sisters whom you like and respect if they are members of these reaffirming organizations. Do not limit your search to academic sister circles. Perhaps there is a group that has no connection to academics but offers you what you need to make your academic journey more palatable. Consider what you really need and want from a digital space designed for Black womyn. Join and get from them what you desire. And consider that you are also a sister and be willing to provide the support that you are so eagerly seeking.

Works Cited

Bryant-Davis, T. "Sister Friends: A Reflection and Analysis of the Therapeutic Role of Sisterhood in African American Women's Lives." *Women & Therapy*, vol. 36, 2013, pp. 110-20.

Collins, P. H. *Black sexual politics*. Routledge, 2004.

Collins, P. H. *Black Feminist Thought: Knowledge, consciousness, and the politics of empowerment*. Routledge Classics, 2008.

Cooper, B. *Eloquent Rage: A Black Feminist Discovers Her Super Power*. St. Martin's Press, 2018.

Crenshaw, K. "Mapping the Margins: Intersectionality, Identity Politics, and Violence against Women of Color." *Stanford Law Review*, vol. 43, 1991, pp. 1241-99.

Croom, N. N., et al. "Exploring Undergraduate Black Womyn's Motivations for Engaging in Sister Circle Organizations." *NASPA Journal About Women in Higher Education*, vol. 10, no. 2, 2017, pp. 216-28.

Davis, O. I. "In the Kitchen: Transforming the Academy through Safe Spaces of Resistance." *Western Journal of Communication*, vol. 63, 1999, pp. 364-81.

Denton, T. "Bonding and Supportive Relationships among Black Professional Womyn: Rituals of Restoration." *Journal of Organizational Behavior*, vol. 11, 1990, pp. 447-57.

Fries-Britt, S., and B. Kelly. "Retaining Each Other: Narratives of Two African American Women in the Academy." *The Urban Review*, vol. 37, no. 3, 2005, pp. 221-42.

Greif, G. L., and T. L. Sharpe. "The Friendships of Women: Are There Differences between African Americans and Whites?" *Journal of Human Behavior in the Social Environment*, vol. 20, no. 6, 2010, pp. 791-807.

Guo, W., and M. Tsui. "From Resilience to Resistance: A Reconstruction of the Strength's Perspective in Social Work Practice." *International Social Work*, vol. 53, no. 2, 2010, pp. 233-45.

Harley, S. *Sister Circle: Black Womyn and Work*. Rutgers University Press, 2002.

Harris-Perry, M. V. *Sister Citizen: Shame, Stereotypes, and Black Women in America*. Yale University Press, 2011.

McKay, N. Y. "Forward." *Sister Circle: Black Women and Work*, edited by S. Harley and the Black Women and Work Collective, Rutgers University Press, 2002, pp. ix-xii.

McCandless, A. T. *The Past in the Present: Women's Higher Education in the Twentieth Century American South*. The University of Alabama Press, 1999.

Pearson-McNeil, Cheryl, and Michelle Ebanks. *Powerful. Growing. Influential. The African American Consumer*, Nielsen, 2017, www.nielsen.com/wp-content/uploads/sites/3/2019/04/nielsen-essence-

2014-african-american-consumer-report-Sept-2014.pdf. Accessed 16 Jan. 2022.

Person, T. *Socialization Experiences and Friendships among African-American Women.* Dissertation Abstracts International, Pepperdine University, 2005.

"Reaching Black Women across Media Platforms." *Nielsen,* 2017, www.nielsen.com/us/en/insights/article/2017/reaching-black-women-across-media-platforms/. Accessed 16 Jan. 2022.

Saleebey, D. *Introduction: Power in the People.* 3rd ed. Allyn and Bacon, 2006.

Wade, A. "When Social Media Yields More Than Likes: Black Girls Digital Kinship Formations." *Women, Gender, and Families of Color,* vol. 7, no. 1, 2019, pp. 80-97.

Notes on Contributors

Jill Andrew, PhD, (she/her) is a child and youth worker, equity human rights educator, and a body justice advocate. Her PhD research explored the trifecta of anti-Black racism, sexism, and fat hatred experienced by Black women and their accommodation and resistance of dominant body ideals through fashion and dress, activism, self-valuation, and social interactions. Jill is cofounder of Body Confidence Canada and is a politician in Ontario, Canada.

Briana Barner, MA, is currently a PhD student in the Radio-Television-Film department at the University of Texas at Austin. Her research interests include representation and identity formation within the intersections of popular culture and digital media, with a particular focus on podcasts created by people of colour.

Erin L. Berry-McCrea, MA, is doctoral candidate in the Language, Literacy, & Culture (LLC) program at the University of Maryland, Baltimore County (UMBC). She is also a lecturer for the Department of Communication Studies at Towson University. Her research interests are aligned in Digital sociolinguistics, womanism, and Black rhetoric.

Jade Crimson Rose Da Costa (they/them/she/her) is a gender nonbinary queer woman of colour PhD sociology candidate at York University and a community organizer in the Greater Tkaronto-Hamilton Area (GTHA). Their dissertation explores how to vision a collective memory of Black, Indigenous, and People of Colour HIV/AIDS activism in and around Tkaronto using a Black feminist and queer of colour approach. Jade is also the founder of *New Sociology: Journal of Critical Praxis* and the cofounder of *The People's Pantry*. For more information on her work, please visit jadecrimson.com.

Jelisa Clark is a lecturer at Fayetteville State University. She earned her PhD in applied sociology at the University of Louisville. Her research and teaching are focused on the intersection of race and gender in education, with particular emphasis on how raced and gendered ideologies operate in schools and shape the experiences of Black students.

Lisa Covington is a PhD candidate at the University of Iowa studying the sociology of education, African American studies, and digital humanities. Her research is rooted in understanding the experiences of Black girls within schooling and community environments. Lisa is a practitioner who works directly with young women of colour and trains school districts and nonprofits on best practices for empowering students of colour.

Joseanne Cudjoe an Assistant Professor of Critical Digital Media Studies in the Department of Arts, Culture, Media at the University of Toronto. Her inter-disciplinary research lies at the intersection of media studies, Africana studies, and Black feminist critique. Her research explores Black female body politics, social reproduction, and alternative digital media production.

Ja'Dell Davis is a recent PhD graduate from the department of Sociology at the University of Wisconsin-Madison. Her work focuses on race-ethnicity in education, particularly the experiences of youth and practitioners in out-of-school time and afterschool education, the transition from high school to post-secondary education, and race discourse in educative contexts.

Colette M. McLemore Dixon, PhD, works at the University of Missouri St. Louis as assistant dean for student and alumni affairs in the College of Nursing. In addition to having a doctorate in higher education administration, she also has a certificate in contemporary adult spirituality, both from Saint Louis University.

Yarneccia D. Dyson, PhD, MSW, is a graduate of the Whitney M. Young, Jr. School of Social Work at Clark Atlanta University. She is currently an associate professor and department chair for social work and gerontology at the University of North Carolina at Greensboro. She is a social/behavioral scientist and health equity researcher who is

dedicated to work that focuses on ensuring justice, equity, diversity, inclusion, and access.

Christina Wright Fields is a faculty member within the Education Department at Marist College in Poughkeepsie, NY. She holds a bachelor's in biology from Millersville University, a MS in higher education administration from Drexel University, and a PhD in higher education administration from Bowling Green State University.

Sara C. Flowers, DrPH, is vice president of education at Planned Parenthood Federation of America and advocates for evidence-informed practice and emotional intelligence in sex education. Her research interests focus on fidelity and adaptation of sex education curricula and other sexual health topics related to disparities, youth of colour, and abortion access.

Jacqueline M. Forbes is a recent Ph.D. graduate in the department of Educational Leadership and Policy Analysis at the University of Wisconsin-Madison, where she researches racial narratives in education. She is currently an Assistant Professor at Dickinson College where she explores how racial narratives about Blackness are constructed and applied throughout the college-going process.

Ashley N. Gaskew is a doctoral candidate, pursuing a joint Ph.D. in Curriculum and Instruction and Educational Leadership and Policy Analysis at the University of Wisconsin-Madison. Her research focuses on the inclusion of for-profit education. Her research interests also include faculty in postsecondary faculty, neoliberalism in education, and critical theory.

Autumn A. Griffin, PhD, completed doctoral studies at the University of Maryland-College Park in the Department of Teaching and Learn-ing, Policy, and Leadership. Her research interests include humanizing and antioppressive pedagogies, the literacy practices of Black girls, and the experiences of Black girls in K-12 classrooms.

LaTrina D. Parker Hall, PhD, PhD, is the Director of the McNair Scholars Program at Texas Christian University. She earned her doctorate in higher education administration at Saint Louis University, where her research interests included Black family culture, racial and ethnic identity, and student development.

Sara Birnel Henderson is a researcher and educator in the sexual and reproductive health field. She is currently the manager of evaluation in the education department of Planned Parenthood Federation of America. Sara is an abortion doula and serves on the board of directors for the New York Abortion Access Fund.

Marcia Hernandez is a professor of sociology at the University of the Pacific. Her research focuses on the intersections of race, gender, and class in higher education and popular culture. Hernandez's current research includes exploring the experiences of alumnae members in Black sororities.

Gloria L. Howell, PhD, is the Director of the Neal-Marshall Black Culture Center and faculty coordinator for a first-year intro-ductory research course in the School of Education at Indiana University. Her research focuses on Black student identity develop-ment and affirmation, specifically through cultural performing arts engagement in postsecondary classrooms.

Leah P. Hunter, PhD, is an assistant professor in the School for Journalism & Graphic Communication at Florida Agricultural and Mechanical University.

ArCasia James-Gallaway, PhD, completed her doctoral studies at the University of Illinois at Urbana-Champaign in the Education Policy, Organization, and Leadership department. As a historian of African American education, she examines African American lived experiences of past education policy, Black feminist pedagogies, and the history of social studies education.

Adrianne Jackson is a Specialist for the Primary Prevention of Vio-lence with the United States Air Force. She has served as the director of the Florida A&M University's Bachelor of Social Work Program. Adrianne has attended Florida A&M University, Barry University and is currently a PhD candidate in the Florida State University Higher Education Administration program.

Cherell M. Johnson, PhD, is an instructor for leadership studies in the Student Academic Success Center at the University of Colorado-Boulder. She earned both her doctorate and master's degree in high-er education administration from Saint Louis University, where her

research interests included examining social movements on college campuses.

Tamara Bertrand Jones is an associate professor of higher education at Florida State University. She uses qualitative methods and critical and feminist theories to examine the education and professional experiences of Black women in academia. She is a founder and past president of Sisters of the Academy Institute, an international organization that promotes collaborative scholarship and networking among Black women in academia.

Danielle Krushnic, MPH, is a public health professional whose work is centred on sexual health education and HIV prevention. She is currently pursuing a biostatistics degree to conduct research and evaluation projects that are focused on sexual health education and maternal and child health.

MaKesha Harris Lee, EdD, has been a higher education practitioner for over 15 years. Her research interest focuses on the relationship between Black women and their hair. Currently, Dr. Harris Lee serves as the Director of CORE TEAM at Southern Illinois University.

Krystal O. Lee, EdD, is a Research Associate at the Johns Hopkins Bloomberg School of Public Health. Her current research interests center around incorporating Anti-Oppressive principles in public health pedagogy and practice.

Jamila L. Lee-Johnson is an inclusive excellence lecturer at the University of Wisconsin-Whitewater: Higher Education Leadership program. Her current research projects focus on Black women's leadership experiences at historically Black colleges and universities (HBCUs) and successful mentoring practices for students of colour in their transition into graduate programs.

Deborah A. Levine, LCSW, ACSW, has over thirty years of experience in community engagement. She serves as the cochair of the NYC DOHMH's *New York Knows* and Women's Advisory Board. Currently, she is the Harlem Health Initiative CUNY-SPH director and a founding member of the National Black Women's HIV/AIDS Network, Inc.

Melanie Marshall is a doctoral student at the University of Illinois at Urbana-Champaign in the Department of Curriculum and Instruction. Her research interests include gender, sexuality, and multiculturalism in children's literature, literary representations of Black girlhood, and the digital literacy practices of Black girls and women.

Denise Davis Maye is a professor in the Department of Social Work at Alabama State University. Her research interests include the factors that influence the emotional development of adolescent girls and women of African ancestry. She is a past president of Sisters of the Academy Institute, an international organization that promotes collaborative scholarship and networking among Black women in academia.

Angel Miles Nash, PhD, is an assistant professor at Chapman University in the Donna Ford Attallah School of Educational Studies. Angel's teaching, leading, and service in K-12 schools and higher education galvanize her research endeavours examining the intersectional realities and emboldening of Black girls and women in STEM and education.

Veronica A. Newton is an assistant professor of race at Georgia State University. Her research examines how Black undergraduate women experience gender racial microaggressions at a historically, predominantly white university (HPWI).

Tara Nkrumah, PhD, is the acting Executive Director for the Center for Gender Equity in Science and Technology at Arizona State University, Tempe. Through her research agenda centring culture, equity, and engagement in science curriculum development, Tara explores culturally responsive leadership to address the underrepresentation of Black girls and women in STEM education and careers.

Rhonda Gillian Ottley is a PhD candidate in sport management at Florida State University. She is a national of Trinidad and Tobago (T&T) and a graduate of Temple University. Her research includes exploring T&T's colonial past and its influence on governing practices. Rhonda is also the administrator for SANKO-FA HP LLC.

Katrina M. Overby, PhD, is an Assistant Professor in the School of Communication at the Rochester Institute of Technology (RIT) in Rochester, NY. Her doctorate is from the Media School at Indiana

University. Her dissertation was titled *Doin' it for the Culture: Defining Blackness, Culture, and Identity on Black Twitter.*

Dr. Devona F. Pierre is the inaugural Equity, Diversity, and Inclusion Director at St. Petersburg College. Her research interests include the success of Black women in academia, mitigating barriers for Black women academics, and mentoring Black women in higher education. She is a proud graduate of Dillard University in New Orleans and Auburn University in Alabama.

Kimberly L. Mason is a licensed professional counselor-supervisor, a national certified counsellor, an approved clinical supervisor, a distance credentialed counselor, and a doctoral student at Mississippi State University. She is an advocate for minority mental health with research interests inclusive of diverse approaches for working with clients and supervisees.

Sophia Rahming is an associate director in the Center for the Advancement of Teaching at Florida State University. She earned her PhD at Florida State University, researching the experiences of Afro-Caribbean women in STEM in the United States. Sophia works to increase opportunities that lead to science for all in STEM

Kalisha V. Turner-Hoskin, EdD, has been a higher education practitioner for over 15 years. Her research interest focuses on minority student access and college readiness. Currently, Dr. Turner-Hoskin serves as the Program Director for the TRIO Student Support Services program at St. Louis Community College.

Arielle Weaver is a PhD Student at the Evans School of Public Policy and Governance at the University of Washington. Broadly, Arielle's research interests are aligned with addressing issues of social equity, access and opportunity in the public sector. Specifically, she looks to examine the policies, practices, and environments that negatively impact leadership opportunities for women of color.

Daphne Wells is a native of Sacramento, CA, longing to make her way back east. She is currently pursuing her PhD in higher education administration at Morgan State University.

Francesca A. Williamson, PhD, is an Assistant Professor in the Department of Pediatrics at the Indiana University School of Medicine. Her research focuses on three main areas: 1) postsecondary STEM teaching and learning; 2) community-engaged STEM outreach and learning; and 3) discourse studies. She has taught service learning in STEM and research methods.